Eve Arnold's
People

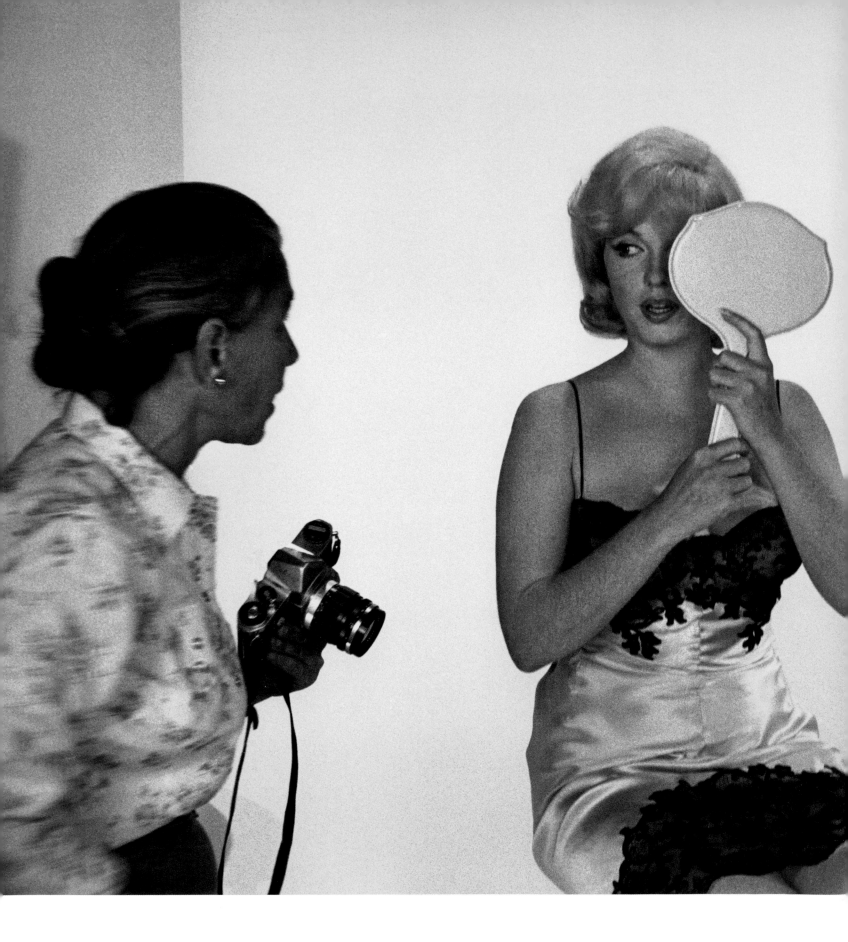

Eve Arnold and Marilyn Monroe during the filming of *The Misfits*, Nevada, 1961

Edited by **Brigitte Lardinois**

Eve Arnold's
People

With texts by **Anjelica Huston**

and **Isabella Rossellini**

Contributions from **Elliott Erwitt, Beeban Kidron,**
Mary McCartney, Sheena McDonald, David Puttnam,
Michael Rand, Jon Snow and John Tusa

Thames & Hudson

To Linni Campbell, 'the Number One'

First published in 2009 in hardcover in the United
States of America by Thames & Hudson Inc.,
500 Fifth Avenue, New York, New York 10110

thamesandhudsonusa.com

Library of Congress Catalog Card Number 2008908218

ISBN 978-0-500-54371-9

Designed by Maggi Smith

Printed and bound in Singapore by C.S. Graphics

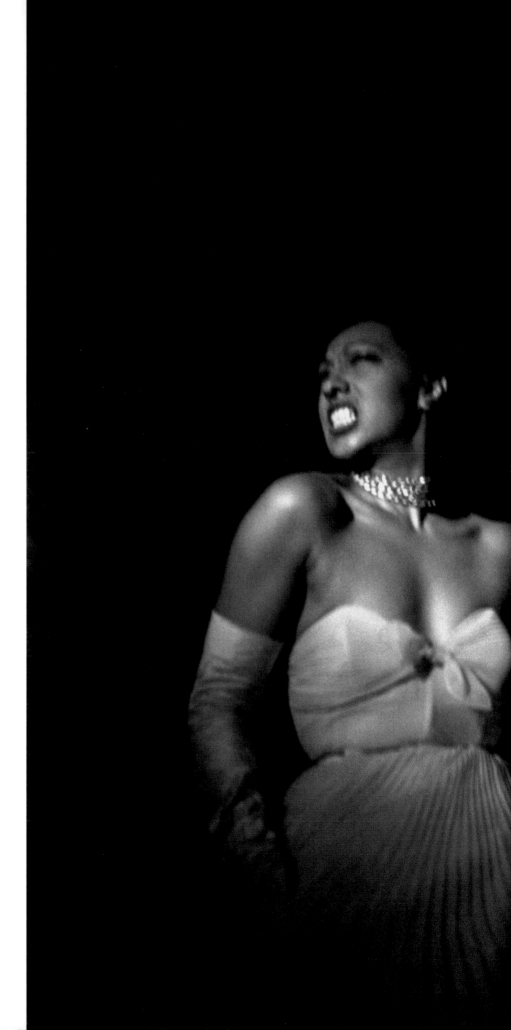

Josephine Baker, Harlem, New York, 1950

Contents

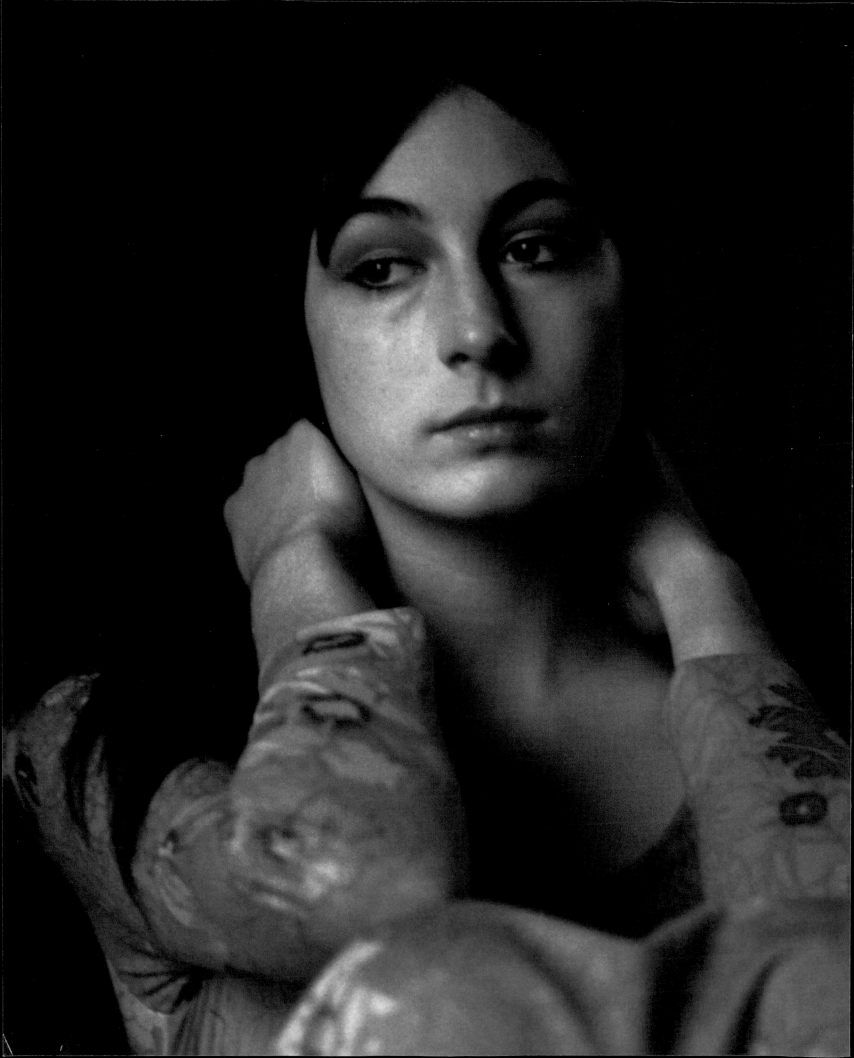

The Many Faces of Eve Arnold
by Anjelica Huston

Eve Arnold has had a long, fascinating and prolific life. Her first teacher was the renowned Alexei Brodovitch, the art director of *Harper's Bazaar*. In 1951, she became, along with the photographer Inge Morath, one of the first women to join Magnum Photos – a cooperative whose founder-members included Henri Cartier-Bresson and the great American war photographer Robert Capa.

Eve has travelled the campaign trail in India with Indira Gandhi, ridden the subways with the Guardian Angels in New York, participated in a peyote ceremony with the Navajo, photographed male strippers, gay nuns, chemical dependents and survivalist groups, including one in New Orleans that according to a local sheriff could 'out-gun' the police department of that city. Eve has travelled south to record the activities of the Klu Klux Klan, 'sitting with the Imperial Wizard as he ranted against Blacks, Vietnamese, Jews, Catholics, homosexuals and women.' Later, she returned to photograph Jerry Falwell, the head of the Moral Majority. In the 1960s, Eve ventured to Zululand, the USSR, Afghanistan and Dubai. She was assigned to a story in 1973, 'Black in South Africa', an episode about which she remarked, 'One thing worse than being black in White South Africa is being black in Black South Africa.' In the late 1970s she was one of the first photographers to be allowed to travel and take pictures with relative freedom in China.

Each face tells its own story, and Eve Arnold's pictures tell their own story, too. In a book that emphasizes cultural, social, economic and spiritual differences, she introduces us to the personal world of her subjects. In one of the first indelible images, this idea is illustrated in a three-way conversation between Eve (who includes herself in the photograph), Marilyn Monroe (whose attention remains on the hand-mirror she is holding but whose eyes have travelled to Eve), leaving ourselves and the camera to share the moment of intimacy between the women. Another example of this view inward is beautifully evoked by a photograph of the actress Silvana Mangano with a sculpture by Brancusi, that looks remarkably like her, at the Museum of Modern Art, New York. Something about this idea reminds me of a temple in Kyoto, Japan – over one thousand bodhisattvas reside there, and it is thought that visitors can recognize themselves in the faces of the statues.

The last time I saw Eve, she was occupying a corner room at an old people's home in London down the hall from a man crying in anguish for his teddy bear. How odd to find Eve, the calm and constant observer, suddenly and ironically in a parallel reality, like the virtual ghost of one of her own photographs. In her book *In America*, Eve remarked on 'an aged, sad woman in a wheelchair who broke my heart' – she found out later that the woman was Norma Shearer.

But this is not quite the case with Eve. Although physically fragile, and past her ninetieth birthday with some five years since we had last seen each other, Eve looks up directly as I enter her room, and without hesitation exclaims in a strong voice, 'Anjelica Huston'. She fixes me with that intelligent, tolerant gaze – the look that doesn't judge. And I remember with Eve, one never has to defend

Actress Anjelica Huston during the filming of *A Walk with Love and Death* directed by her father, John Huston, Austria, 1968

oneself, one only has the feeling that she has seen much of what paradise and hell have to offer, and all that considered, she is unhappy with her circumstances at present. 'It is not my choice to be here,' she says.

I ask her if she is taking photographs. 'That's over. I can't hold a camera any more. But,' and suddenly there's a glint in the eye and she looks around furtively, conspiratorially, 'there's a story here, the written word.' I ask her if she's been reading. 'Extensively,' she says, 'Dostoyevsky, Mann, Tolstoy mostly.'

I remember that it was Eve who photographed the first five minutes of a baby's life on Long Island in 1958, and Eve who photographed the oldest people in the world in the USSR in 1965 and 1966 under constant surveillance by the KGB. Then there's all that's gone between. The spectrum of Eve's work stretches across continents, cultural divides, political landscapes, sexual orientations, spiritual journeys, and examines what lies beneath the skin.

Eve, the reporter, was quite a different being from the woman one might have dined with the night before. Both were gentle and considerate, but the camera-bearing Eve was instinctive as a bird of prey circling her subject. You felt her investment in her plan: the quiet accuracy with which she measured mood and distance and light.

My father had decided to reward my childhood ambition to be an actress by giving me a starring role in a period film he was also to direct, *A Walk with Love and Death*. In order to prove to the studio that I was the right choice, he commissioned a British photographer, the very grand Norman Parkinson, to take some headshots of me at my mother's house in London. Influenced by the top models of the day, I chose an eye makeup worthy of Cleopatra. My father hit the roof and called for Eve to come and save the day, which quietly and expertly she did, saving discord on all sides.

Looking at those pictures now, in the ruins of a castle in the Irish countryside, I can see Eve, quiet and purposeful, speaking to me in that affectionate, low, froggy voice and the feeling that she, the camera and I were as one.

Eve was never sentimental, but many of her photographs display sheer love of her subjects – the photographs of the fragile, incandescent Marilyn Monroe, sad, sweet, soft and laughing; of Isabella Rossellini's classic profile and questioning eyes; of a small boy in Afghanistan blowing on the skeleton of a dandelion flower; a mortal Marlene Dietrich furrows her brow over a sheet of music, then faces the shadows, head in hand, the light kissing her blonde hair, the curve of her shoulder, the bracelets at her wrist and those famous legs; Paul Newman sits alert as a young lion at the Actors Studio, New York.

Eve went straight to the essence of the subject. Her portrait of my father, John Huston, is both fond and revealing; the painterly choices in colour, of an instant, caught in the delighted smile of the young and beautiful Queen Elizabeth, looking skyward, as the sun emerges from a cloud. And by contrast, the bored, glowing grumpy faces of the cherubim waiting to see her, Union Jacks in hand. The black and white photographs are equally luminous and expressive – a fisherman and his wife laugh joyfully with their little girl, her head tossed back like an angel in her father's arms, as the light beams from above. These photographs celebrate the magic of everyday life.

There was the intrepid, subversive, undercover Eve who gained access to Senator Joe McCarthy, and who slipped like soap between the bars of the Texas State Penitentiary, photographing the lost souls on death row, the mentally insane in Honduras, and who followed the appearances of Malcolm X and the activities of the Black Muslims. She recorded the cold ferocity of George Lincoln Rockwell, the head of the American Nazi Party, and she travelled to

Egypt for a feature about women, *Behind the Veil*, and to Dubai in 1971 to photograph the women of the harem.

And then there was the empathetic Eve, the recorder of pain, loss, war, age and social injustice. The intensely concerned photographer whose compassionate nature allowed sorrow to speak its name in the eyes of a young Haitian girl, trapped in an asylum, living the life of a lab specimen, or a bar girl in a brothel in Havana, Cuba, in 1954, gazing into an uncertain future, or recording the labours of migrant farm workers and their living conditions in Long Island in the 1950s. Here, there are photographs of people from all walks of life, movie stars and mad men, monsters and victims, angels and devils – but many of the images simply portray people at work, at rest and play, performing their life's function.

I think that Eve, like all great artists, is telling us about herself, what she cares about, what registers and resonates within her - and that it is no coincidence that on the cover of her book, *In China* (1980), she chooses a photograph of a retired worker in Guilin, who bears a remarkable resemblance to herself.

And finally, there is the Eve of great irony and mirth. Her sweet, funny, solemn pictures of the British; of Mikhail Baryshnikov at play with his dog; Anthony Quinn and Anna Karina making cigarettes look good; Dirk Bogarde, dashing; Richard Burton and Elizabeth Taylor, each glowing in their own limelight; and Joan Crawford, resplendent in peacock blue, raises her dark eyebrows in tacit self-approval to the mirror… and me, moody and rebellious at fourteen, standing on my head with my father laughing beside me, a moment only Eve could have made possible.

This beautifully compiled edition of Eve Arnold's long and courageous visual journey is a definitive collection of a true original. My life has been enriched by our friendship and the world has been enriched by her art.

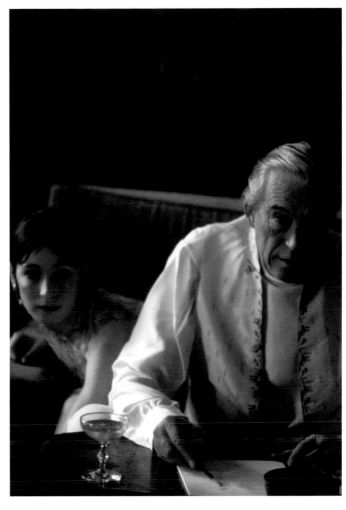

John Huston with his daughter Anjelica, Ireland, 1968

The Compassionate Eye

by Isabella Rossellini

Isabella Rossellini studying her lines for the film *Blue Velvet*, a film by David Lynch, Massachusetts, 1985

Eve is small with white hair collected in a neat bun. Everything she wears is elegant and reveals a bit of her nomadic life – a scarf from India, earrings from Mongolia, a cashmere sweater from England – and she is barefoot.

Her bare feet worried me when I first met her as she was running around the set of the film *White Nights*, my debut American film, in 1983. She was taking photos of everybody on the set, but especially of the principal actors, Misha Baryshnikov, Gregory Hines, Helen Mirren, and myself. 'What if she steps on a nail?' I thought. 'Does she have to tiptoe around us so as not to be noticed and take candid photos?' If she saw me noticing the camera, she stopped photographing me.

I was used to posing for photographers in my career as a model. I posed being very aware of the camera, of the angles and framing, and slightly changing my position accordingly. Photographers like Avedon would direct me, 'Change your thought.' He seemed to really see what I was thinking. Once, I tested him. I disobeyed, and went back to my original thought, the one he had asked me not to have. He caught it immediately and said, 'No, I told you not that thought.' Photographers see everything, it's scary.

Eve didn't like me posing. She was a photo reporter, after all. She once told me, 'I just hope to be fast enough to catch the image I'm after.' 'Just like a hunter,' I thought. She saw, she snatched. Through Eve's eyes, I have travelled to many distant places, have seen what I always wished to see: the birth of a baby; a harem; life in a remote village in China; or Malcolm X, and Marilyn Monroe… now, just think for a minute about these two last names: Malcolm X and Marilyn Monroe. Don't they give you the incredible range of what Eve has photographed?

'What makes you tick?' I asked. 'If you were to define in one word, what is the engine that powers you, what would that word be?' She answered, 'Curiosity.' That answer stayed

with me. Eve is more than a photographer who took my picture. She is even more than a friend. She is a role model to me. I observed her, I studied her, and wanted to understand how Eve became Eve. I want curiosity to become my engine too.

She was one of the first women to join the prestigious photo agency Magnum, founded by Robert Capa and Henri Cartier-Bresson. Eve dealt with men like a man. I have never seen her flirtatious, delicate, or coy. Eve is always direct, strong, together, and infinitely benevolent. In her eyes there is always a twinkle, a smile, and lots of warmth.

I saw Eve often, as often as I could. We talked about children, about friends, and about politics. She never talked in an intellectual way, but in a 'hands-on' way. When talking about politics, she would say, 'Indira Gandhi told me…', or 'Malcolm X said…' When talking about cinema, she would say, 'John Huston said to me… John Schlesinger told me… Marilyn Monroe and I…'

Eve's intimacy with people is revealed in her photos. Her subjects are relaxed and spontaneous in front of her lens. How did she do it? How did she conquer the trust of such revered people? I knew that answer as soon as I met her. She loves life and human beings, and that's what she is after. With her compassionate eyes and her sense of humour, she is there pointing her lens to take the picture of a human being behind the star, behind the politician, behind the destitute, and behind the child.

I told her once, 'I always like having you around me taking photos. Instead of being spied on by you, I feel protected. How is that? Do the others feel the same? Are you barefoot to tiptoe around us so we are not aware of you?' 'Barefoot?' She said. 'Oh. That's because I have a bunion.' Stupid me. I had made up all these theories about how she approached her subjects tiptoeing barefoot… Forget about it. I cannot describe Eve.

Isabella Rossellini modelling Betsy Johnson clothes, New York, 1995

On my kitchen wall amidst the photos of my children and parents, I have photos that Eve gave me of her work. They always make me smile. Her compassion, her irony, and her humour present in the photo is comforting to me; a reminder of her look on life that I'd like to make mine.

I also have a photo of Eve made by another photographer friend, Brigitte Lacomb. In the photo, Eve is captured straddling a chair, her white hair collected in the neat bun, waving her hands in front of her, and smiling. I know what she is saying: 'No photos of me please.'

1948
1960

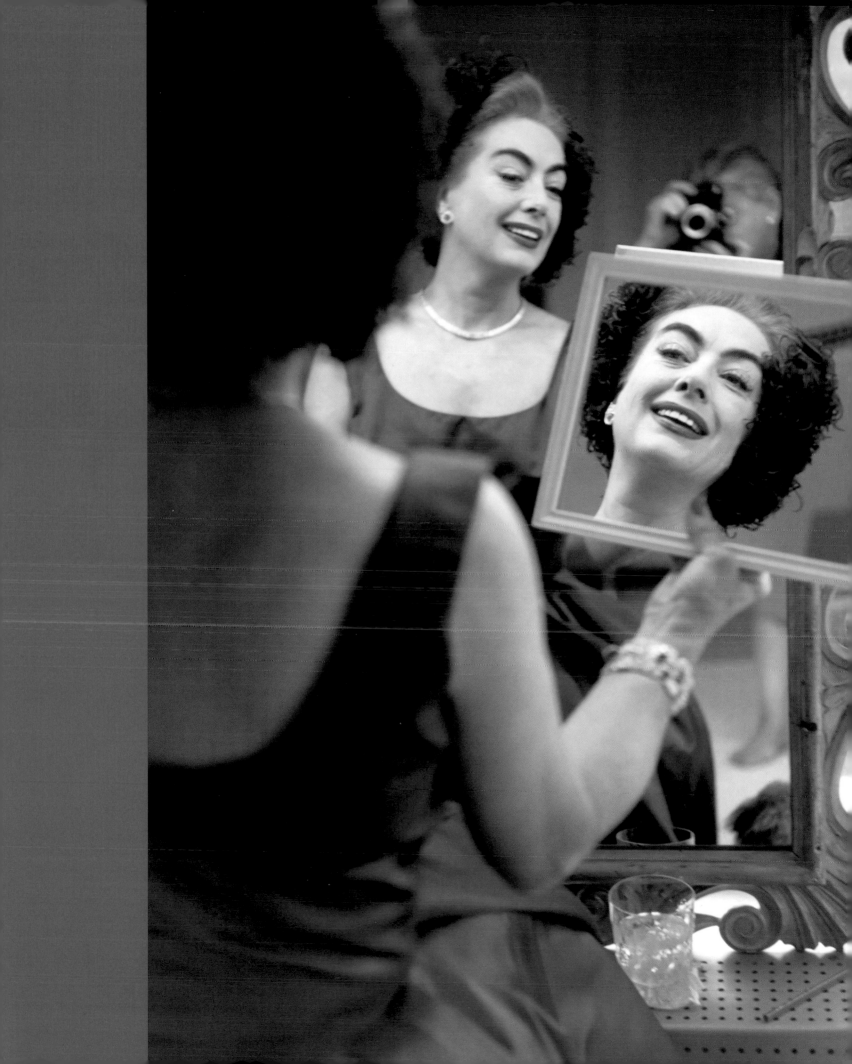

This book brings together a selection of the portraits that Eve Arnold has taken during the course of her long and productive career. Photographing people from every walk of life – at work, at rest, but above all simply showing people as they are – has been her life's work. Ten friends, associates and creative colleagues have added their own words to this collection, creating an affectionate composite portrait of the woman they know. They, too, are Eve Arnold's people. Through their words and her pictures, this book presents a picture of the woman herself.

Eve's date of birth was never mentioned until she reached the age of ninety, when she stopped concealing her age. She was born in Philadelphia, Pennsylvania on 21 April 1912, in the same week that the *Titanic* sank, the seventh of nine children of immigrant Russian-Jewish parents, Velvel Sklarski and Bosya Laschiner, known as William and Bessie Cohen. It is worth remembering that Eve's photographic career started relatively late, when she was nearing forty. To recall her date of birth is also to bear in mind that some of her most demanding journeys, such as the long trips to China, were made when she was nearly seventy, and that she worked as a very active vice president of Magnum Photos when she was in her eighties.

Sir John Tusa, distinguished journalist, broadcaster and senior figure at the BBC for many years, was head of London's Barbican Arts Centre for twelve years. He met Eve on the occasion of her exhibition 'In Retrospect' in 1996, and he interviewed her for BBC Radio 3 in 2002.

Eve Arnold's People – *of course! What else is she about? What else is worth photographing? And not just the famous, still less the famous on their own terms, where the photographer is reduced – willingly or unwillingly – to being an arm of the image-making publicity and fame machine. (Though Marilyn Monroe did have her way of getting her way.) Eve Arnold photographed the rich, the poor, the known, but chiefly the unknown, the comfortable and the weary, the content and the suffering, the still and the active, the exceptional and the apparently routine and humdrum. She approached them all in the same way, as she told me in 2002.*

'You want to go as deeply into them as people as you can. But usually what happens, if you're careful with people and if you respect their privacy, they will offer part of themselves that you can use and that is the big secret. It has to do with the relationship of the photographer to the subject.'

That relationship is one of mutual trust and respect, where the photographer does not abuse the subject's 'gift' of himself or herself. Eve Arnold would not be the photographer that she is without this fundamental belief.

So what else is she? Given the huge range of Eve Arnold's People – and, by the way, they are not hers in a possessive way, they are not selfishly appropriated, they are not there to fuel her own celebrity – a range that stretches from Afghan barbers to the greatest beauties of the twentieth century, can her work itself be caught in any sensible way?

Looking at these pages, certain constants seem to me to emerge. Eve Arnold is: percipient but not intrusive; concerned and compassionate but never sentimental; detached but not indifferent; involved but not committed; aware but not self-conscious; business-like but not exploitative.

She could have exploited Joan Crawford's drunken weakness in insisting that Eve photograph her naked. Principle and practical common sense about the consequences for Crawford's career if she did prevented her. It also led to one of Eve's most famous and perceptive observations: 'Something happens to flesh after fifty and she was well past fifty' – an observation that carries in it a wealth of human compassion and understanding that informed the eye and mind of the photographer.

Her respect for people allows them all – whatever their job or daily task – a dignity that justifies their existence. For Eve, catching the spirit of work, of people at work, especially the most daily routine, lies at the heart of the experience. And we are all united by work – look at Clark Gable filming, Marilyn Monroe flirting (that's work too), a bare-bummed Vanessa Redgrave getting into costume, an Afghan house fumigator, an Arran Island farmer. They are all working, doing their jobs. It is as if she sets out to capture the words of George Herbert's seventeenth-century poem and hymn, 'Who sweeps a room as for thy laws, Makes that and the action fine.' We are all dignified, often defined, by our work and are fortunate if we have an Eve Arnold to capture that sense of worth in work.

As Eve herself put it to me: 'You get closer to people when they are at work… Grinding labour is part of the work. I respected them and didn't want to savage anybody.' In Eve Arnold's photographs, nobody's work is better than anyone else's – some is far better paid, of course, some far more comfortable to do. But no one is graded lower on some scale of superiority or inferiority because of the job they do, the task they undertake.

Eve claimed to have taken up photography by accident. In 1943, while working as a book-keeper for an estate agent during the Second World War, she answered an advertisement in the *New York Times* for 'an amateur photographer' which led to a job at a photograph printing and finishing plant in New Jersey. It was the start of a lifetime of what she calls 'learning by doing', the exception being a tough six-week

course of study at the New School for Social Research under the tutelage of Alexey Brodovitch.

Her first photo story was on fashion shows in Harlem, New York (see p. 21). Despite New York's cosmopolitan atmosphere, the United States was still a segregated society in the 1940s and 1950s; the Civil Rights movement had yet to gain pace. Eve recalls taking her seat amongst the paying all-black audience in the deconsecrated church where a show was to take place. People smiled and started striking poses for her camera. She found her way backstage to try to take more discreet pictures, hoping that the people working there would be too busy to notice her. This was a very novel way of photographing fashion: in those days fashion was all about posing in a studio, in a carefully controlled environment, while Eve was pursuing an exercise in pure photo reportage. 'It was daunting to bring my pale face into that all-black audience and get up enough courage to put my camera into their faces. … My hands were shaking, from fear not of the people but of my ability to bring forth pictures.'[1]

Without Eve's knowledge, *Picture Post* in London syndicated the story and it was widely distributed in Europe. In 1951 she approached Magnum Photos, combining this photo story with another she had done on an opening night at the Metropolitan Opera in New York. 'It was a daring thing,' said Eve, 'for a rank beginner to approach these giants: Cartier-Bresson, Capa, Rodger, Seymour. I had no illusion or hope that they would consider me for membership, but I was desperate for a path to open.'[2]

Elliott Erwitt, a distinguished and much-published photographer, is a longtime Magnum colleague and a friend of Eve's from the early days. He joined the agency at the invitation of Robert Capa in 1953.

I met Eve Arnold at the beginning of my career in the Magnum Photos cooperative agency and in the gestation of hers. At that time, married and with a young son, Eve was essentially a home-maker – a Long Island housewife and mother living in the village of Port Jefferson baking very good cookies. Everything Eve did was always very good. As best I can remember her interest in photography was from the beginning. It may have been a way to overcome the tedium of domesticity.

Eve Arnold's photographs are in the best journalistic tradition. She is endowed with the keenest visual sense plus curiosity and passion for the human condition. She is a reporter who does not intrude. She is the observing fly on the wall, the responsible ethical witness, the enterprising adventurer – and if that were not enough, and as is obvious to anyone who has picked up any of her many picture

essays or read any of her books in the past five decades, she is one of the few photographers on the top of our visual game who is also a distinguished writer.

Magnum is a cooperative founded in 1947 by and for photographers. In the early days new members were usually taken in on the nod of Robert Capa or Henri Cartier-Bresson, two of the four founders. Inge Morath joined the Magnum Paris office at the same time that Eve joined in New York; famously, neither would ever claim to be the first woman to join Magnum, always insisting that they joined together.

Eve was part of the first Magnum contingent, the group that struggled to keep the agency going after the sudden unexpected deaths of two leading members, Robert Capa and Werner Bischof, in 1954. Eve called Magnum a family – where 'you love them all but don't necessarily like them all'.[3] She described her friendships and influences at Magnum, where she absorbed the lessons of many independent-minded fellow professionals: Henri Cartier-Bresson taught her how to tell a story in a single definitive image; Eugene Smith taught her how to put a story together; Robert Capa taught her to be daring. From Inge Morath she learned how to introduce lightness into her photographs; Ernst Haas taught her about colour; and Erich Hartmann taught her technical restraint and discipline. She discussed story lines with Burt Glinn and Dennis Stock. And she credits Elliott Erwitt with showing her how humour works in photography. Dennis Stock, and later, when Eve was living in England, Ian Berry and George Rodger (together with his wife Jinx), became firm friends as well as professional colleagues.

Under the tutelage of this talented collective Eve developed into one of the great photojournalists of our time. Through Magnum she gained access to movie stars, and it was at a party given by John Huston that she met Marilyn Monroe. It was the beginning of an association that would span a decade until Monroe's untimely death in 1962. When asked whether she and Monroe were actually friends, Eve replied, 'Marilyn wanted a mommy, and I would not be that for her.'

Sheena McDonald is a British journalist and broadcaster and the winner of the first-ever Woman in Film and Television Award. She met Eve on the occasion of putting together an exhibition of work by women Magnum photographers: Eve, Martine Franck, Susan Meiselas, Inge Morath, Lise Sarfati and Marilyn Silverstone. The show was called 'Magna Brava'; it was published under the same title and has since become a classic.

As a television journalist, I conventionally insist that the camera always lies, turning the old adage on its head, because the limitations of framing and

perspective inevitably mean that only part of the whole picture can ever be seen. Then the TV report is edited; and images recorded in different parts of the world and at different times can be stitched together to achieve an apparently seamless sequence. Any truth obtained thereby has been knitted together by craft and ingenuity, but is often not innate. Technology is a treacherous enabler.

Truth, of course, is the journalist's stock-in-trade. It's what we seek to find, and what we claim to publish. And it's the most elusive quality.

So surely a stills photographer is compromised by technology and circumstances when trying to convey a truth? After all, the images are static, frozen in time. Can a momentary caught image convey any truth?

Eve Arnold's work is testimony to what can be achieved in the hands of a master. For almost sixty years, her skill and discipline have produced astonishing images which repeatedly fathom the complexity of life on earth with deceptive simplicity. We recognize her subject-matter – in this book, people known and unknown – but she presents familiar faces and situations with a genuinely original freshness, as if she has inherited the eye of a wise Martian!

How does she do it? This question has relevance to my work. There is a strict TV convention that requires any interviewee to sign a release form which permits the programme-maker to use the material recorded. Stills photography does not oblige any equivalent practice. What Eve's work reveals is the extraordinary level of trust which she has inspired.

So we see Jacqueline Kennedy looking simply happy, and as full of life as usually only an artistic image can achieve. Clark Gable, Marlene Dietrich, John Huston are all relaxed, their defences are down. Marilyn Monroe joins Laurence Olivier in spontaneous laughter. The famous men and women who trust Eve Arnold to immortalize them are demystified – but never put in their place. Stars retain their glamour in Eve's eye, but also display their humanity.

At least as importantly, the humanity of the ordinary men and women Eve photographed shines through, making them as extraordinary as every individual has the potential to be, whether they are migrant workers, army veterans, bartenders or toddlers. To say her work gives them dignity is patronizing, I think. What her method enables is a degree of understanding and empathy with strangers. She turns photo-reportage into a force for good, opening the minds of those who see her images – at the same time as pleasing the eye.

1 *In Retrospect*, 1995, p. 3.

2 *In Retrospect*, 1995, p. 6.

3 *In Retrospect*, 1995, p. 7.

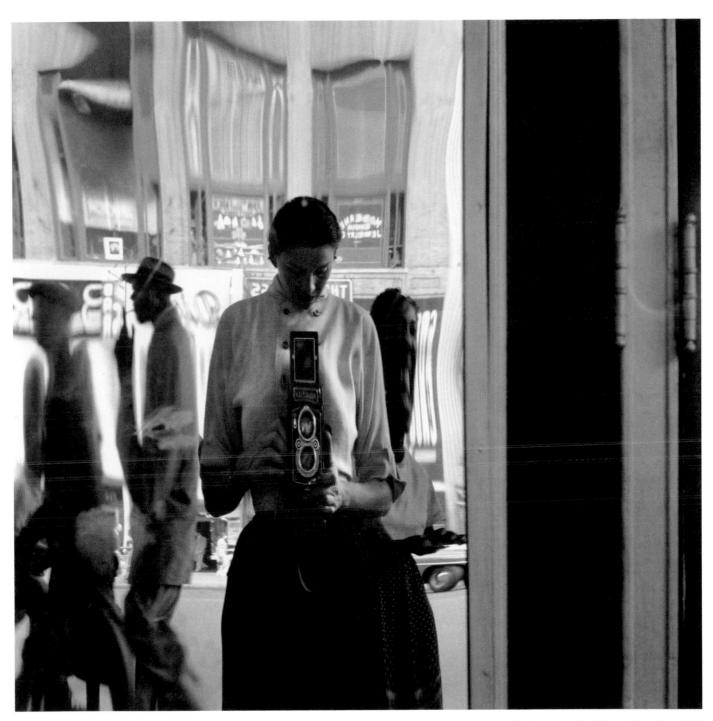

Self portrait, 42nd Street, New York, 1950

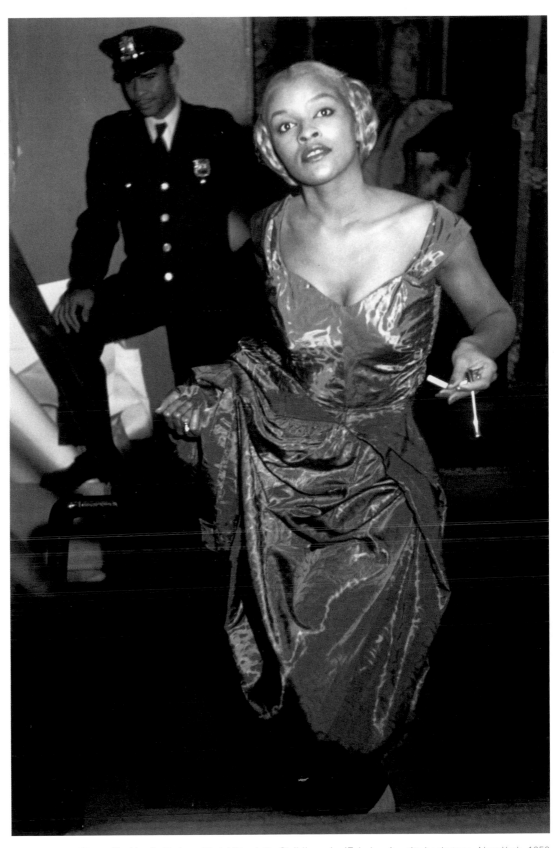

Above Fashion in Harlem. Model Charlotte Stribling, aka 'Fabulous', waits backstage, New York, 1950

Opposite Outside a premiere at the Metropolitan Opera, New York, 1950

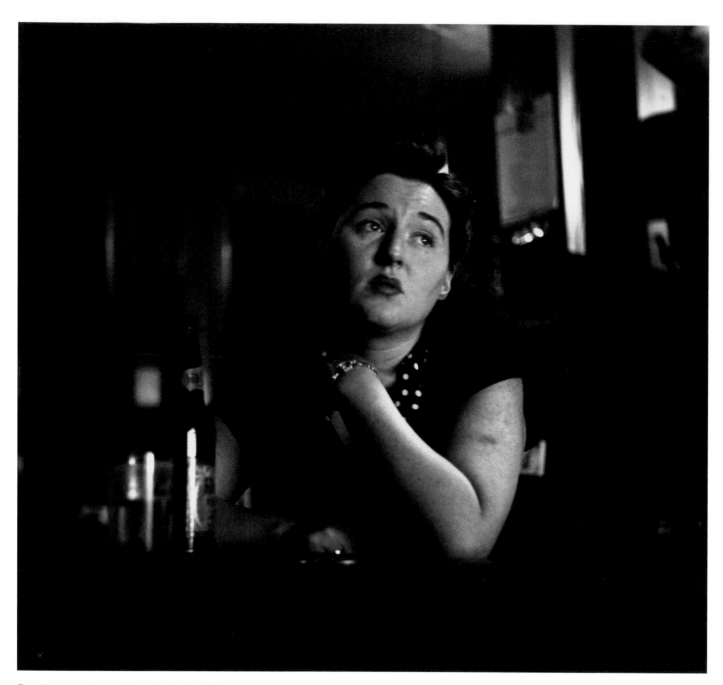

Female bartender on strike, New York, 1950

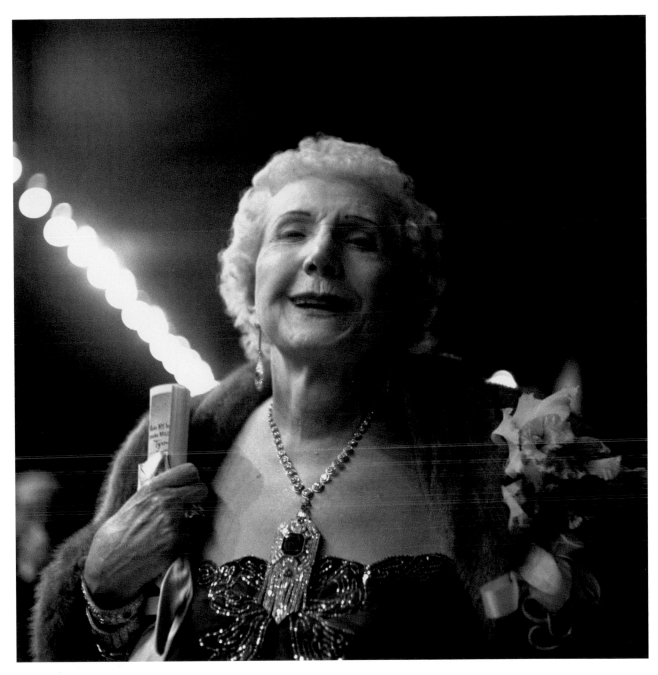

Mrs George Washington Kavanaugh, a descendant of George Washington, at the opera, New York, 1950

Bar girl in a brothel in the red-light district, Havana, Cuba, 1954

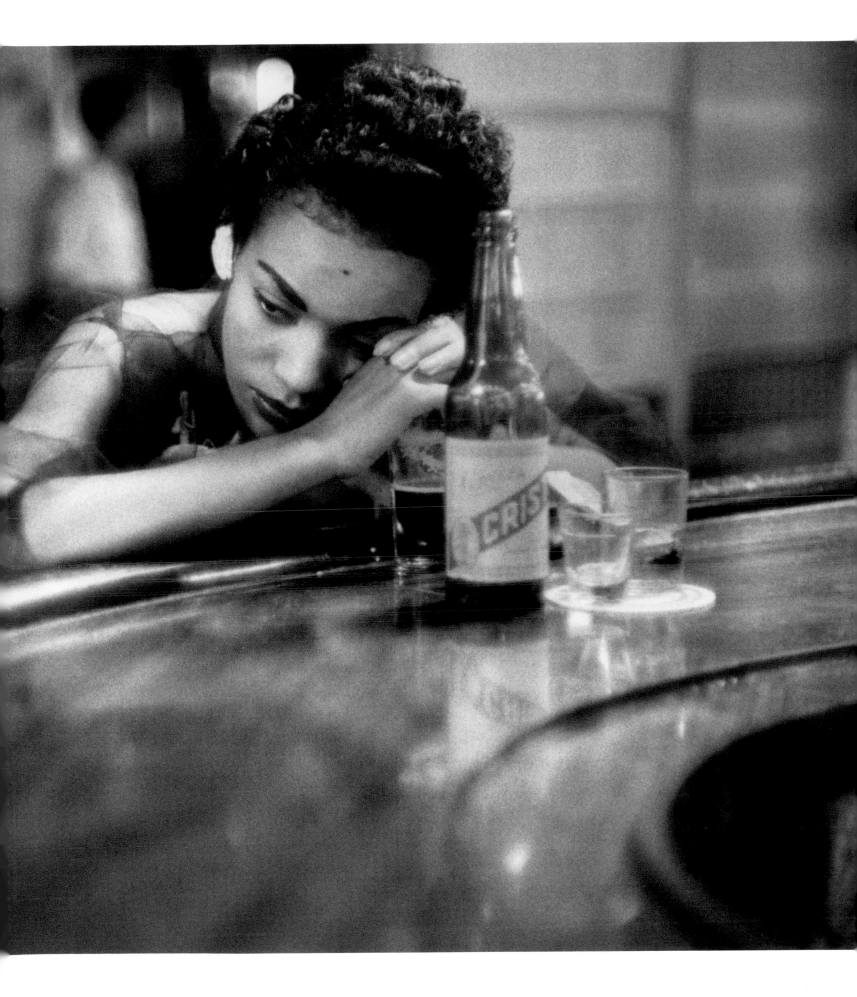

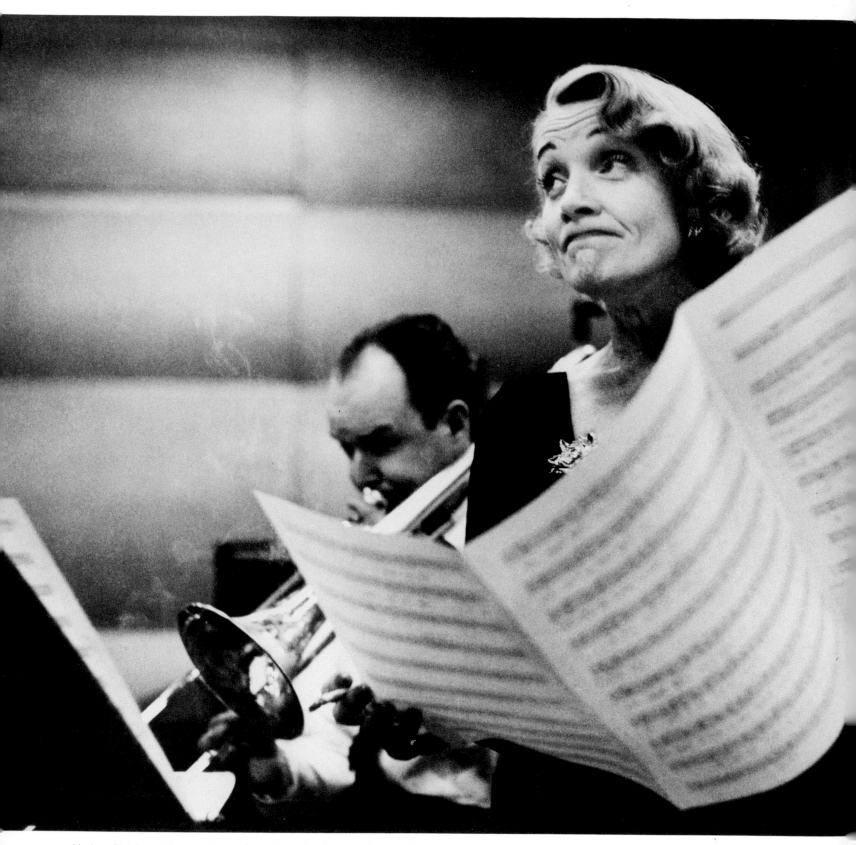

Marlene Dietrich at the recording studios of Columbia Records. She was 51 years old and starting a come-back in show business. It was a wet and cold November night and work could only begin at midnight, at the advice of Marlene's astrologer, New York, November 1952

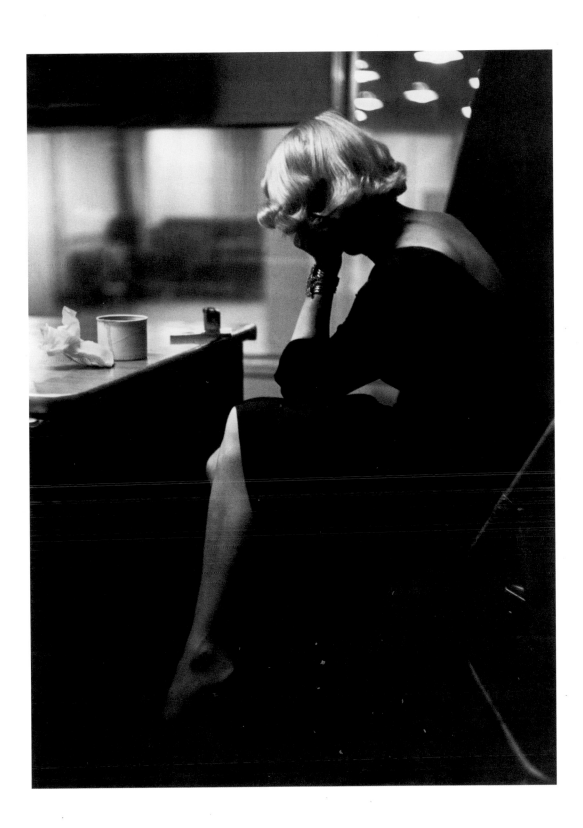

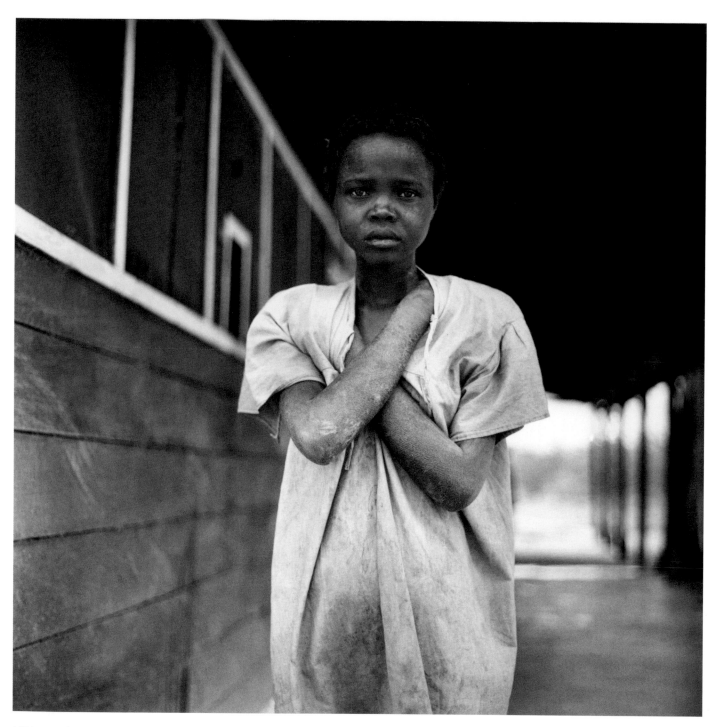

Milltown, a best-selling tranquillizer drug, was tested by American drug companies at this asylum, Haiti, 1954

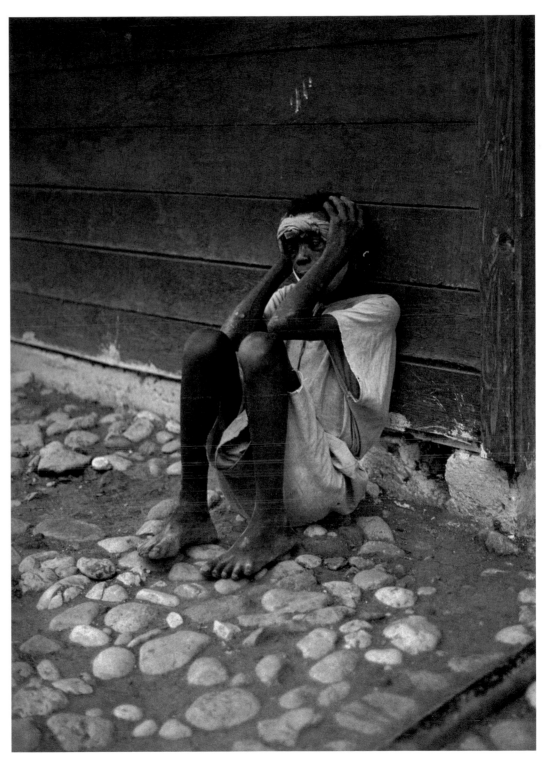

Insane asylum, Haiti, 1954

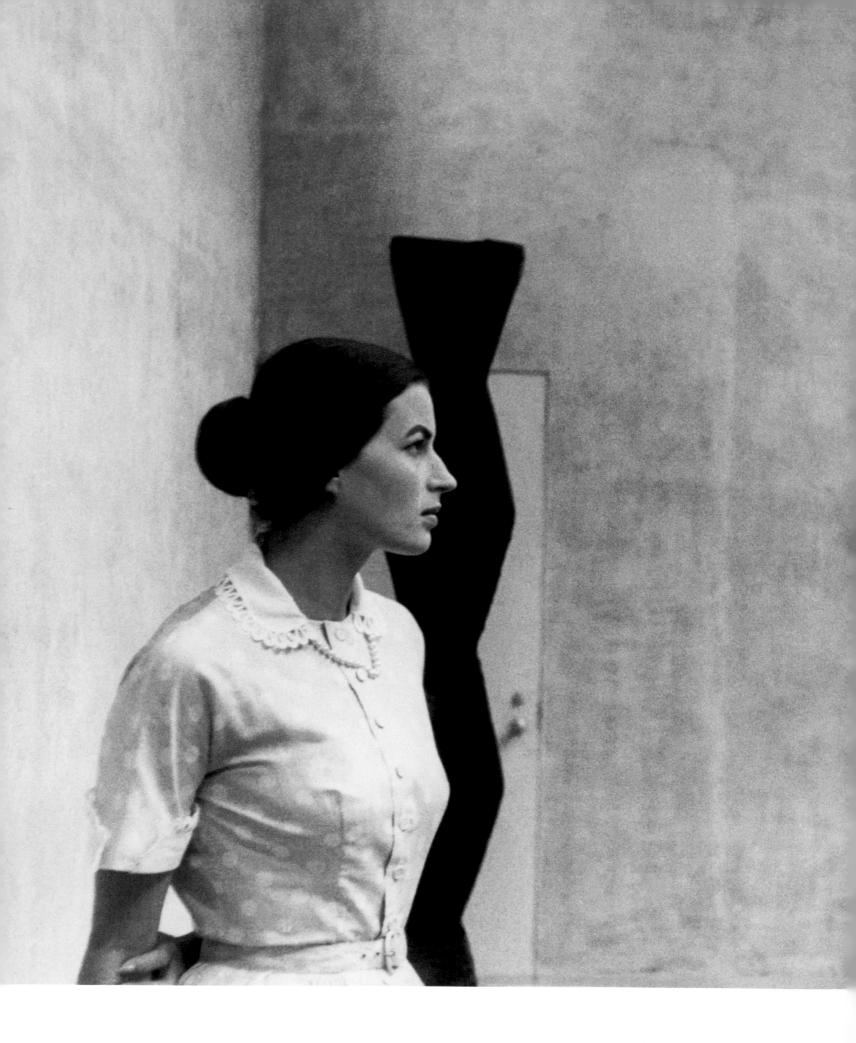

Silvana Mangano, actress, at the
Museum of Modern Art, New York, 1956

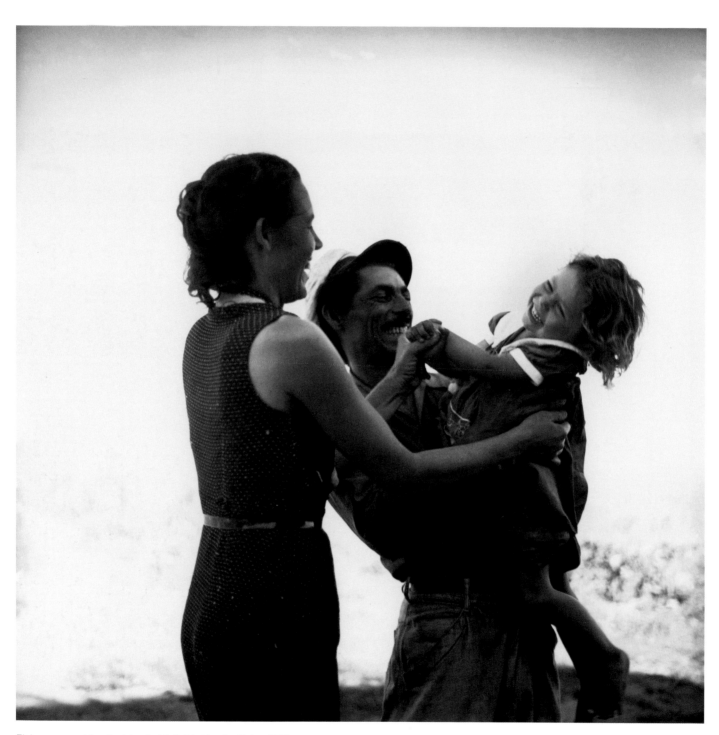

Fisherman and family. Island girl, Bahia Honda, Cuba, 1954

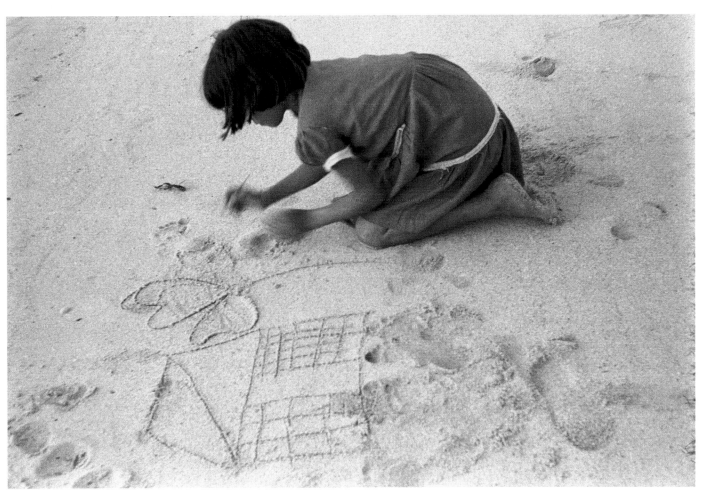

Juana Chambrot draws her dream house in the sand on the beach, Cuba, 1954
Eve was to meet her again forty-three years later – see p. 152.

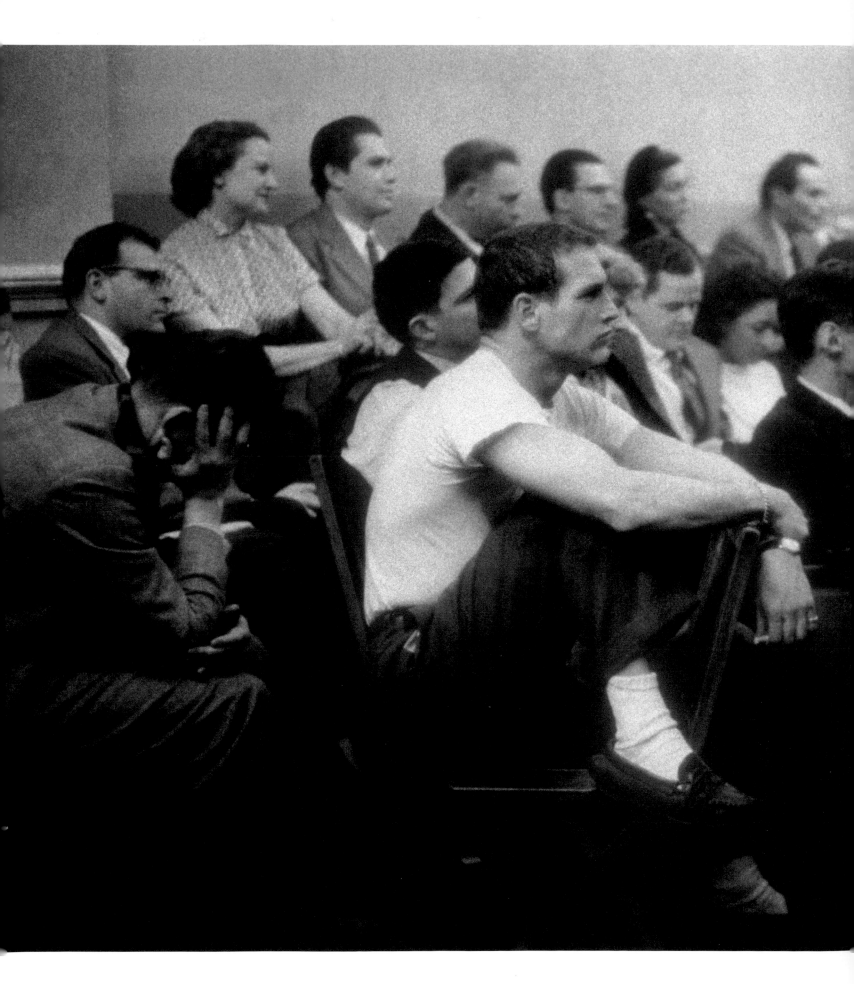

Paul Newman at the Actors Studio, New York, 1955

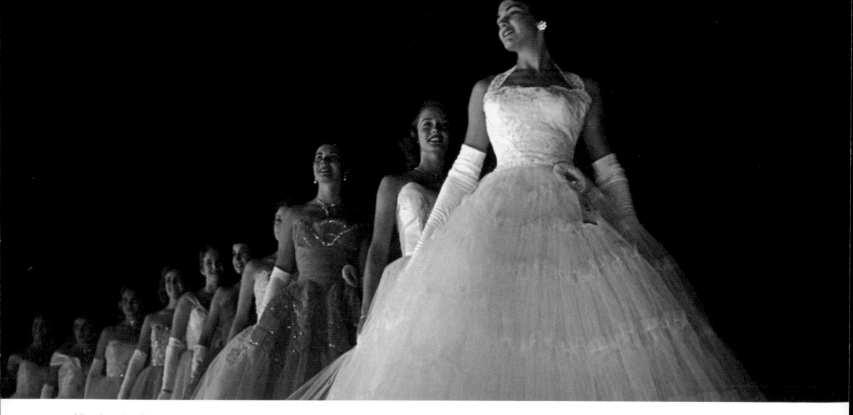

Miss America Pageant, New York, 1954

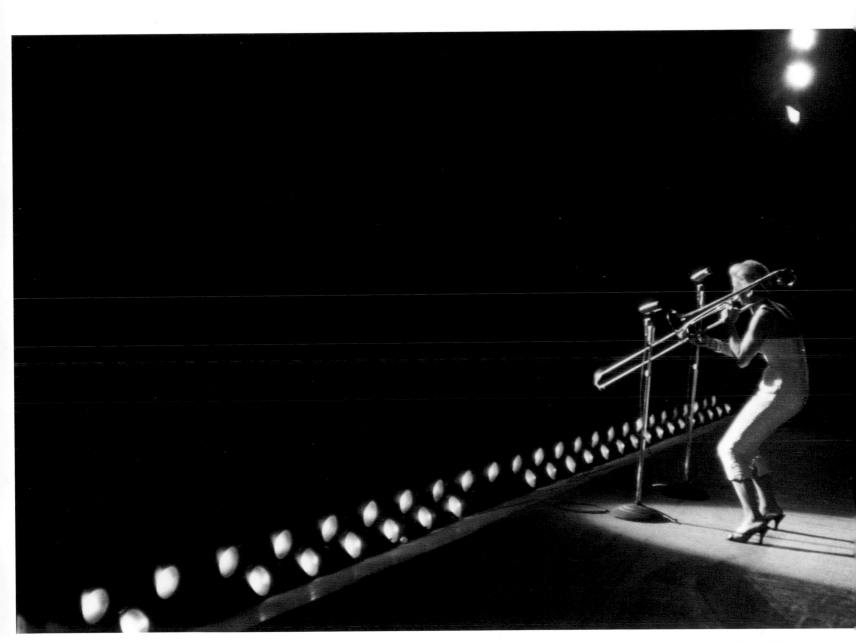

Trombonist Lillian Briggs, performing at the Brooklyn Opera House, New York, 1955

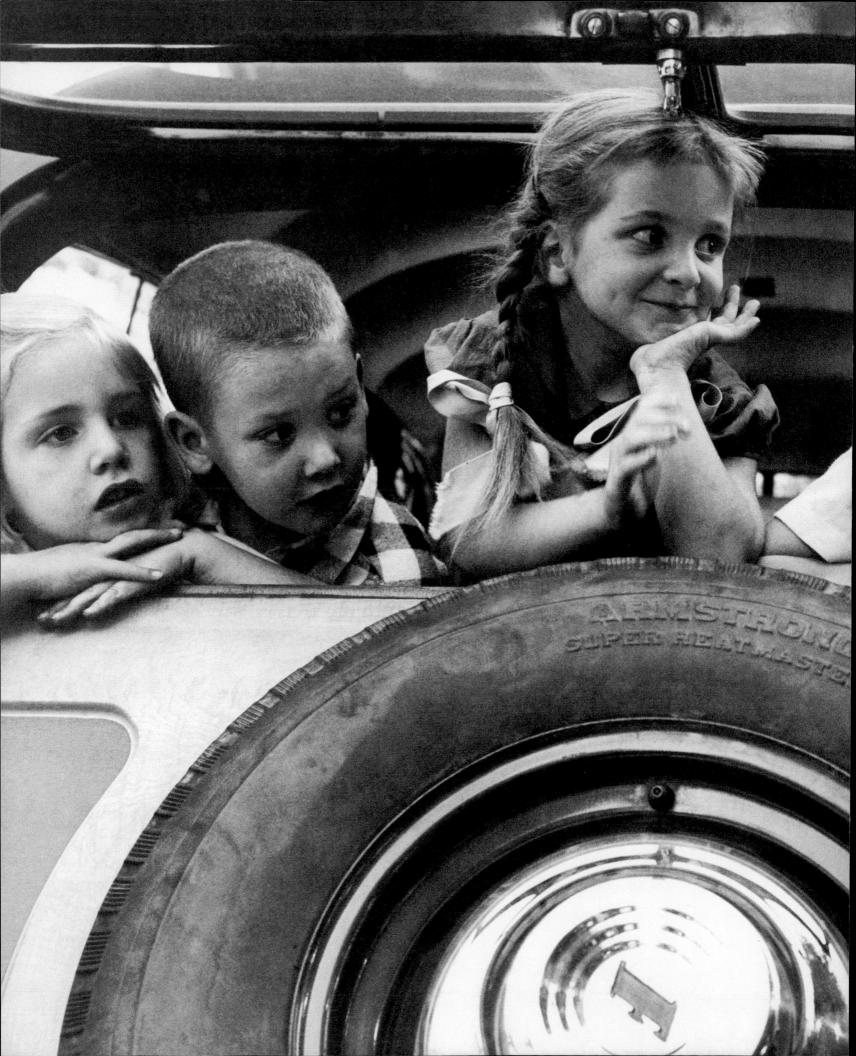

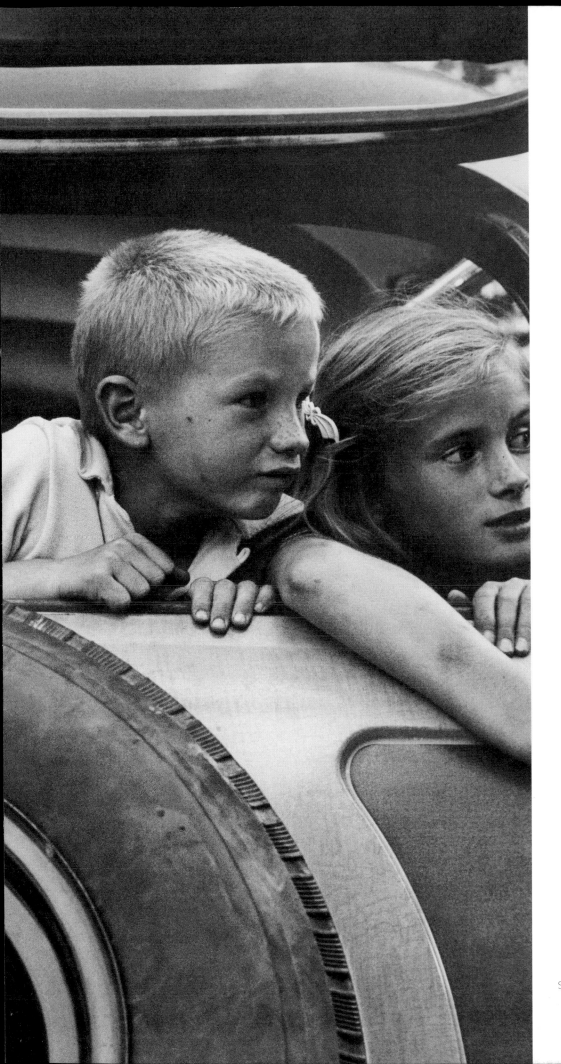

Standard Oil advertisement, USA, 1958

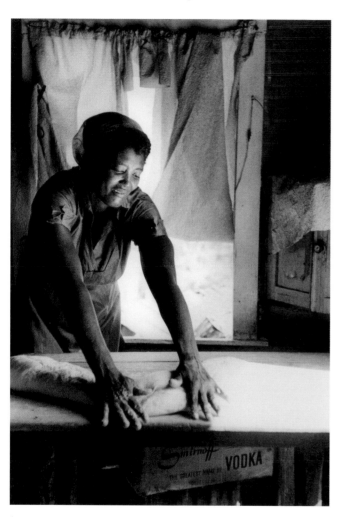

Bread-making in a small town in the Bahamas, 1960

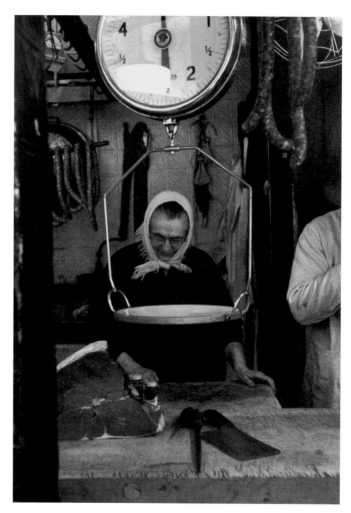

Woman butcher, New Jersey, 1958

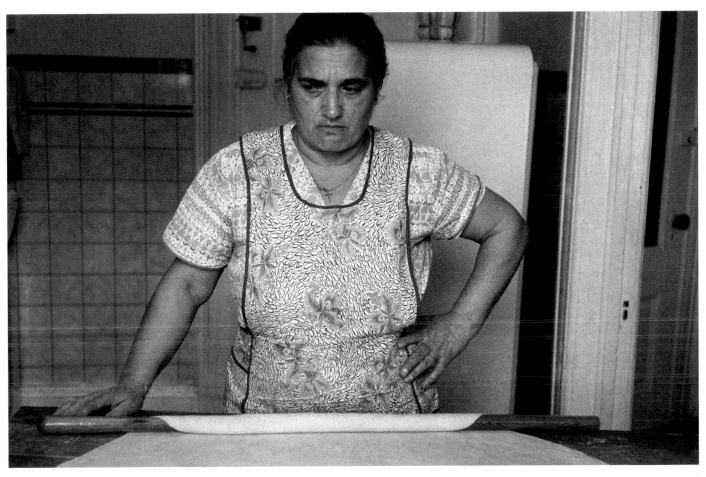

Mama Colaurde preparing pasta, New Jersey, 1958

The Davises of Brookhaven Town.
The first five minutes of a baby's life,
Long Island, New York, 1958

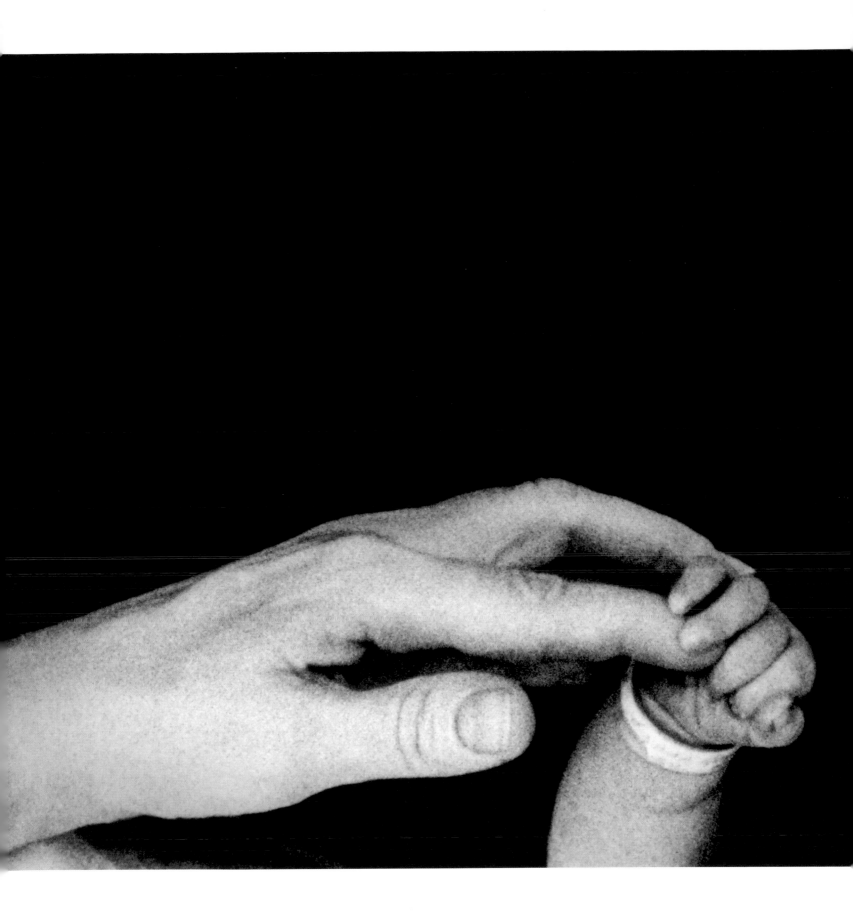

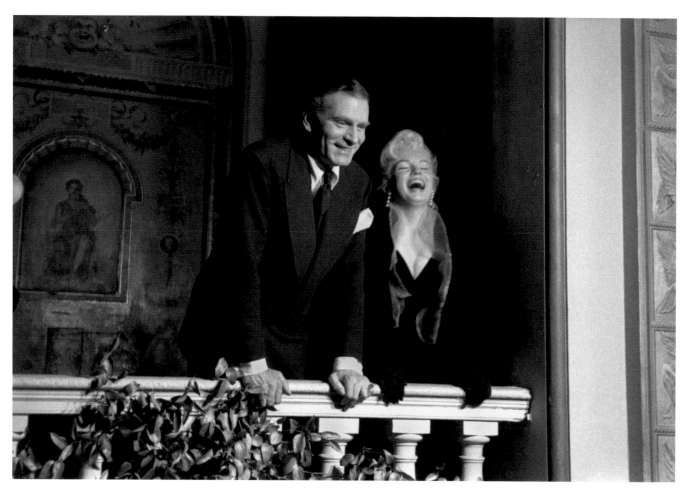

Before the filming of *The Prince and the Showgirl*, Marilyn Monroe and Laurence Olivier held a press conference, New York, 1956

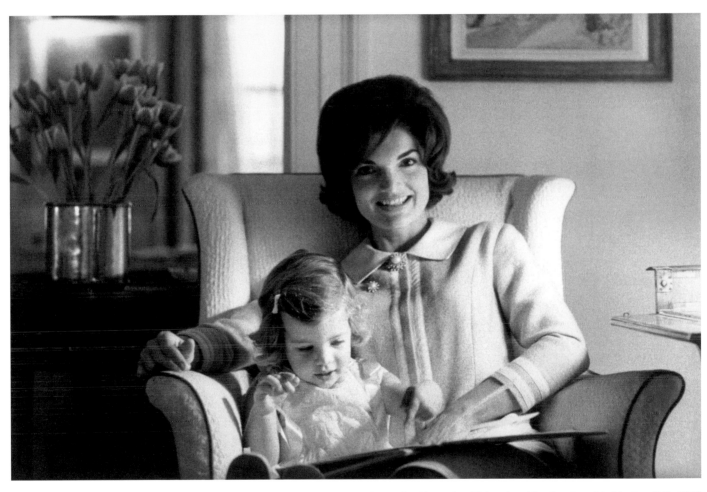

Jacqueline Kennedy with her daughter Caroline, Washington, D.C., 1960

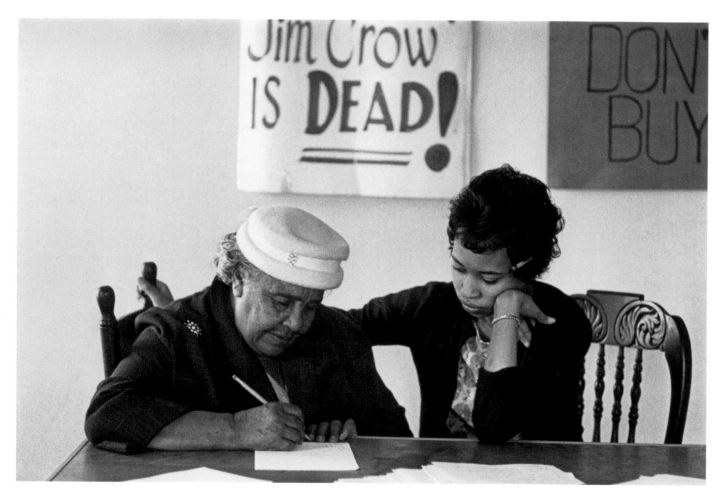

Black woman attending a literacy class. Those registering to vote had to pass a literacy test,
Petersburg, Virginia, 1960

Opposite At a school for black civil rights activists, a young woman is trained not to react
when smoke is blown in her face, Virginia, 1960

Following pages Farmer Davis with migrant pea-pickers, Long Island, 1958

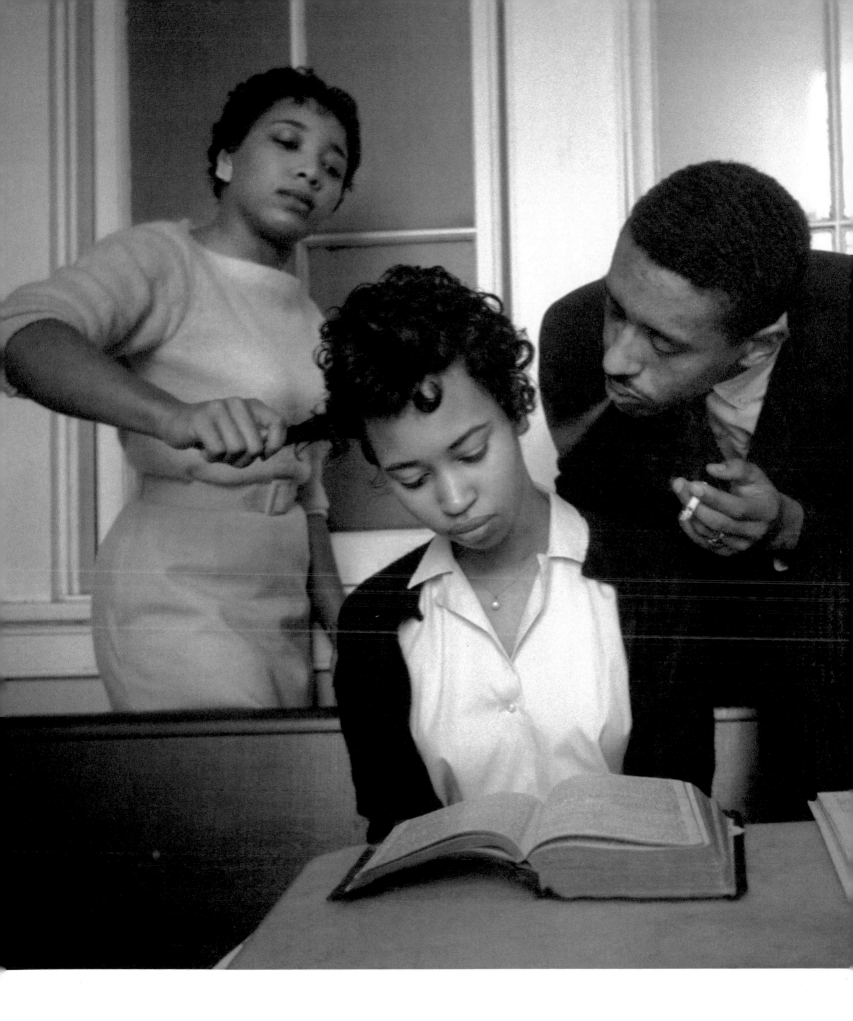

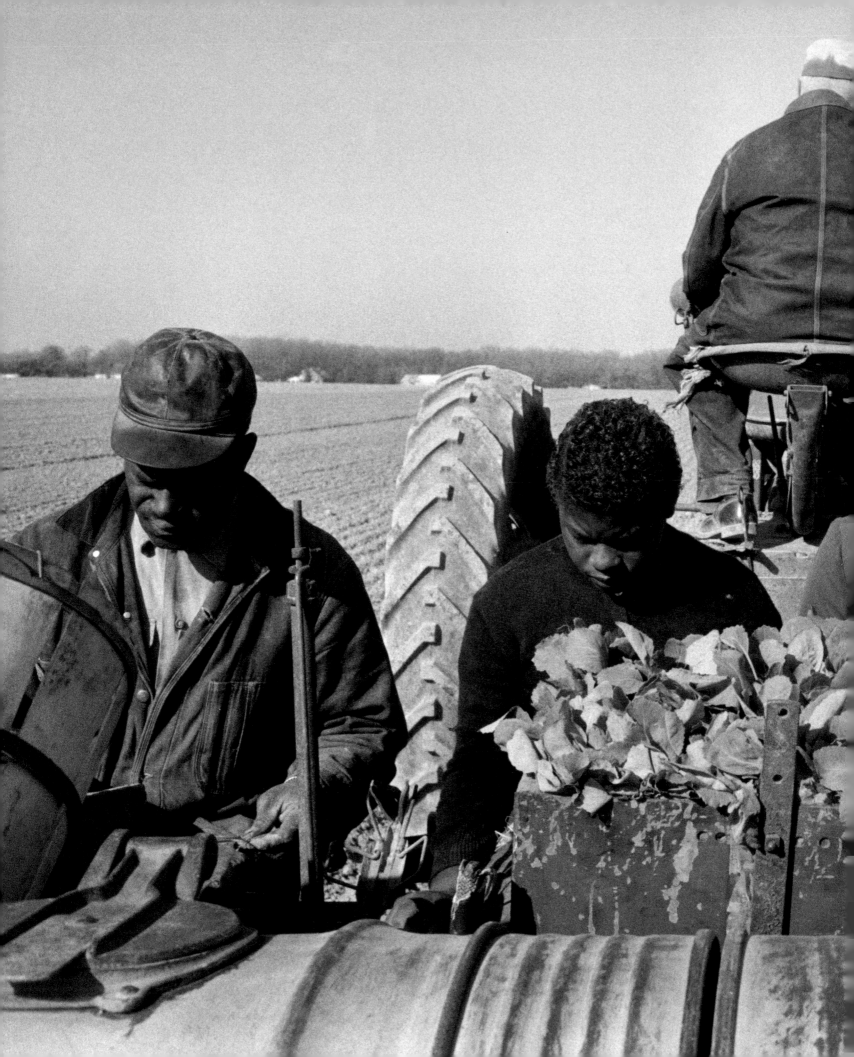

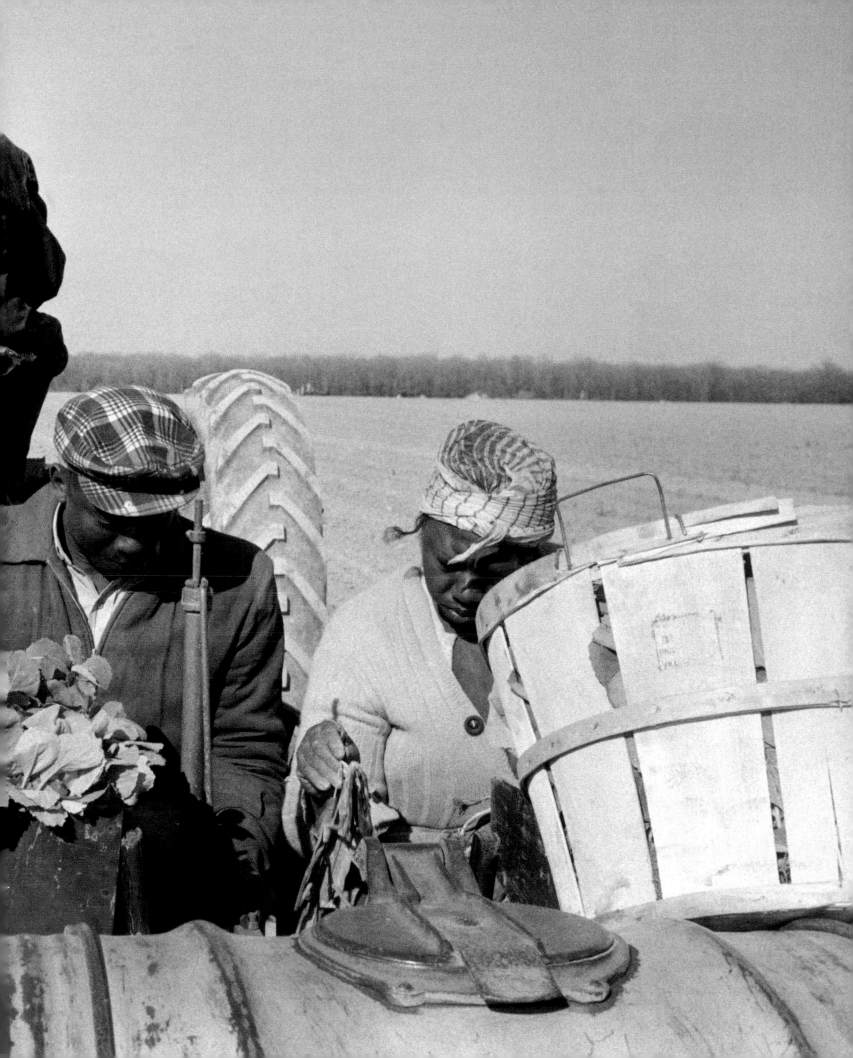

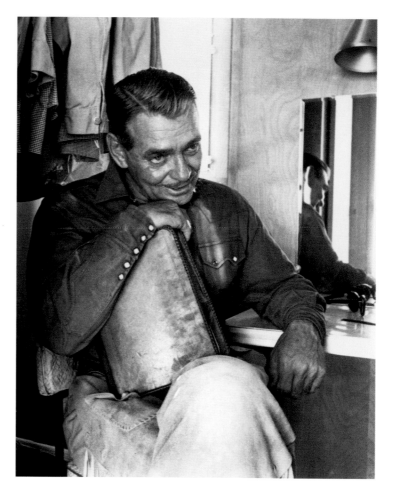

Above left and right Clark Gable during the filming of *The Misfits*,
Nevada, 1960

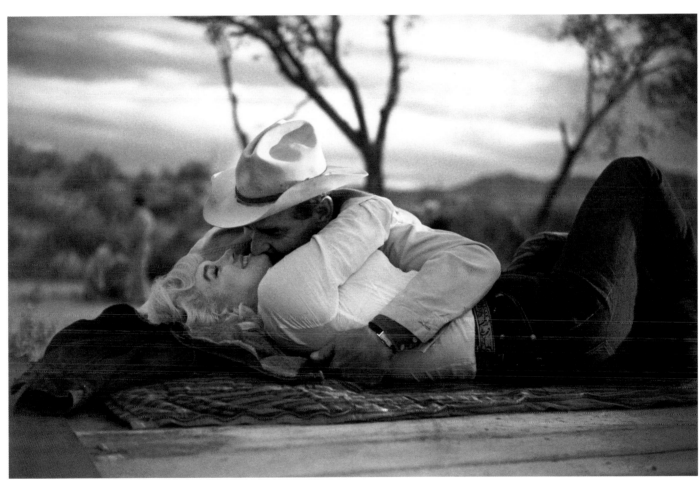

Marilyn Monroe and Clark Gable during the filming of *The Misfits*, Nevada, 1960

In the Early Days

Migrant Workers, Long Island, 1951

Marilyn Monroe, 1950–60

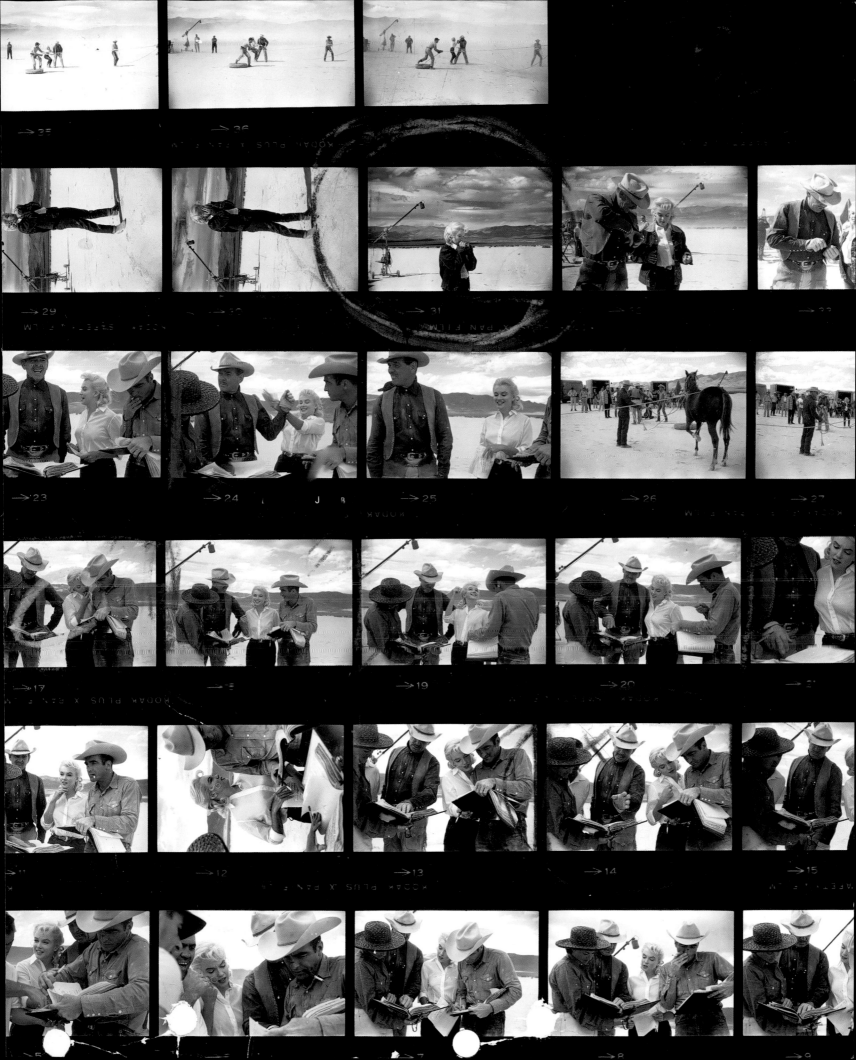

Migrant Workers, Long Island, 1951

It was Eve's husband who pointed out to her the plight of migrant workers toiling in the farms not far from their home. These workers in the early 1950s started their harvesting work in Florida, following the maturing crops all the way up north to the Long Island farms, where they eventually settled after that kind of farming work was supplanted by modern methods.

Taking her Rolleiflex camera Eve went out to the fields and the dwellings of those migrant workers, thereby starting her most remarkable career. She was soon covering the most diverse corners of our world, picturing and reporting on the modest along with the sublime – all treated with the same sympathy, understanding, empathy and equanimity that permeates all of her work.

Elliott Erwitt

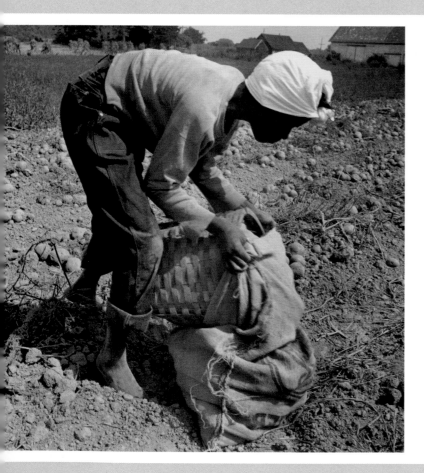

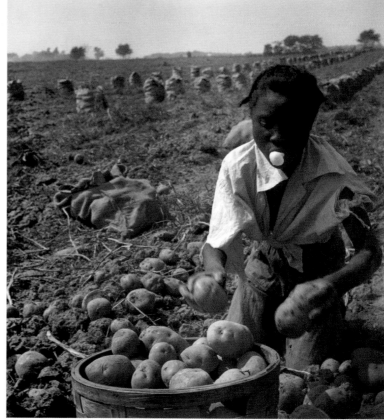

Opposite left and right Migrant potato pickers,
Long Island, New York, 1951

Below right Migrant potato picker, Port Jefferson,
Long Island, New York, 1951

Below left Migrant labour camp, Long Island,
New York, 1951

Eve and her husband lived on Long Island in the early 1950s. Although in the 1920s the area had begun to be transformed into the classic American residential suburbs, after the Second World War many working farms still remained. As it turned out, the opportunity to put together one of her first photo stories was more or less on Eve's doorstep. In the 1950s thousands of migrant workers travelled north from the southern United States of America to Suffolk County, Long Island. They worked very long hours in 'Migrant Alley', as the farming strip was known, sorting potatoes, picking strawberries or planting at nurseries. At night, they slept in crowded, ramshackle camps. Those who stayed on were usually too poor to return home to the South, so they were forced to stay and seek work with no

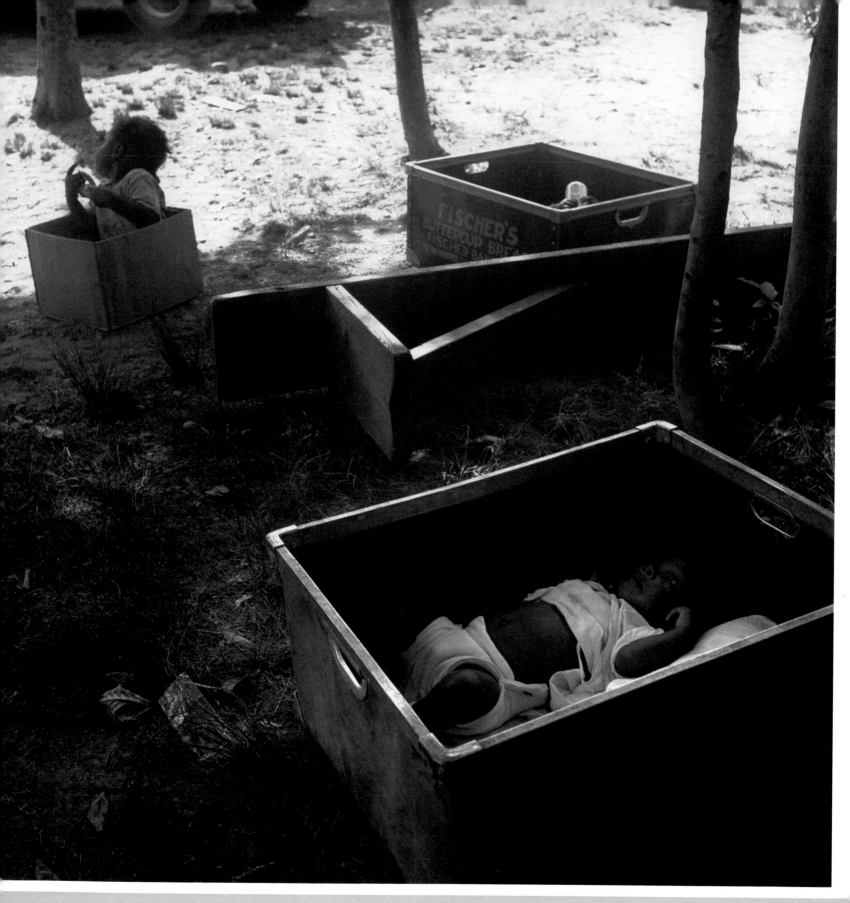

Migrant labour camp, Long Island, New York, 1951

guaranteed minimum wage, and no effective union representation or insurance compensation, taking their chances according to the picking season. Sub-standard living conditions were common, and farmers would often bend the regulations to the migrant workers' inevitable disadvantage.

Eve photographed their plight. The story drew attention to her natural aptitude for photojournalism that was to flourish at Magnum, the agency whose founders she met that year. 'If a photographer cares about the people before the lens and is compassionate, much is given,' she said. It is the photographer, not the camera, that is the instrument.'

Eve's natural compassion is evident in these early pictures, and while they are indisputably well-made photographs, it is not their technical proficiency that we notice first: her subjects, the people, seize our attention and tell their story. In each frame, adults and children alike are unsentimentally portrayed carrying their daily burden, but with humanity and dignity intact.

This was a period when respect for civil rights was by no means universal: black people were still excluded from living in certain residential areas of Long Island by restrictive covenants. The Civil Rights movement was to gather speed only a few years after these photographs were taken; one of its protagonists, the controversial but influential leader Malcolm X, was to be the subject of another of Eve's photo stories, in 1961 (see pp. 104–11).

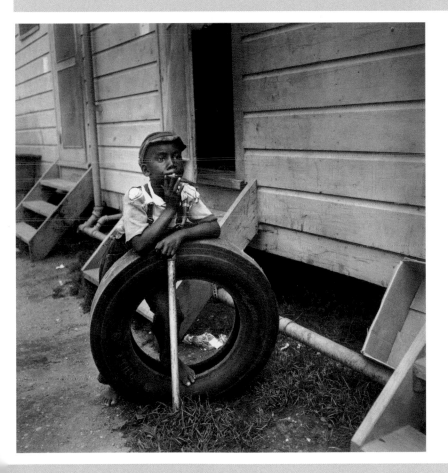

Son of migrant potato picker, Long Island, New York, 1951

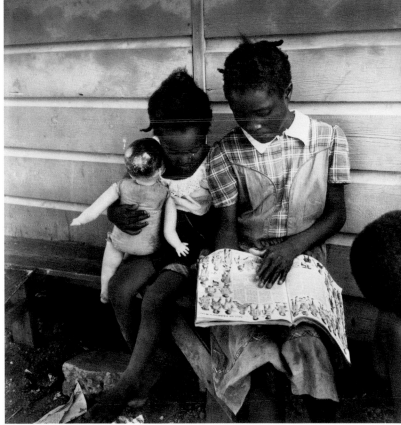

Children of migrant potato pickers, Long Island, New York, 1951

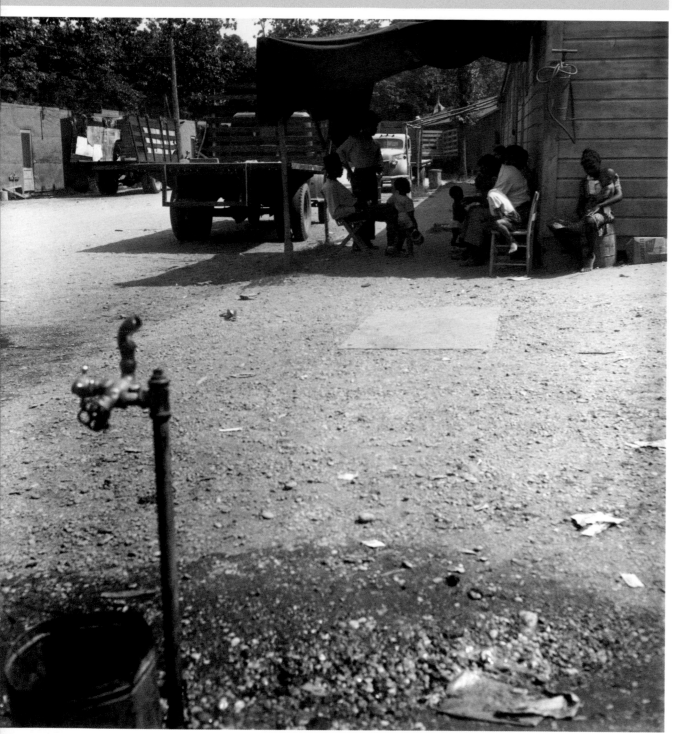

Migrant potato pickers camp, Long Island, New York, 1951

Right Housing at a migrant labour camp, Long Island, New York, 1951

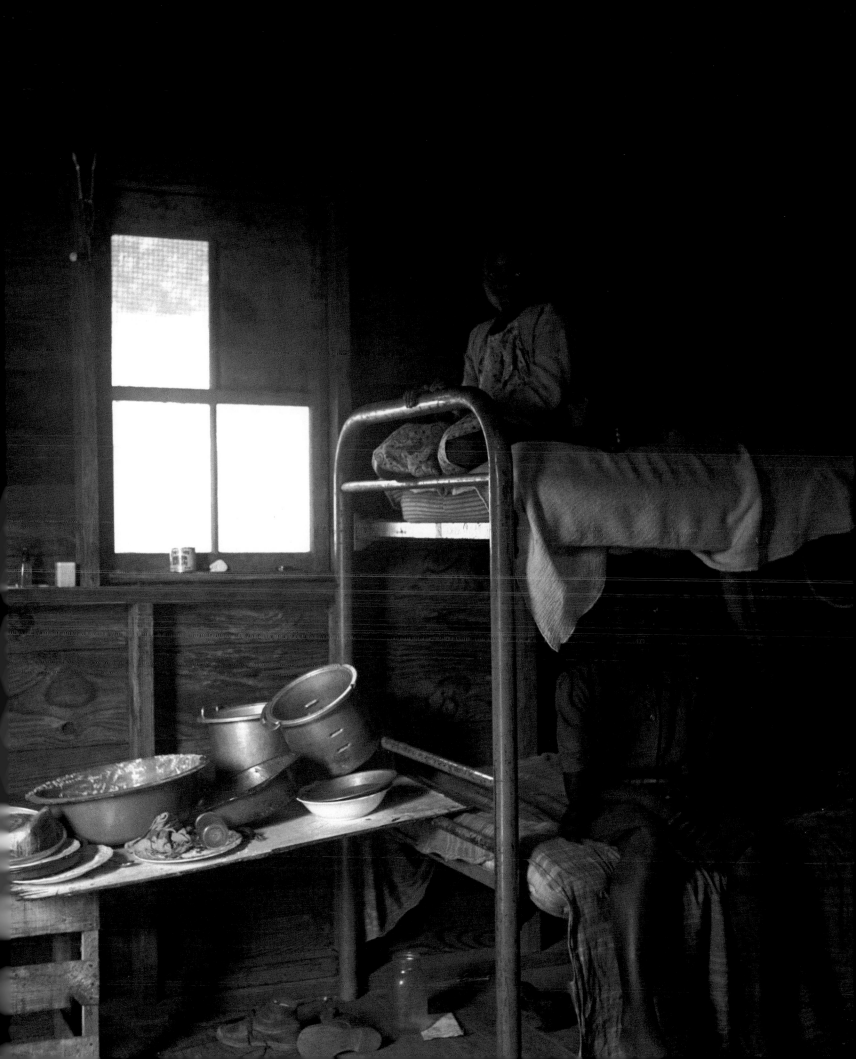

Marilyn Monroe, 1950–60

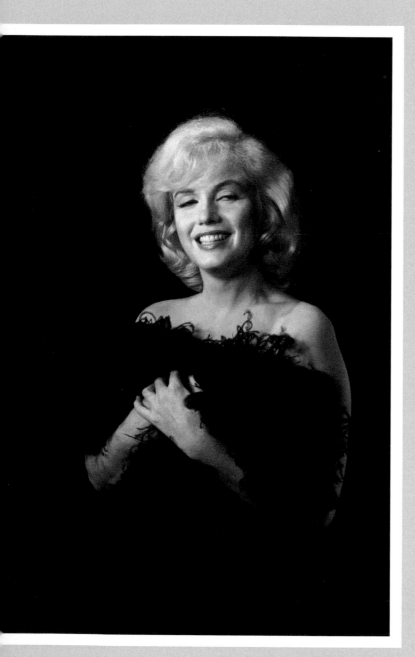

Marilyn Monroe, Los Angeles, California, 1960

Eve met Marilyn Monroe when she was a newly discovered starlet, and when Eve herself was a photographer at the start of her career. Marilyn liked Eve, and over the years she would often pose for her. This has resulted in a collection of work that at times has threatened to overshadow the rest of Eve's output: several books and many exhibitions have been devoted to these pictures. However, despite the enormous pressure to reveal unseen images of Marilyn, there were pictures that Eve promised Marilyn she would never show – none of them have ever appeared.

Eve had known Marilyn for almost ten years when she photographed her on the set of *The Misfits*. Eve portrays someone contending with personal demons that are almost visible, but are seemingly contained within the powerful aura of Marilyn's physical presence. The Nevada desert is the other star of Eve's photographs: bleak, beautiful, dramatic and unforgiving. Marilyn's problems by 1960 are well documented: her marriage to Arthur Miller was at an end, and she was plagued by alcohol and drug dependency. Eve's sympathy and compassion are evident in every picture.

Film director Beeban Kidron writes:
Eve was already a world-renowned photographer when I met her, with a body of work that included photo essays on remote parts of the world that few had visited and none had photographed. She was arguably the world's best-known and most celebrated woman photographer – brave and compassionate, exacting and socially concerned. It was ironic, then, that she had also become the photographer of choice for the

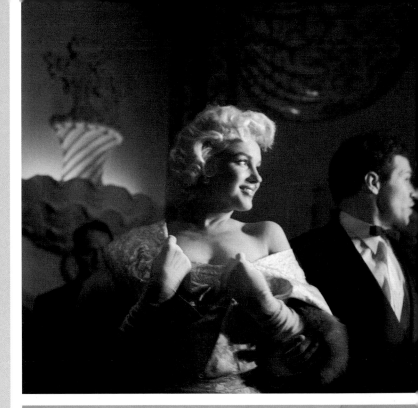

'grandes dames' of Hollywood, and stranger still that her pictures of Marilyn Monroe would remain among the most famous images of the iconic star long after her death.

Eve approached her time with Marilyn as she did all her other subjects. These photographs came at a time when 'stars' were seen in highly produced images with glamour lighting and formal poses, but Eve wanted always to see the most unadorned view of whatever she trained her camera on. She sought neither to judge nor to promote, but to let her subject find a relationship to the camera. Eve was a 'safe place' and Marilyn repaid her by providing some of the most open and intimate pictures, introducing us to a 'private view' of one of the most public faces of the twentieth century.

The photographs are so normal that Marilyn's beauty appears almost achievable. Her image is not a threat to us, in spite of her having enjoyed an unchallenged reign as the world's most beautiful woman for two generations.

The magical sensuality of Marilyn and the easy intimacy of Eve have produced beautiful and long-lasting images that keep Marilyn's extraordinary life 'present' even now.

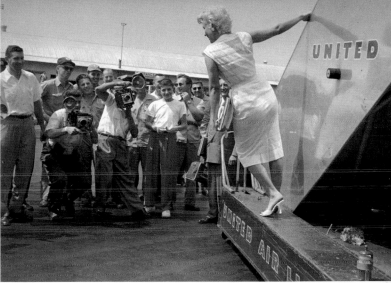

Little more than a year after the last of these pictures was taken, Marilyn was dead. Eve's pictures show her famous, luminous beauty, but also her fragility. They reveal that unique combination of self-consciousness and innocence – a sign of Eve's remarkable ability to capture complexity in a face.

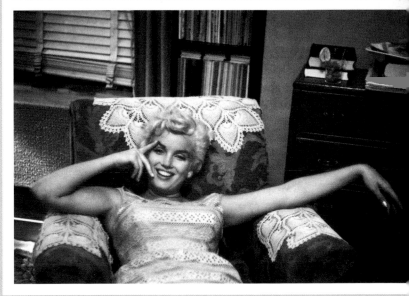

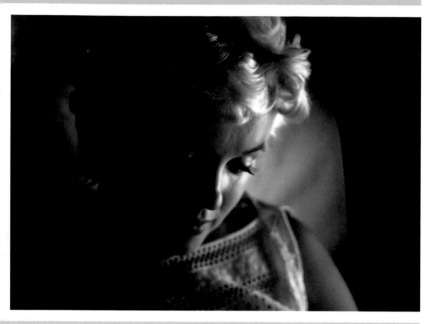

Marilyn Monroe on her way to Bement, Illinois, 1955

Right Marilyn Monroe, Mount Sinai, Long Island, New York, 1955

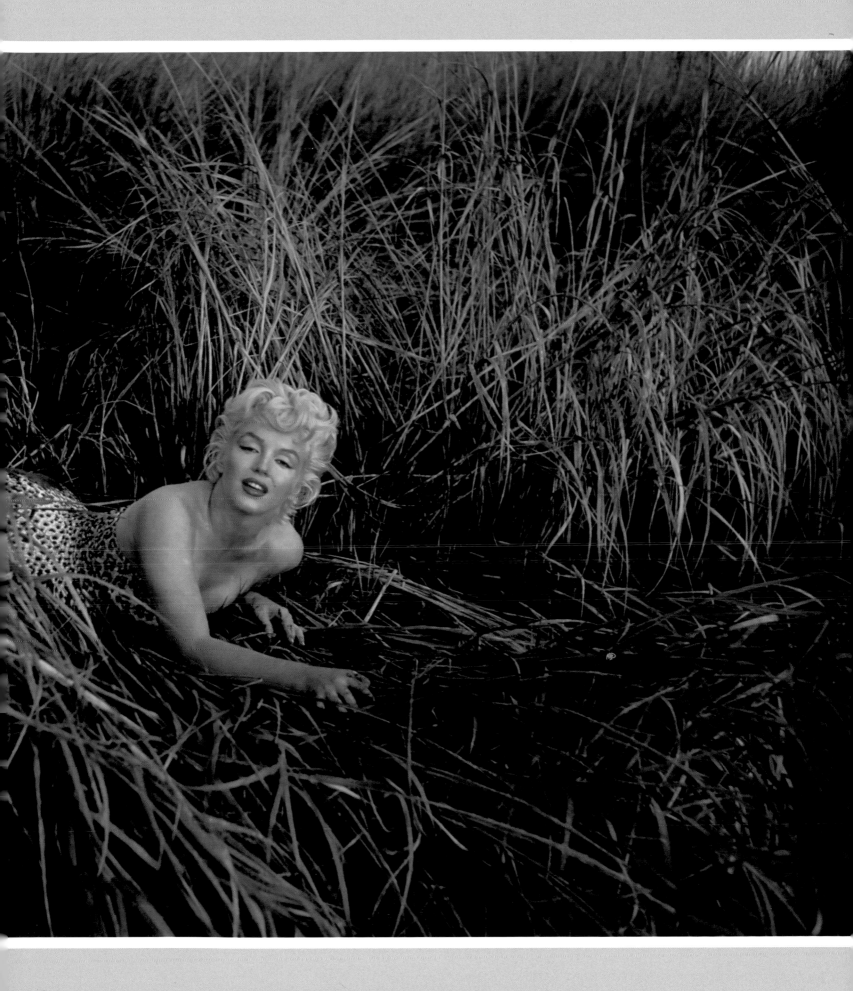

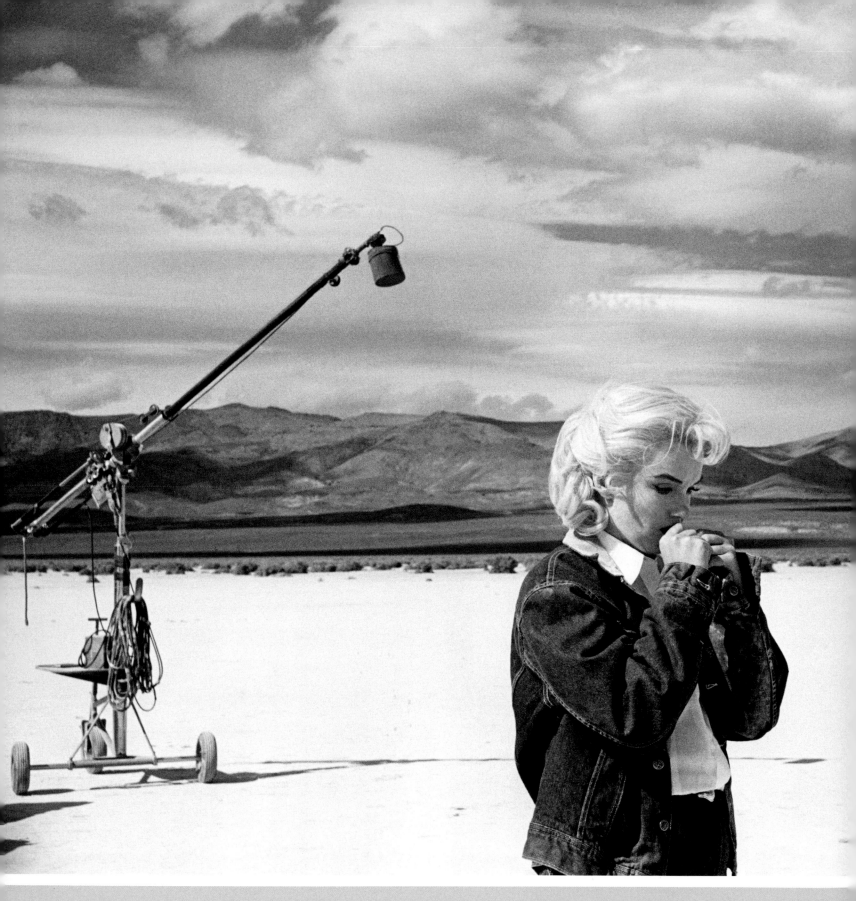

Marilyn Monroe going over her lines for a difficult scene
on the set of *The Misfits*, Nevada, 1960

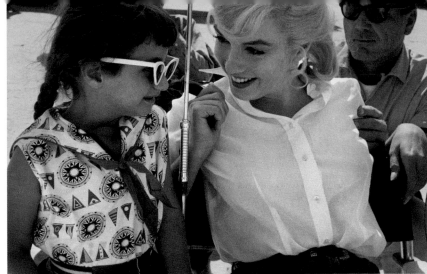

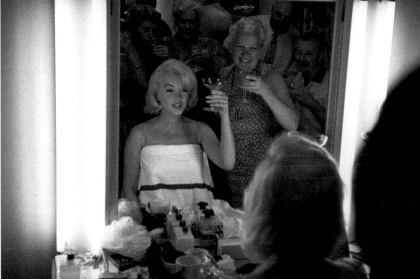

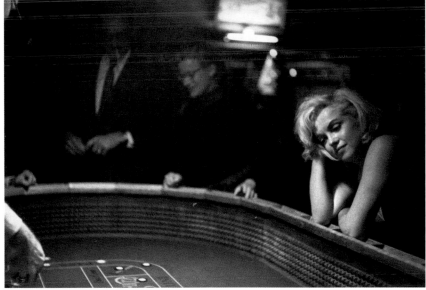

Top right Marilyn Monroe during the filming of *The Misfits*, Nevada, 1960

Centre Marilyn Monroe and her crew during a still photos session, Los Angeles, 1960

Bottom While on location, John Huston spent long hours, sometimes nights, at the gambling tables in Reno. Marilyn went with him once, towards the end of filming for *The Misfits*, Nevada, 1960

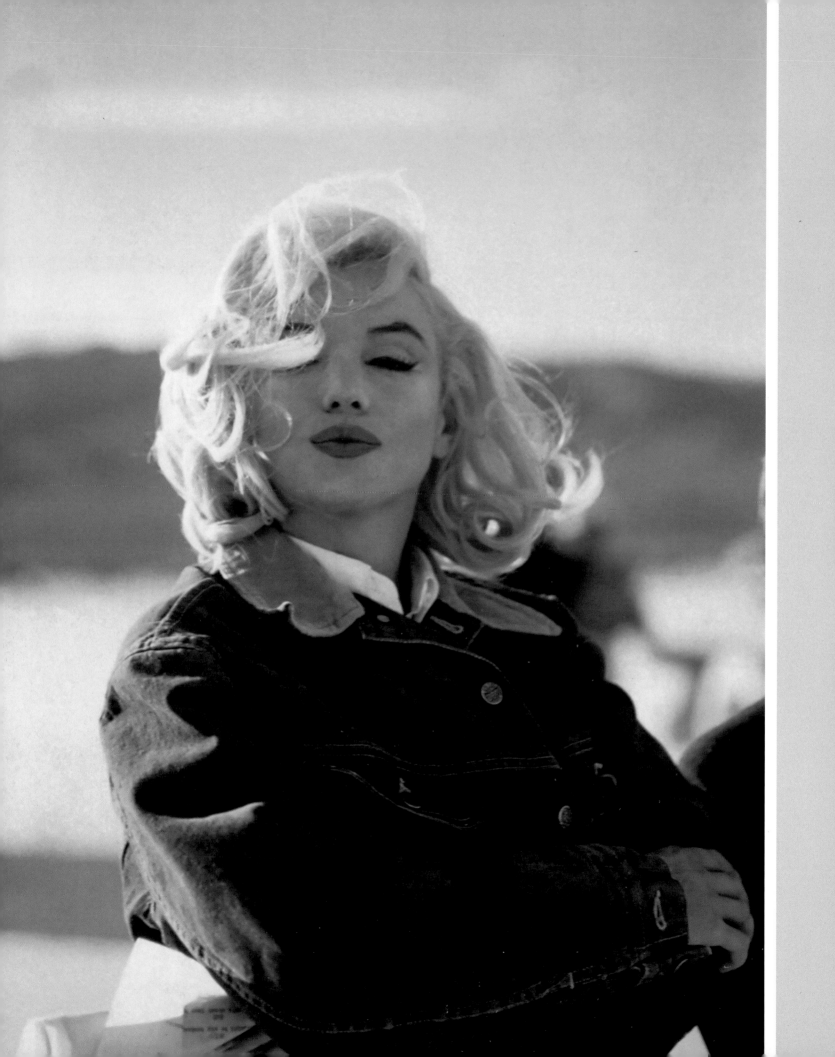

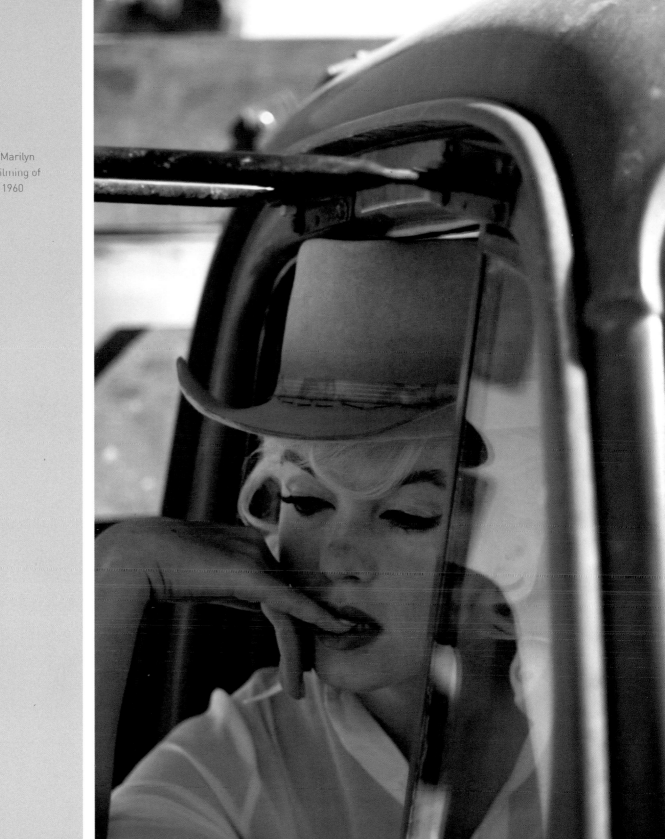

1961
1970

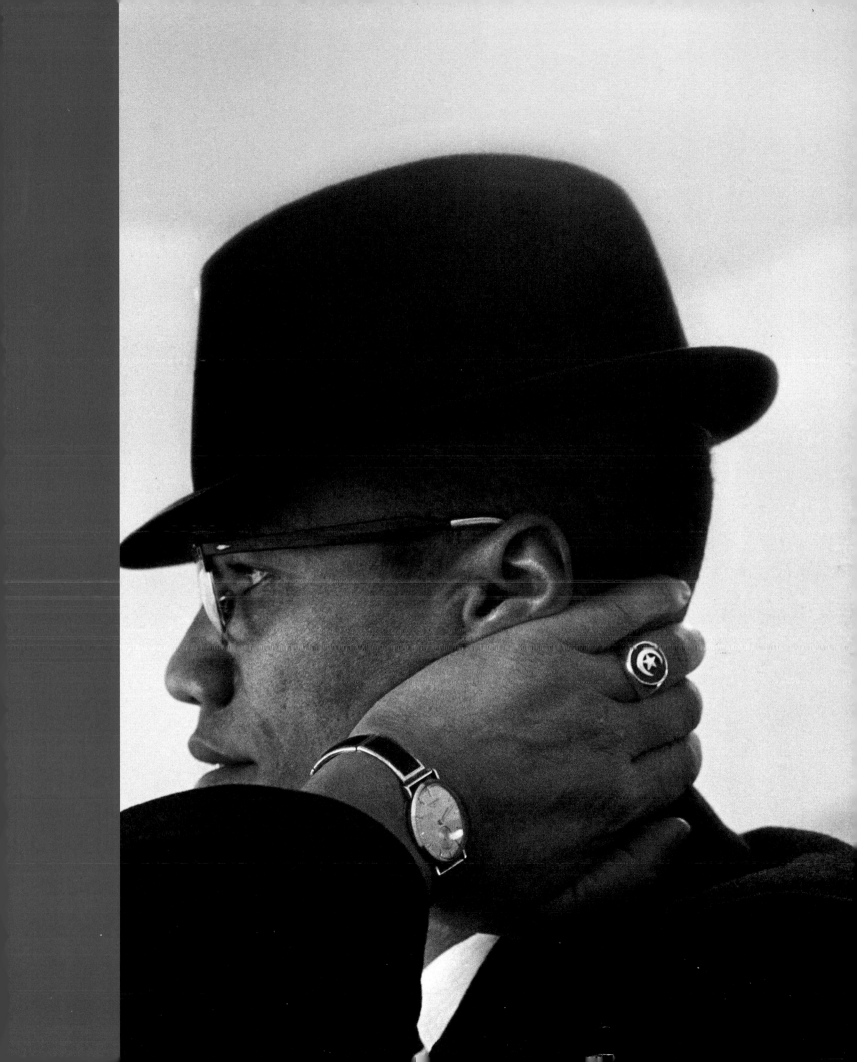

This book is not just a homage to Eve Arnold, it also stands as a reminder of a way of life that no longer exists. Eve's main body of work was done during the vintage years of the great magazines – *Life* in the United States, *Picture Post* and later the *Sunday Times Magazine* in England. Indeed, Eve's arrival in London in 1962 coincided with the launch of that famous magazine.

One of the last assignments Eve had completed in 1961 before leaving the United States, Malcolm X and the Black Muslims (see pp. 104–11), had been left unpublished by *Life*, as they deemed the subject matter too inflammatory to take on. However, *Esquire* took the decision to go ahead, and reproduced it impressively in Eve's eyes. More importantly, the story was syndicated internationally and functioned as the perfect springboard for Eve when she decided to seek work in London.

Much changed for Eve in the early 1960s. She had enrolled her only son Francis at the English boarding school Bedales, which his father Arnold Arnold, from who she was now separated, had also attended as a boy. Although she had only intended to stay in Britain for a limited time, she stayed on and adopted London as her new home. Looking back on that first year in England, her words betray a sense of sadness and upheaval:

We arrived in England one very wet autumn which was followed by the coldest winter in a hundred years. … We were not used to the gloom, during which house lights were turned on upon waking and not extinguished until bedtime. … We were accustomed to overheated rooms and changing seasons that brightened the year. … The endless grey and chill days of England seemed like a punishment and added to our sadness at the sudden changes in our lives.

Eve's arrival in London marked a new professional beginning, however, and her first proper venture into colour photography. When the *Sunday Times Colour Section* (as the *Sunday Times Magazine* was then called) first appeared in 1962, Eve was offered steady, well paid work, and lots of it. At first, the introduction of colour into Eve's work added another dimension of uncertainty for her. Although colour photography seemed to signify the growing prosperity of the 1960s, Eve was conscious of how easily it could be seen as a gimmick.

Harold Evans, later the editor of the *Sunday Times*, was to agree that her time on assignment for the newspaper would not exceed six months in any year (so she could spend time with her son when he was not at boarding school) and she would be free to work on her own ideas and initiatives. The editorial team of the magazine was intelligent enough to use colour carefully, never for its own sake.

Michael Rand, who was Art Director at the *Sunday Times Magazine* from 1963 until 1994, treasures the relationship he built up with Eve over the course of thirty years:

I wish that I could lay claim to having got Eve to work for the Sunday Times Colour Section *in 1962 but I did not join the magazine until the year after. The credit must go to Mark Boxer, the founding editor, who had already installed her as a contributing photographer, on contract to work for the magazine for six months of each year. This proved to be a great coup as she was in part responsible for the magazine's success at a time when magazine photojournalism was at a low ebb worldwide.*

An American, she had recently settled in London. One of her first photo stories for the magazine was on English private girls schools which was in direct contrast to the work she had been doing in New York where she had learnt her craft as a photographer. At that time there was an atmosphere of darkness and political unrest such as the fear and terror of McCarthyism and civil disobedience used as a weapon to forge equal rights for the blacks. Her photo story on English girls shows a refreshing new approach and was spread across the cover and ten pages of the magazine.

In 1963 I first worked with her on a controversial piece on the Black Muslims in America, which was a ground-breaking bit of reportage – Life *magazine would not publish it as it was too controversial for them. It showed all the key players in the Black Muslim movement, their rallies, even pictures of the Neo-Nazi George Lincoln Rockwell sitting at a Black Muslim movement meeting in his brown-shirt uniform and a swastika. Eve had an extremely difficult time. She managed principally because of her unassuming small figure which made her appear to be a mild woman photographer and not a threat, although she was resented. But there was an occasion at one of the rallies where she was photographing and working down the central aisle of the crowd shooting as she went. By the time she got to the other end she smelt burning wool and realized that people had stubbed their cigarettes into the back of her angora sweater. Eve and I worked on the layout together – not something I was used to, but it was a joy; the pictures were so great that they laid themselves out, we were in accord and she didn't baulk at my ruthless editing to achieve maximum impact.*

By then Eve was established as a key member of the magazine team alongside Snowdon and Don McCullin, who distinguished himself through his compelling photographs of war. Eve was creative and innovative as far as the stories she wanted to pursue. Immensely versatile, her input was a surprising

mix of grit and glamour and that was her strength. Her photo-essays ranged from 'Music in Britain' (not a particularly visual subject, I thought, but to my delight she proved me wrong) to the plight of American army Vietnam veterans (pp. 88–89).

During that time her picture profiles were prolific. They varied in subject from Alec Douglas-Home, the British Prime Minister; Marlon Brando on set for the film A Countess from Hong Kong; *Queen Elizabeth on tour; the painter Francis Bacon in his studio; and a frank study of Joan Crawford in make-up, in her underclothes – not a pretty sight. In fact it became a joke between us. If she was setting off to shoot a beautiful actress and asked my advice, I would facetiously reply '…as long as you get her in her underclothes!' In 1966 Eve triumphed with Vanessa Redgrave on the film set of* A Man for All Seasons *changing her costume and baring her bottom (p. 75).*

Then there were her picture essays. In 1965 Eve wangled her way into the USSR to shoot 'The Oldest Men in the World' (p. 90). The Soviet Union was reputed to have more than two thousand men over 100 years old living in the state of Georgia alone. These were the Cold War days when it was difficult to get a visa on an American passport but she succeeded with her charm and diplomacy. Eve got her (oldest) men, and the report was published as a cover story. It was a great success. Years later, on the tenth anniversary of the magazine, a poll of subscribers voted it the most memorable feature of the decade. Eve returned to Russia in 1966 for four months and brought back thirty separate features.

Some time in 1970, I got a call from the front hall commissionaire to tell me that two ladies had arrived to see me. I had no such appointment and told him so. He was insistent that I should come downstairs. I did and was confronted by two Muslim ladies fully veiled. I politely asked what they wanted, and giggling, they threw off their veils. It was Eve and the distinguished writer, Lesley Blanch! It had been Eve's idea some months before to do a story 'Behind the Veil' about the status and plight of Muslim women in the Middle East ranging from Egypt to Afghanistan. They were finally delivering the photographs and words, which made a stunning five-part series.

Eve went on to do many more assignments, including a number of profiles of women seeking election to be world leaders called 'In Pursuit of Power'. One was Margaret Thatcher who tried to control the photoshoot by dictating the camera angles. Eve finally saved the day by photographing her in front of some giant sculptures of Winston Churchill, which made a fine cover. A happier subject was Indira Gandhi who was kind and considerate and gave unlimited access to Eve and the writer, Bruce Chatwin.

After that we assigned Eve to do an essay 'Black in South Africa'. This was at the height of apartheid and she suffered difficulties made by the authorities in getting to the segregated townships. When she did, she was appalled by the deprivation and poverty she saw and couldn't photograph. In the end she returned to London physically ill as a result of what she had witnessed. Towards the end of the 1970s Eve felt that she wanted another challenge: this led to the book In China, *which was a great success and the magazine happily ran a large extract from it.*

Broadcaster and journalist Sheena McDonald became acquainted with Eve's gentle but adventurous spirit; she sums up some of the pleasing contradictions that define her character.

Eve is self-effacing but determined; generous but steely; a gentle carer and a bold adventurer. Her eye took her to parts of the world that were little seen and less known decades before the doors were opened to the wider public. Sometimes, these closed communities were actually neighbours – and yet entering them was as adventurous as any globe-trotting escapade. But when she did venture over the border, it was with vigour and courage! So her work in Afghanistan in the 1960s records a civilization which now seems all but gone in terms of its confidence and richness. And her portrayal of Malcolm X's Black Muslims have a clear sense of their place in the world.

Eve's images turn us all into Mirandas, exclaiming at the brave new worlds we are seeing. Truth can be cold and unattractive. It can be heart-breakingly vulnerable and defenceless. Yet her pictures bring respect and clarity to her subjects.

David Puttnam, fellow of the British Academy of Film and Television Arts (BAFTA) and chairman of the Museum of Photography, Film and Television (now the National Media Museum) in Bradford, first met Eve when she was invited to join the museum's advisory committee; yet he knew of her work long before then. He became involved in film production in the 1960s, and went on to become one of Britain's most notable producers (his successes include *Bugsy Malone, Midnight Express, The Duellists, Chariots of Fire, Local Hero, Memphis Belle, The Killing Fields* and *The Mission*).

It's probably best, when discussing Eve's relationship to the world of cinema, briefly to set out exactly what the appointment of a 'Special Stills' photographer brings to a movie.

First of all, it is no small thing, either financially or in terms of importance. From the producer's point of view it can very easily be something of a win–win. In my day the costs were invariably borne by the studio, and you were pretty well guaranteeing yourself coverage in the more sought-after media at the time of the film's release. You also lived in hope of a single defining image that would provide the 'key art' for an eventual advertising campaign.

The downsides were few, and all revolved around the ability of the photographer to plug herself into the soul of the film crew, seeking neither special privileges nor a potentially disruptive or 'over-special' relationship with the 'stars' – both of which, particularly in the intense atmosphere of location filming, can very easily breed deep resentment.

Uniquely, Eve seems to have turned the projects she worked on into personal and professional triumphs, as well as the basis for any number of lifelong friendships. The nature of her personality allowed her to fit very naturally into just about any film crew – probably because of her instinctive understanding of the demands of absolute professionalism. In my experience movie crews 'do' professionalism very well indeed, and she would have been in her element.

In addition, her natural empathy with artists of all kinds made her a trusted confidant. This single quality can prove invaluable, particularly on 'troubled' films. She got an early masterclass on troubled movies when working on The Misfits. Many years later, the film's producer, Frank Taylor, told me that matters came to a point at which Eve was the only person left speaking to all of the warring camps, and that through her, he was able to broker the many compromises that kept the show on the road – although 'limping along' would probably have been a more honest description. If the resulting movie had been even half as good as Eve's extraordinary stills, Frank Taylor would have died a far happier man.

Eve has written that, in performing the role of the Special Stills photographer, 'handling the camera was the least of it – patience and diplomacy were of the essence.' She managed to deliver all three in abundance; and in doing so she became the most revered and respected visitor to any film set, wherever it might be in the world.

One final accolade: in the early 1960s, when I worked in advertising, and before I even dreamed of being a movie producer, I knew that A Man for All Seasons had to be a great film – because the pre-release stills I'd seen in the Sunday Times Colour Magazine had been shot by Eve Arnold.

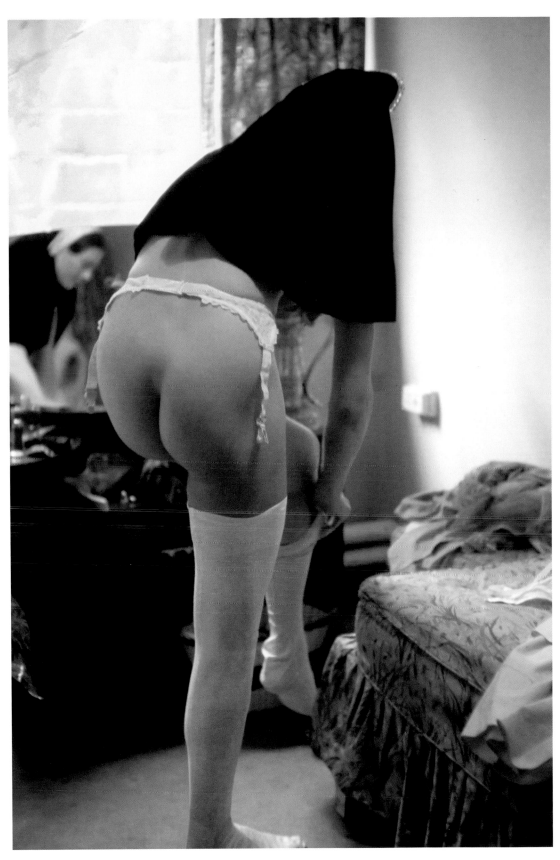

Vanessa Redgrave dressing for the part of Anne Boleyn in the film *A Man for All Seasons*, London, 1966

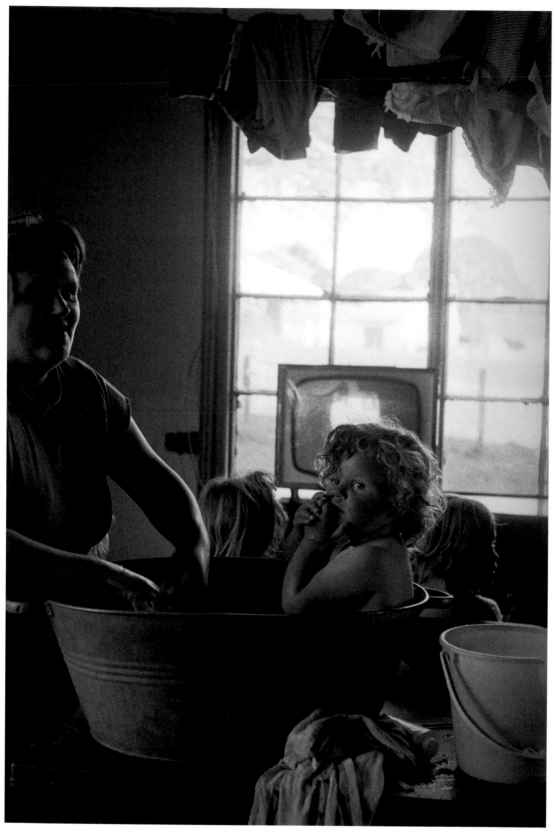

Saturday night bath, England, 1963

Opposite One of four girls sharing an apartment, London, 1961

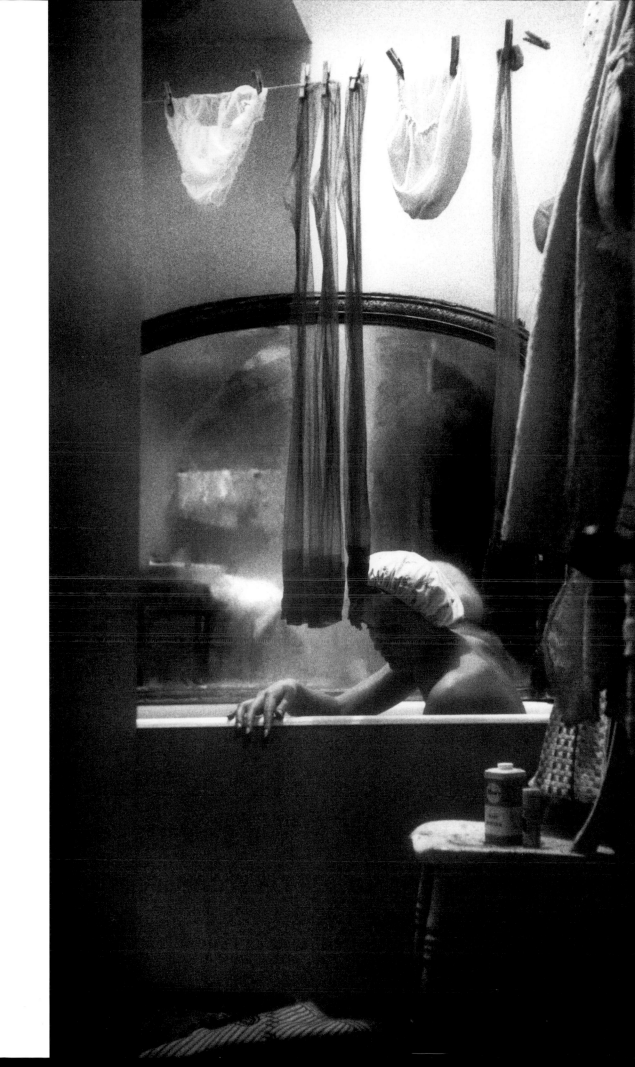

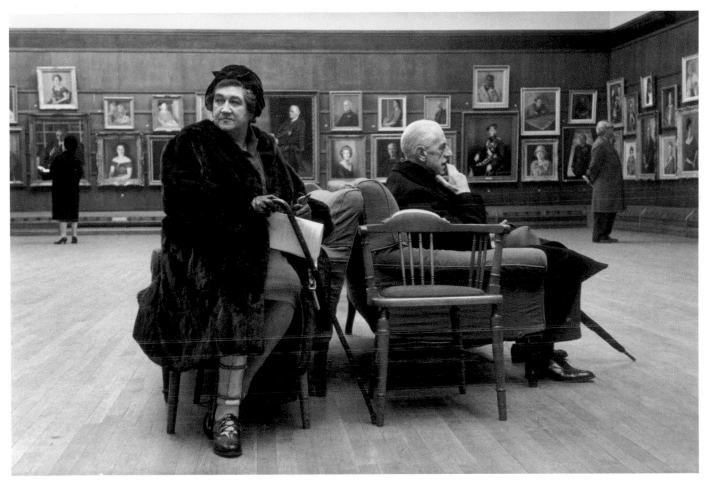

At the Royal Academy of Arts, London, 1961

Opposite A midsummer journey to the Isle of Mull in the Inner Hebrides, Scotland, 1963

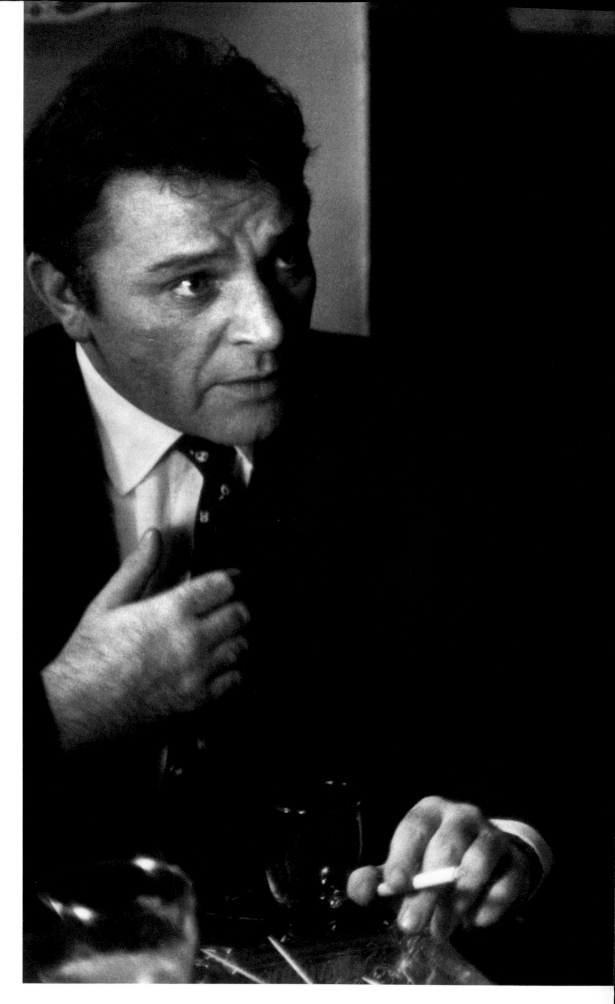

Richard Burton and Elizabeth
Taylor at the local pub during
the filming of *Becket*. Note the
packet of sausages that will be
cooked for her dinner by the
chef at her four-star hotel.
Shepperton, England, 1963

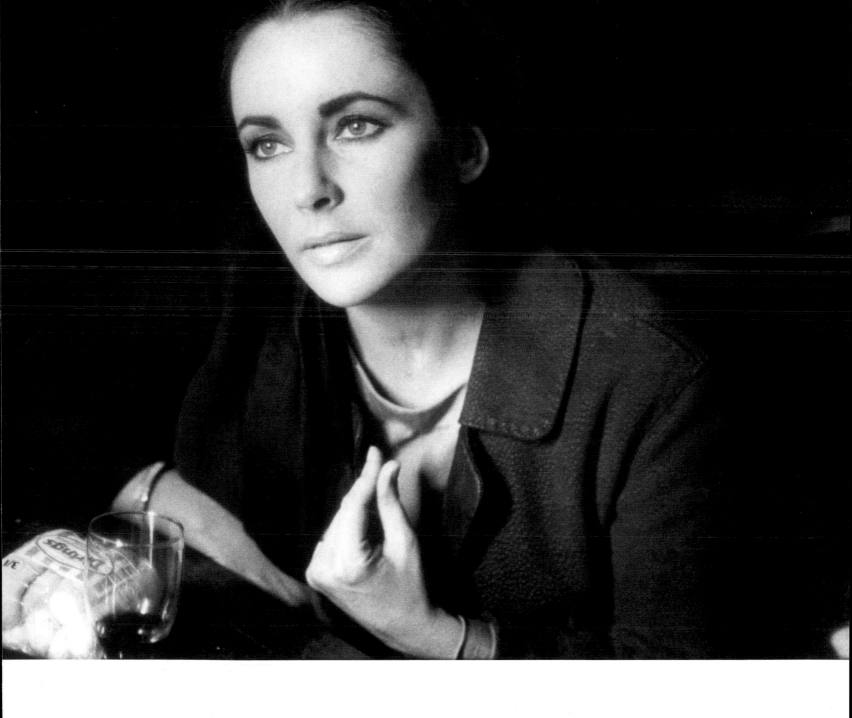

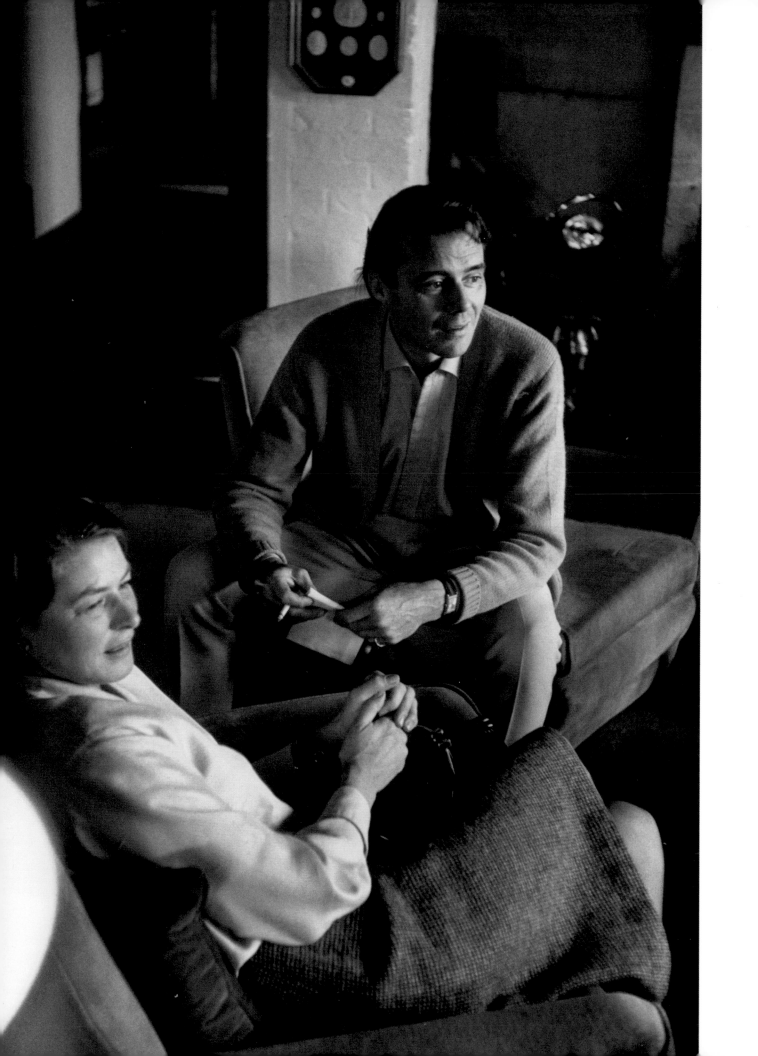

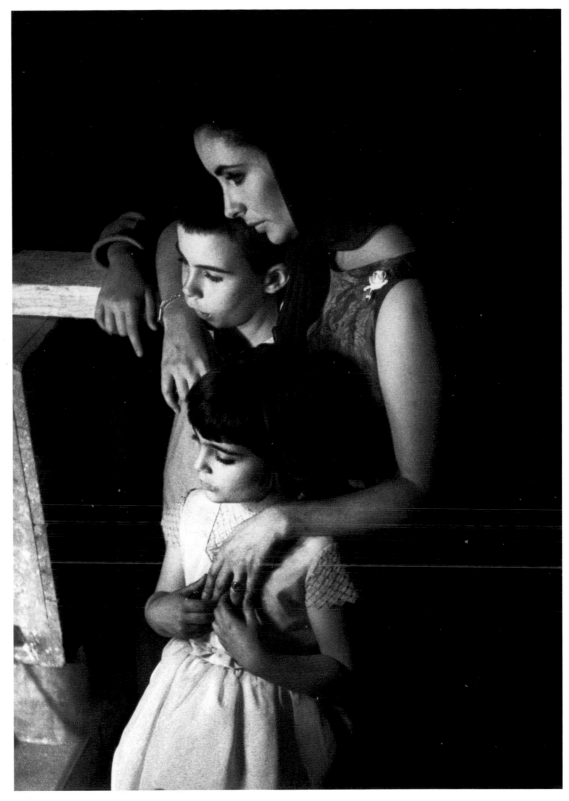

Elizabeth Taylor with her children on the set of the film *Becket*, watching Richard Burton playing the scene in which Becket is murdered, Shepperton, England, 1963

Opposite Dirk Bogarde with Ingrid Bergman, at his country home outside London, England, 1965

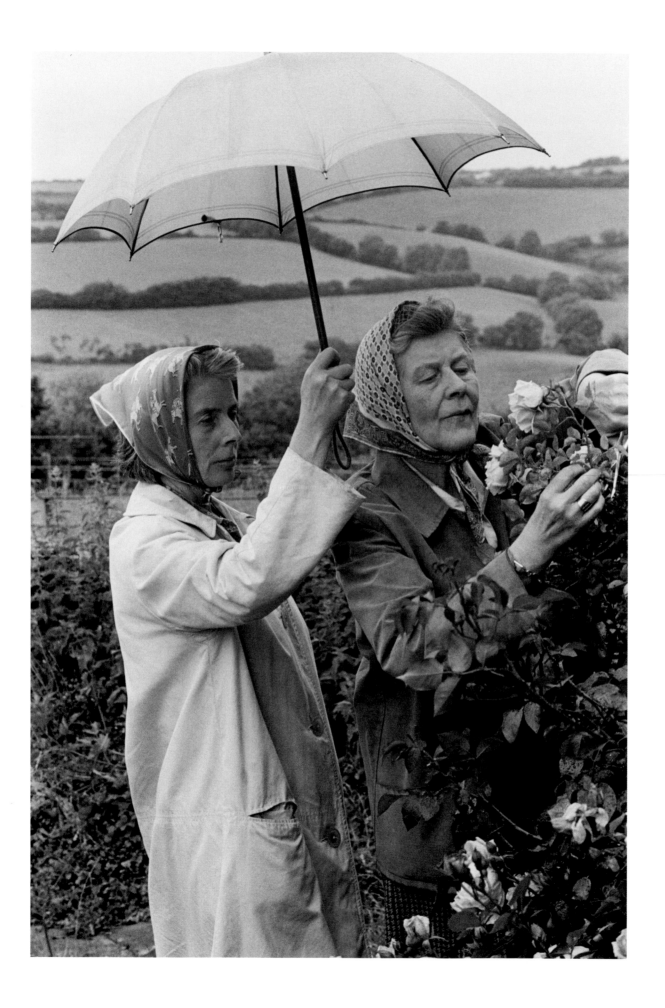

French Lycée, Kensington, London, 1964

Opposite Sisters Prue and Mabel ('Mogg') Mitchell in their garden, Chagford, Devon, 1965

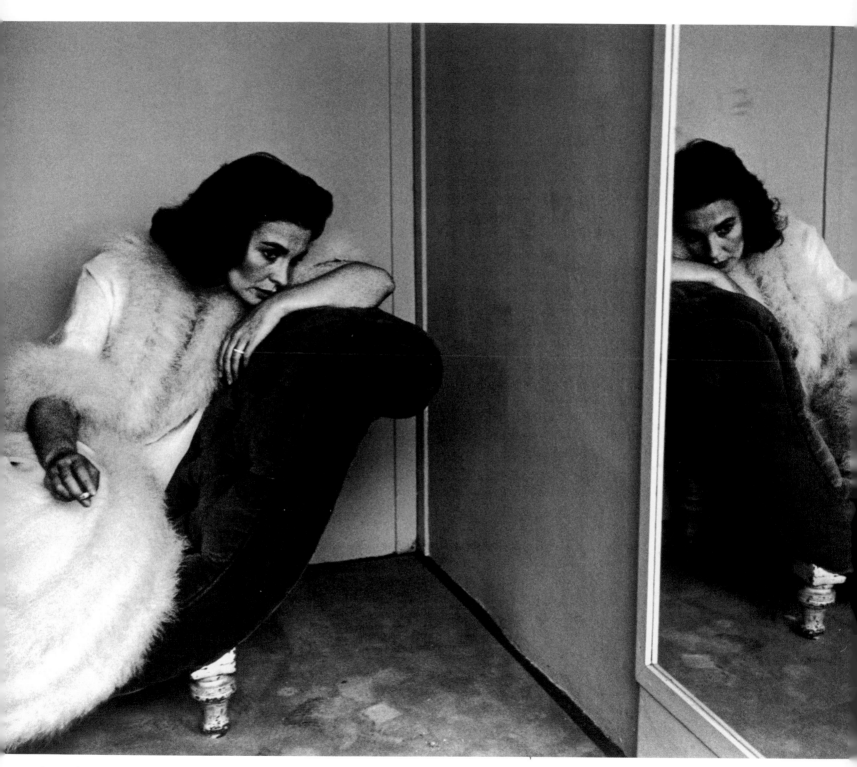

Jean Simmons on location for the film *Life at the Top*, Bradford, England, 1965

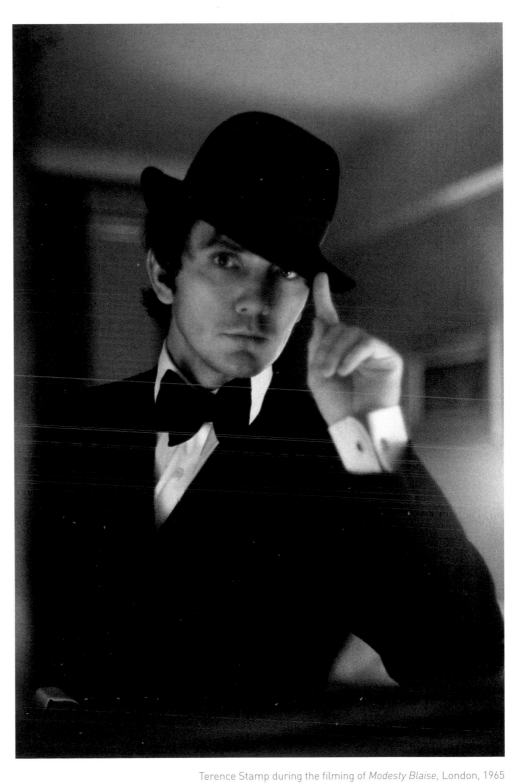

Terence Stamp during the filming of *Modesty Blaise*, London, 1965

Following pages US soldiers returned from Vietnam, Fort Bragg, North Carolina, 1967

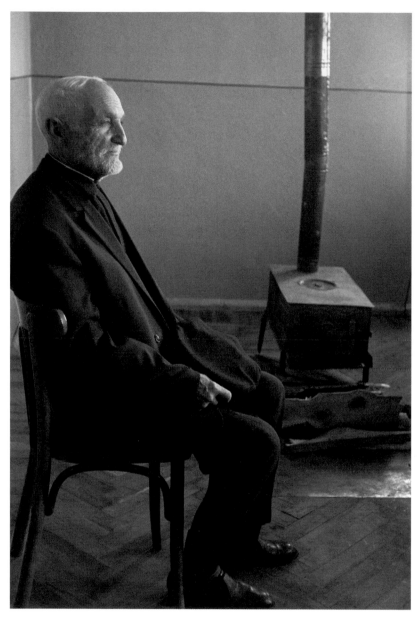

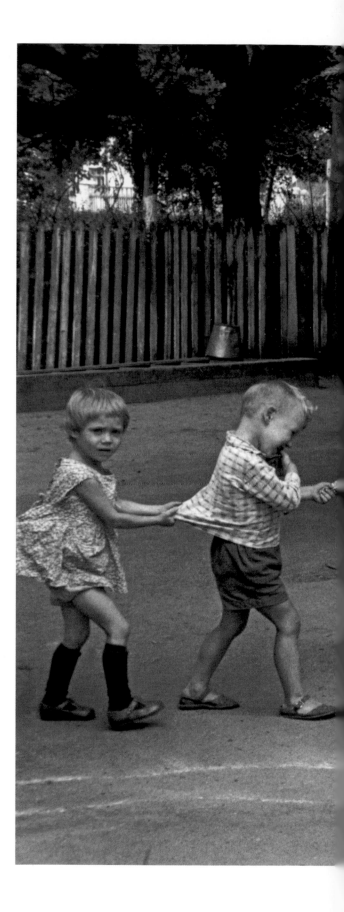

One of the oldest men in the world, 110 years old, in the Caucasus, Russia, 1965

Opposite Nursery school in the Kuban region, Russia, 1966

Following pages Divorce, Moscow, 1966

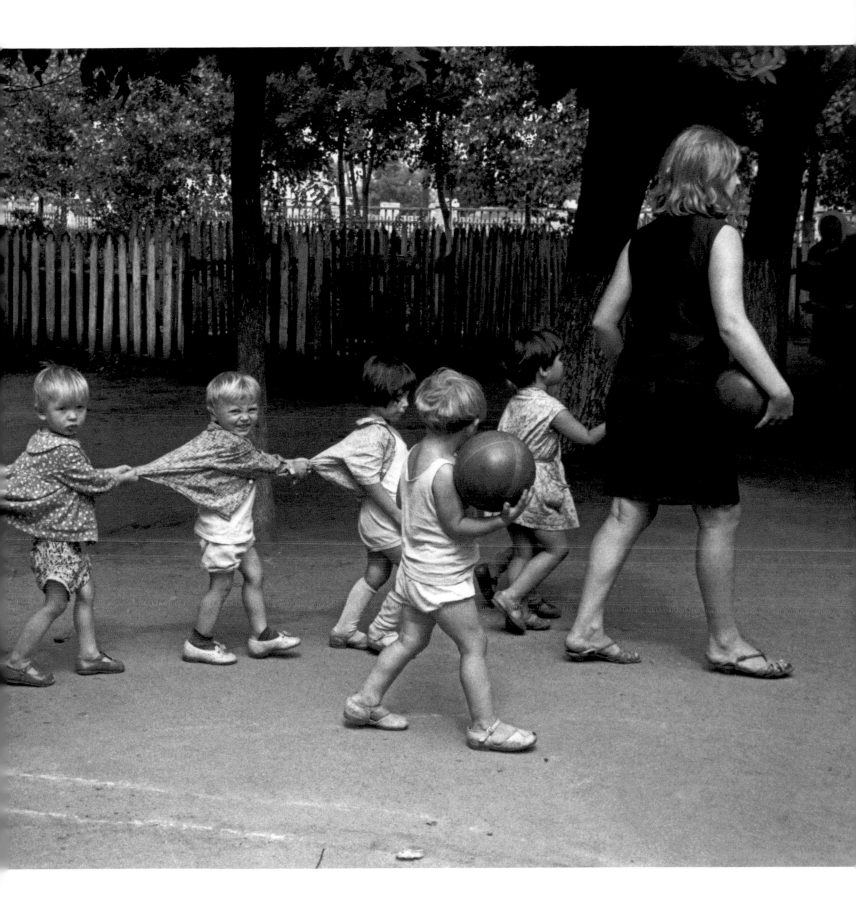

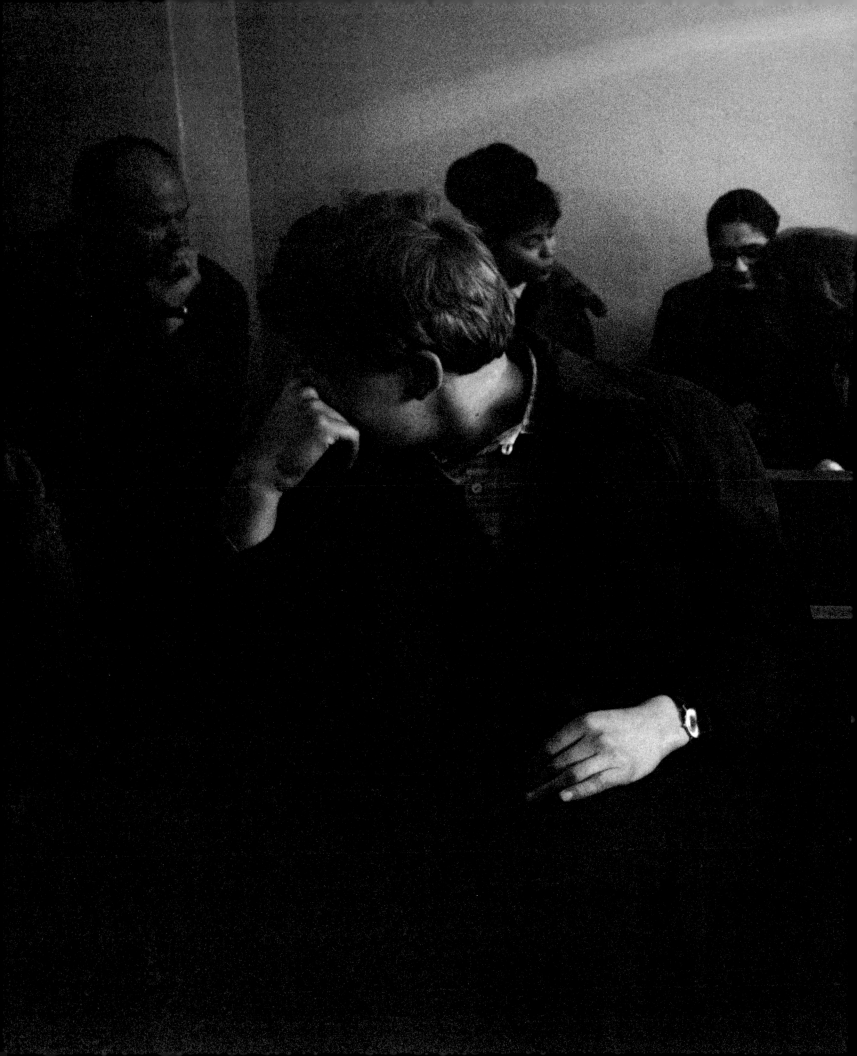

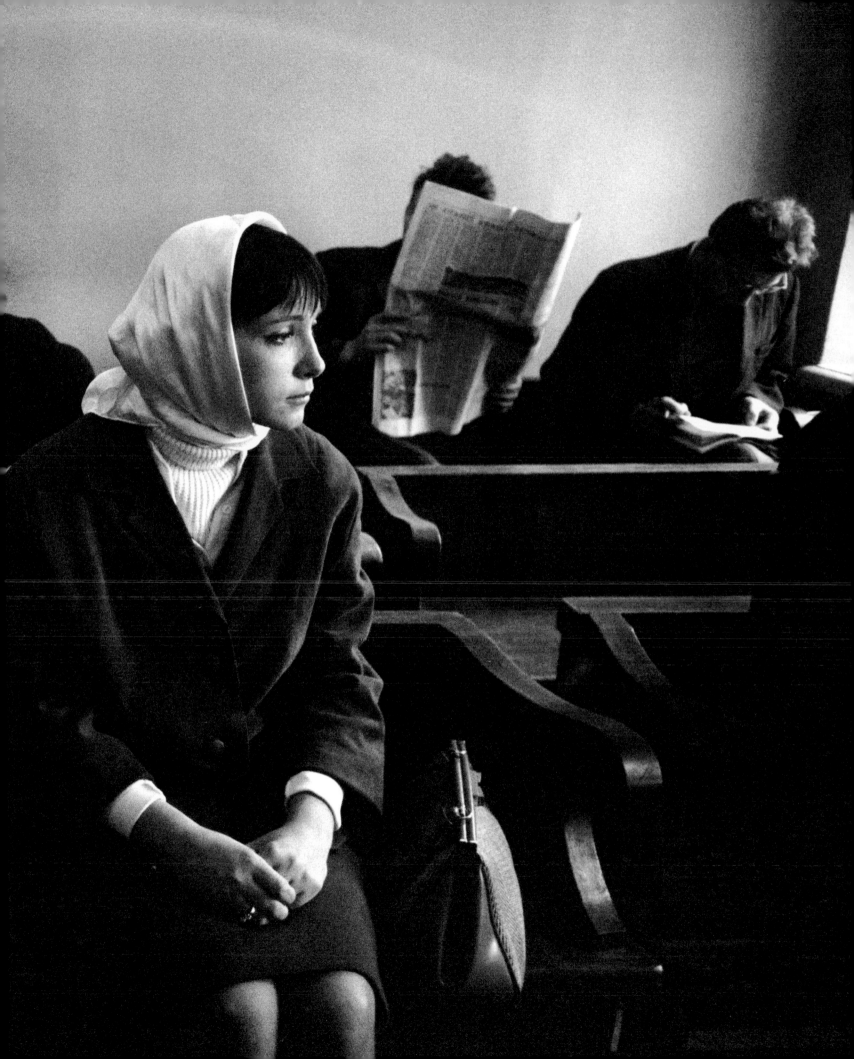

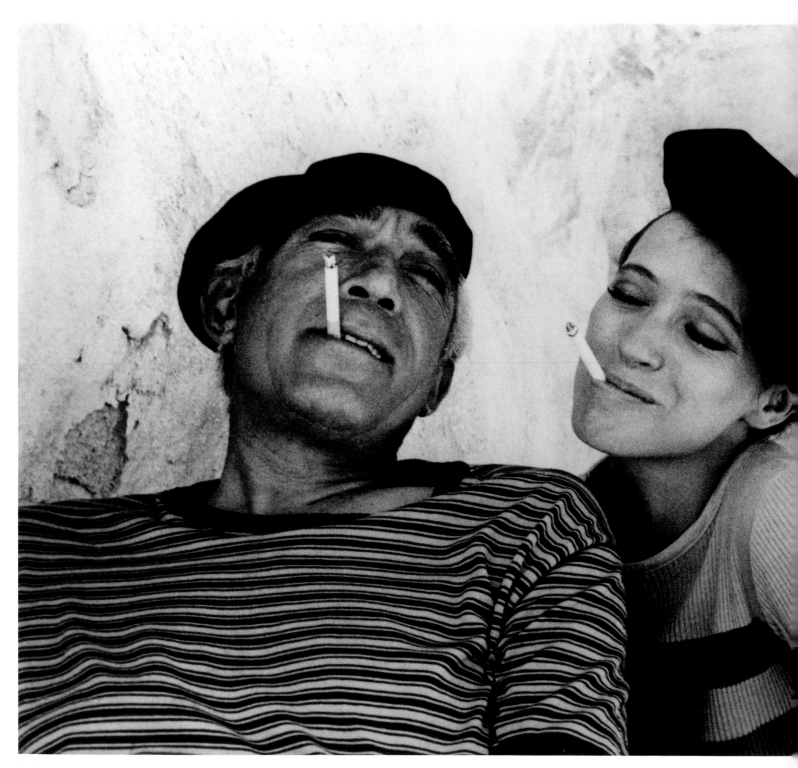

Anthony Quinn and Anna Karina on the set of *The Magus*, Mallorca, Spain, 1967

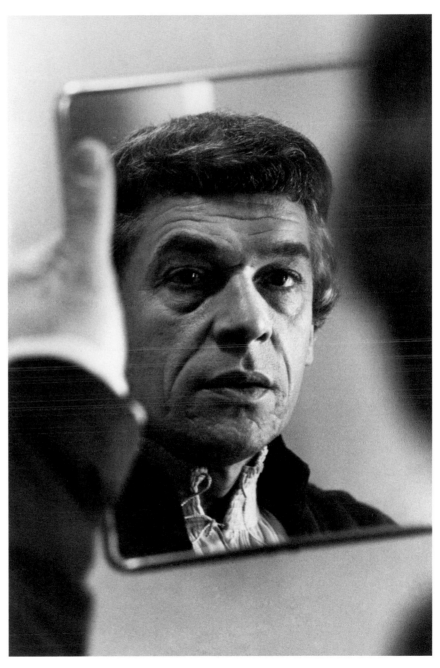

Paul Scofield during the filming of *A Man for All Seasons*, London, 1966

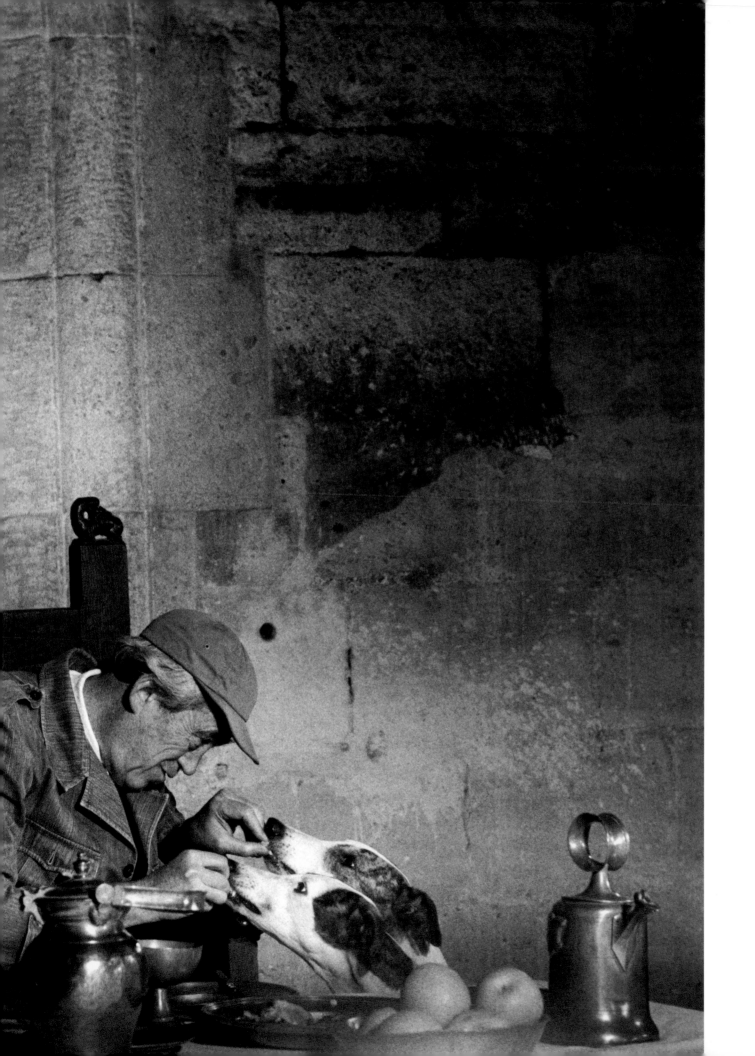

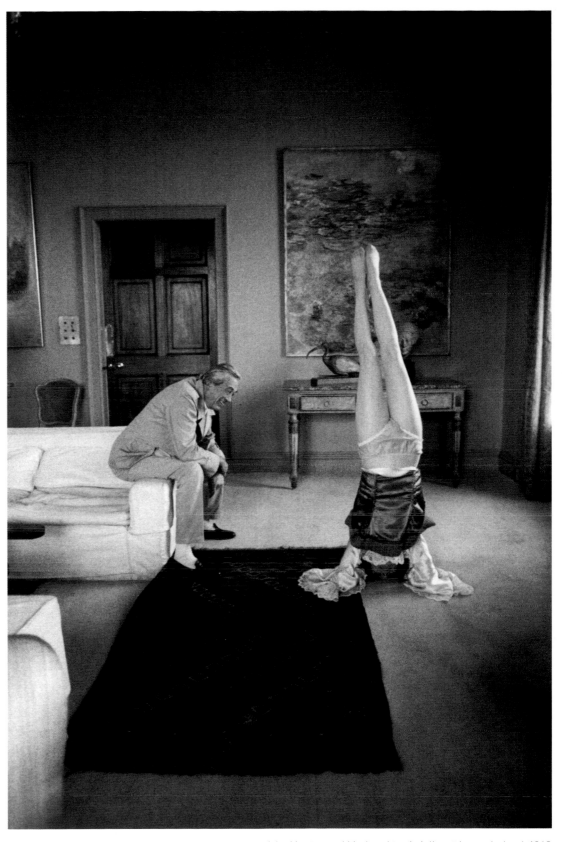

John Huston and his daughter Anjelica at home, Ireland, 1968

Opposite John Huston at home, Ireland, 1968

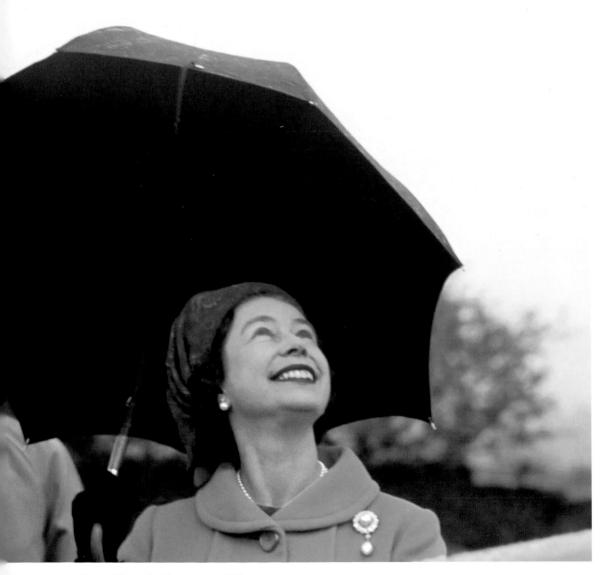

Queen Elizabeth, Manchester, 1968

Opposite Waiting for the Queen, Manchester, 1968

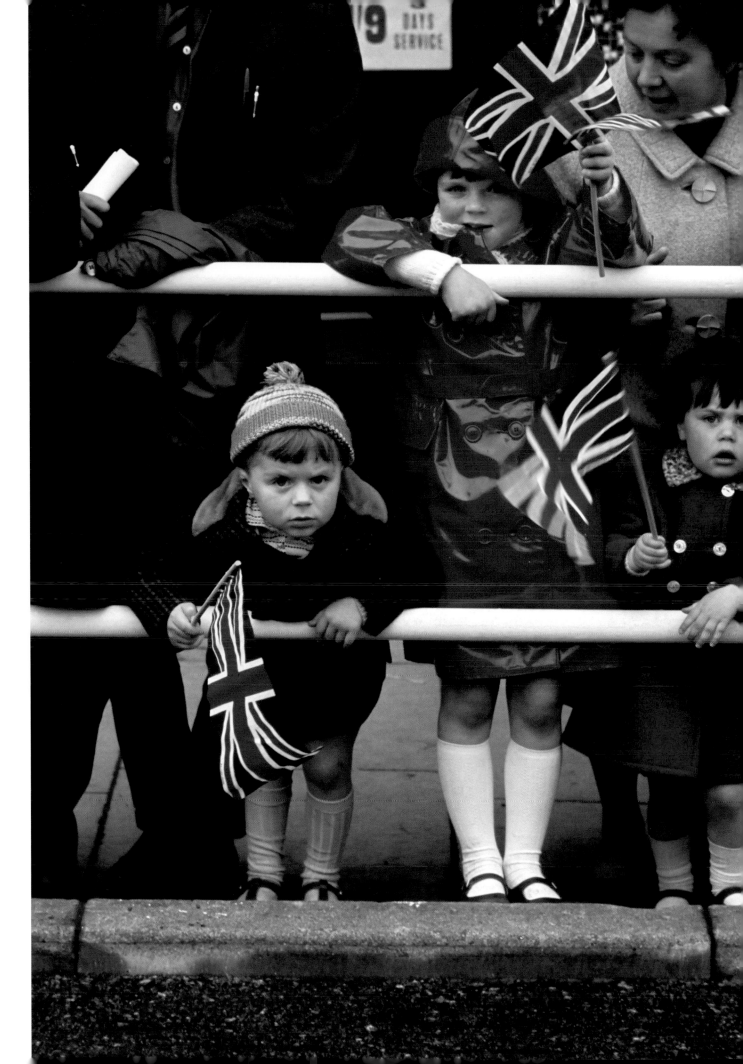

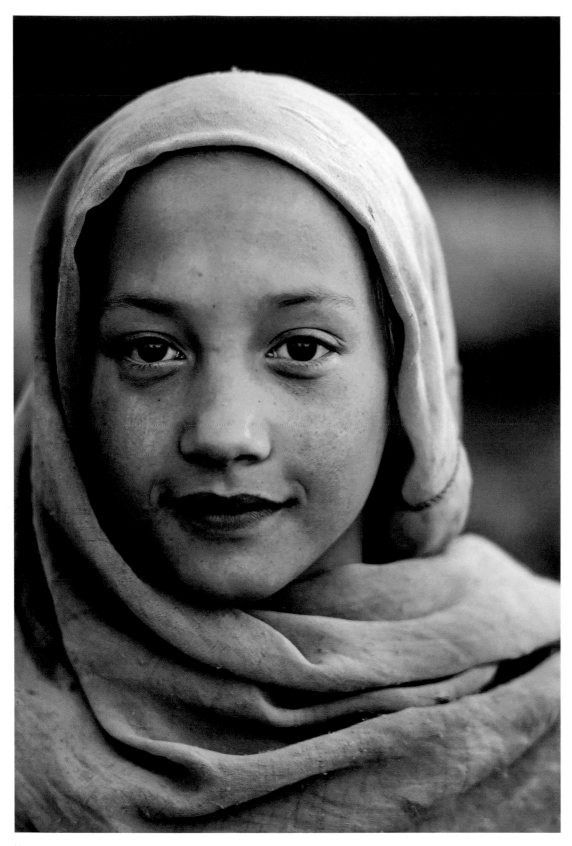

Young girl, Kabul, Afghanistan, 1969

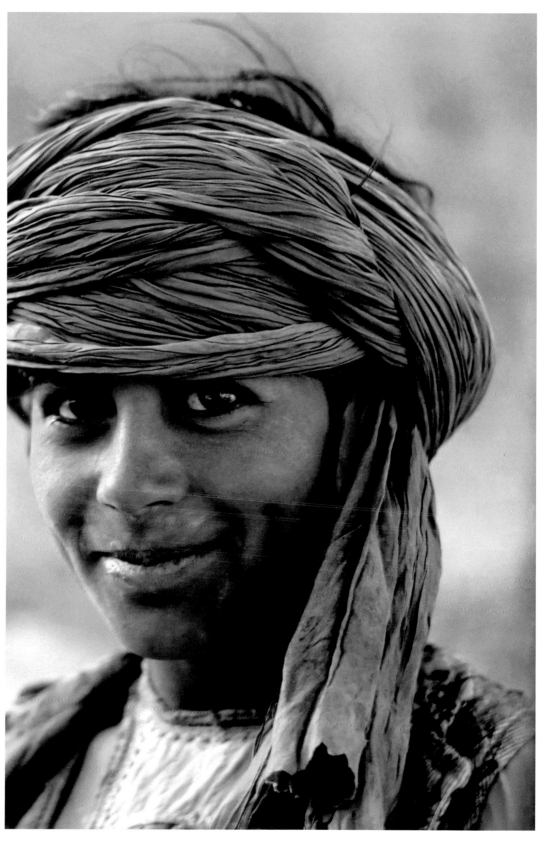

Young man at a Herat wedding, Afghanistan, 1969

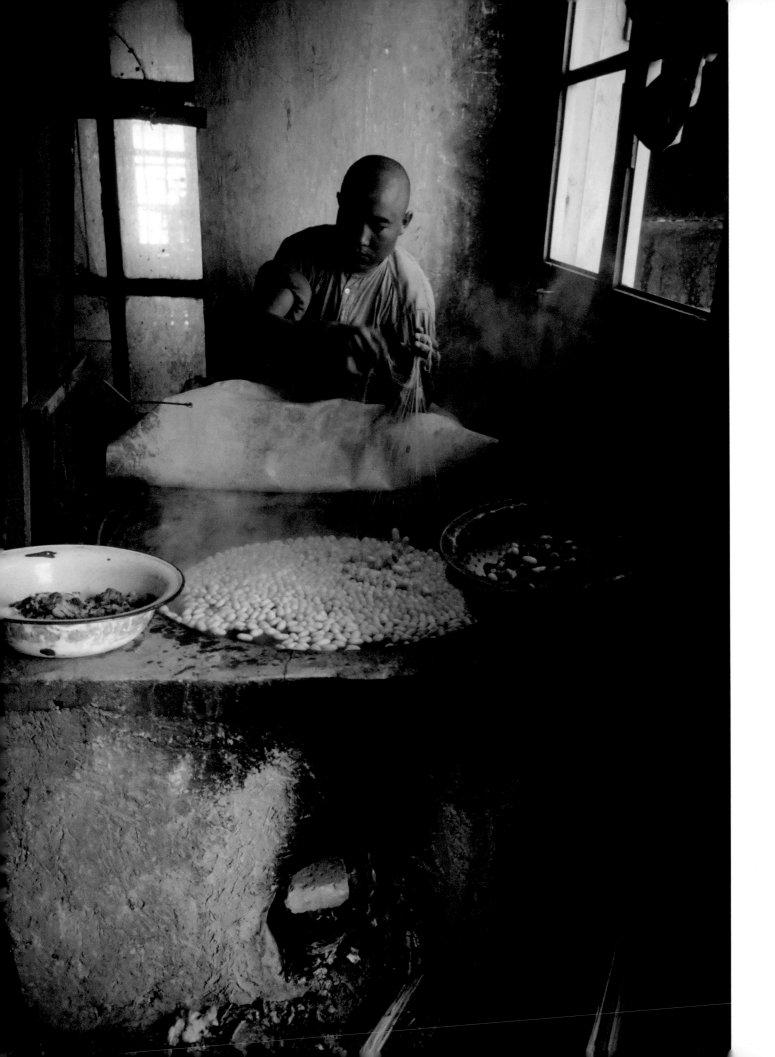

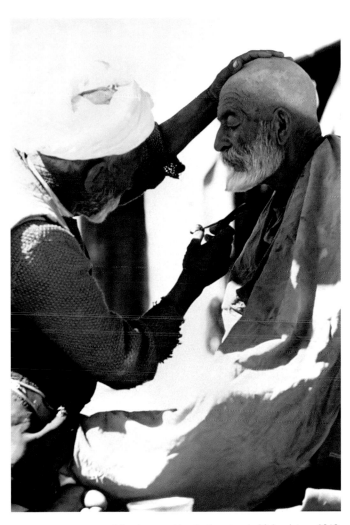

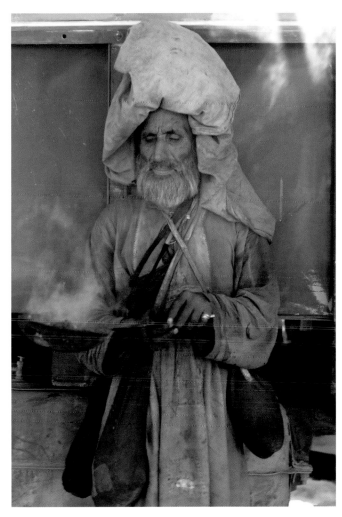

A barber working in the street, Afghanistan, 1969

Opposite Removing strands of silk from heated cocoons, Afghanistan, 1969

A fumigator. He goes from house to house chasing away evil spirits, Afghanistan, 1969

In the Field

Malcolm X and the Black Muslims, 1961

The Veiled Women, 1969

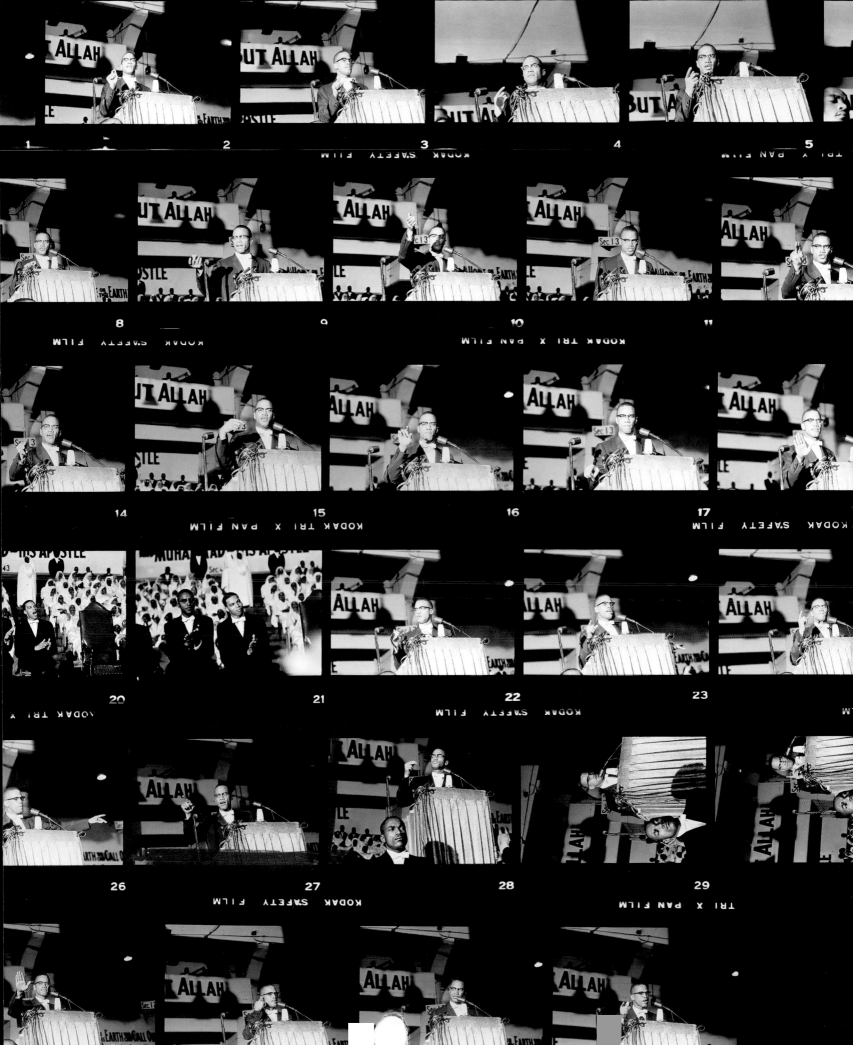

Malcolm X and the Black Muslims, 1961

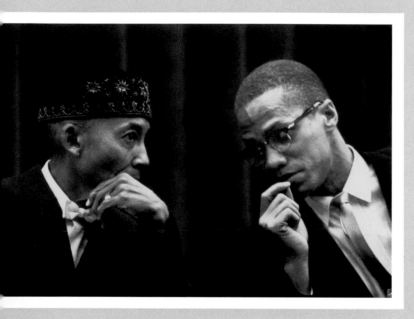

Elijah Muhammad, leader of the Black Muslims, with Malcolm X at a Black Muslim rally, New York City, 1961

The story Eve did on Malcolm X shows clearly her ability to achieve great work, with determination, in exceedingly difficult circumstances. Malcolm X was an African American civil rights leader and activist on behalf of black people in the United States. He changed his name 'to symbolize the true African family name that [I] never could know. For me, my "X" replaced the white slavemaster name… which some blue-eyed devil… had imposed upon my paternal forebears.'

Eve had wanted to photograph Malcolm X, the emerging leader of the so-called Black Muslims in the United States, for a number of years, but getting access to a man of such power and authority was not easy. The Black Muslims (a term used in the 1960s to denote members of the political-religious group the Nation of Islam) had successfully built a psychological barrier between themselves and outsiders – specifically in opposition to white people.

However, Eve's sources provided her with a contact, Louis Lomax, a journalist with high-level access to Malcolm X and his entourage. 'When I had waited for him for two hours and the restaurant we were to meet in was about to close, he breezed in. I tried to contain my displeasure and ordered him a drink. Before I could say anything about the Black Muslims he said, "You don't want to do a story, you just want to sleep with a black man, don't you?" Enraged, I let rip with a few nasty sentences and started to walk out. He caught up with me, apologized and said he was just testing. Once back at our drinks he agreed, for a fee, to be the fixer for the story.' Eve met Malcolm X and got the pictures she wanted. Eve said: 'I am always delighted by the manipulation which goes on between photographer and subject when the subject knows about the power of the camera and how that can best be used to the subject's advantage. Malcolm X was a fascinating example of someone totally immersed in that manipulative situation' (*In Retrospect*, 1995, p. 60).

After a shaky start she was able to build up a rapport with Malcolm X that resulted in some of the most memorable images ever taken of him. When looking at the contact sheets of the photographs for this story (one of

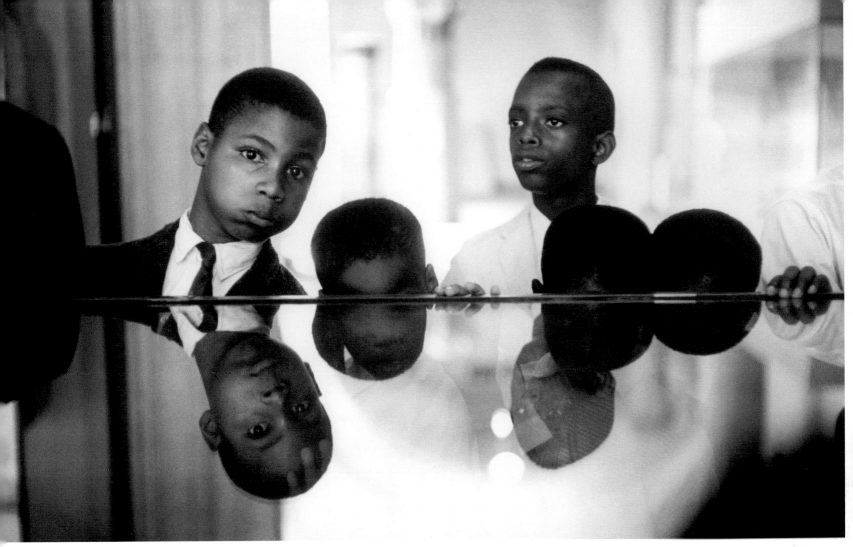

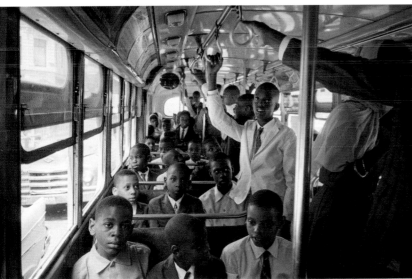

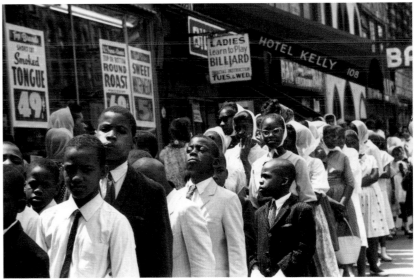

Top Black Muslim children at the Metropolitan Museum of Art, New York City, 1961

Left Black Muslim children on their way to the Metropolitan Museum of Art, New York City, 1961

Right Black Muslim children at a Muslim meeting at the Washington Coliseum, Washington, D.C., 1961

which is illustrated on p. 105), it is apparent how one of Eve's great skills is to be a quiet, patient, strong and stealthy presence when photographing her subject, acting not in a voyeuristic manner, but in a way which ensures that what is represented in the photograph has an unposed authenticity, regardless of how self-aware the subject might be, or of the balance of power between photographer and subject.

Michael Rand, responsible for publishing the story in the *Sunday Times* in London, mentions the air of menace that Eve had to contend with when she took these photographs (see p. 71). Eve recalled, 'My son once asked me how I reacted to those years of intimidation. Had I been frightened? angry? vexed? The question surprised me. I had been none of these during the entire period – from research to finish. All of it seemed expected to me. I had undertaken a difficult and possibly dangerous story and it was my job to get it done. Then I remembered that when it was all over I got a severe case of the shakes' (*In Retrospect*, 1995, p. 68). The result, however, stands as one of Eve's most accomplished pieces of work.

Opposite top George Lincoln Rockwell flanked by members of the American Nazi Party at a Black Muslim meeting, Washington, D.C., 1961

Opposite left Daughter and wife of Elijah Muhammad with Malcolm X, Chicago, Illinois, 1961

Opposite right Black Muslim meeting, Chicago, Illinois, 1961

Below left Nation of Islam meeting, Washington, D.C., 1961

Below right Black Muslim graduation, New York, 1961

Following pages Malcolm X giving a speech at a Black Muslim rally Washington, D.C., 1961

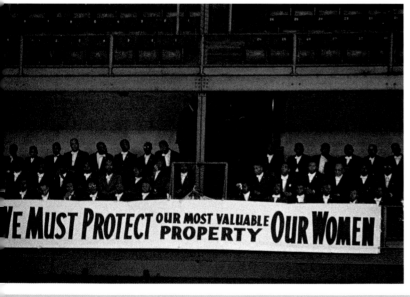

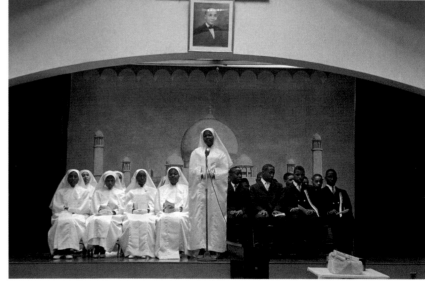

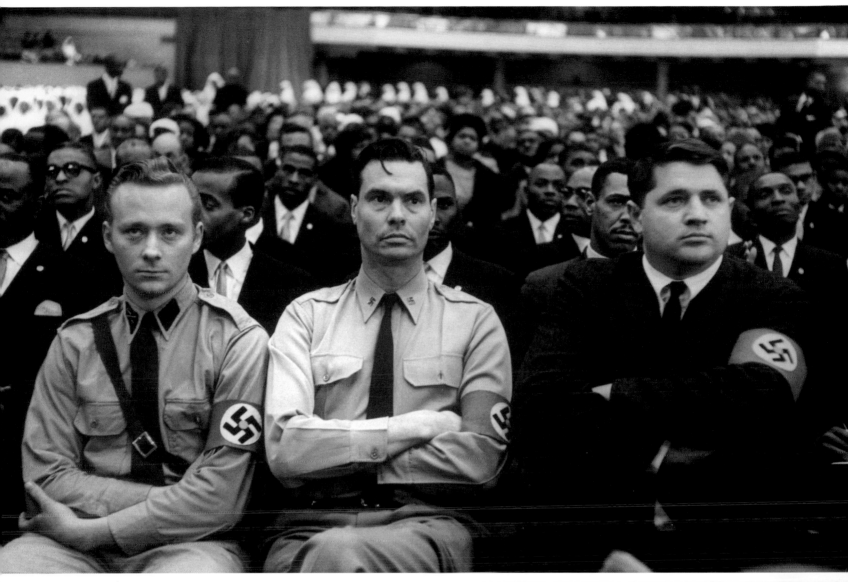

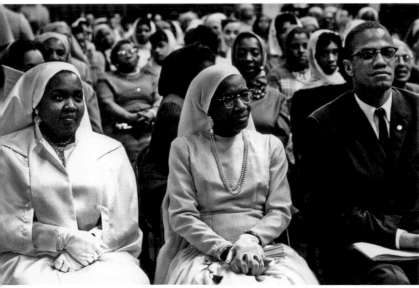

The Veiled Women, 1969

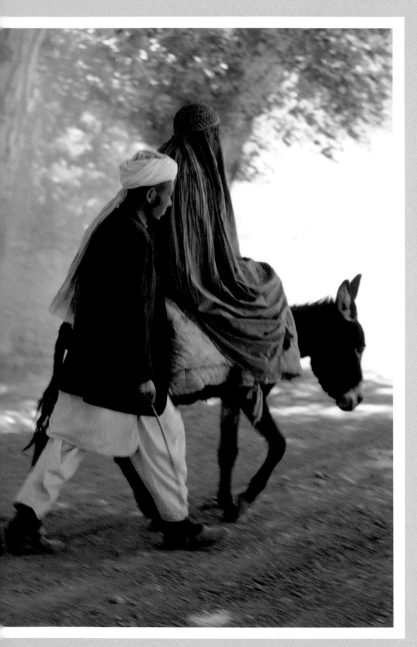

A man and one of his four wives, Jalalabad, Afghanistan, 1969

Jon Snow writes:

Eve Arnold possesses an infinite capacity to be in the midst of what she is looking for without disrupting what she's trying to capture. In her 'Veiled Women' you see two aspects of Eve's art in play. At first, she is merely there picking up what's going on. These are pictures taken at the end of the 1960s: the great 'clash of civilizations' is still three decades away. The women's movement had already highlighted the enslaved nature of women's lives in Saudi Arabia and other Arab states; but the wholesale emphasis upon political and cultural Islam was yet to come. We were still decades away from any war with 'Islamic fundamentalism'.

Here is the texturally beautiful shot of three women in burkhas striding confidently past classic turquoise mosaic walls; here is a Muslim man hurrying along with his wife more or less draped upon a donkey. These are matter-of-fact shots which provide the backdrop for the more intimate portraits to come. Not that anything in Eve's oeuvre is ever 'matter-of-fact', because to these facts must be added light and shade. The shoes of the striding women, in bright sun, speak of normality and confidence. The texture of the burkhas say more about Eve's vast skill in describing black. Every fold, every gathering of the fabric finds a way of playing with the overpowering light that beats on the stony ground beneath. For me, these three women represent one of Eve's iconic moments. She is not affecting the construct, and in no way has she posed it. It has happened and she has caught it.

So we move to what most defines Eve – that moment when she has so developed the women's confidence in what

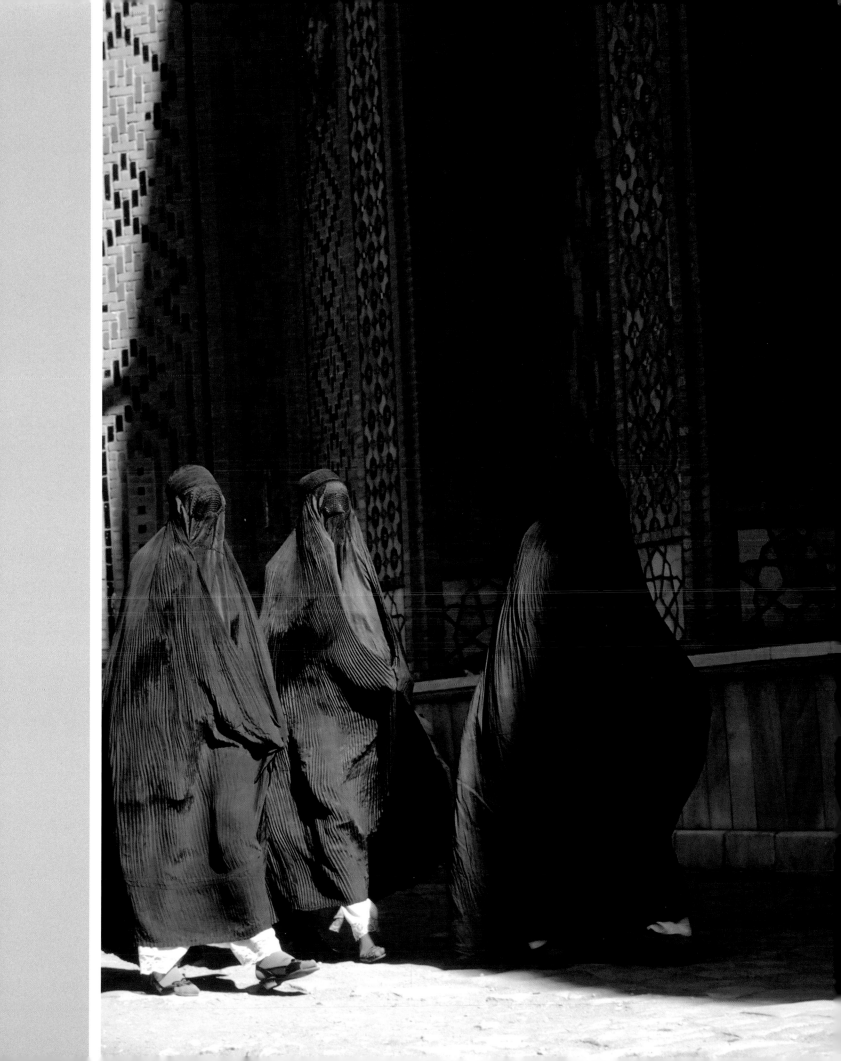

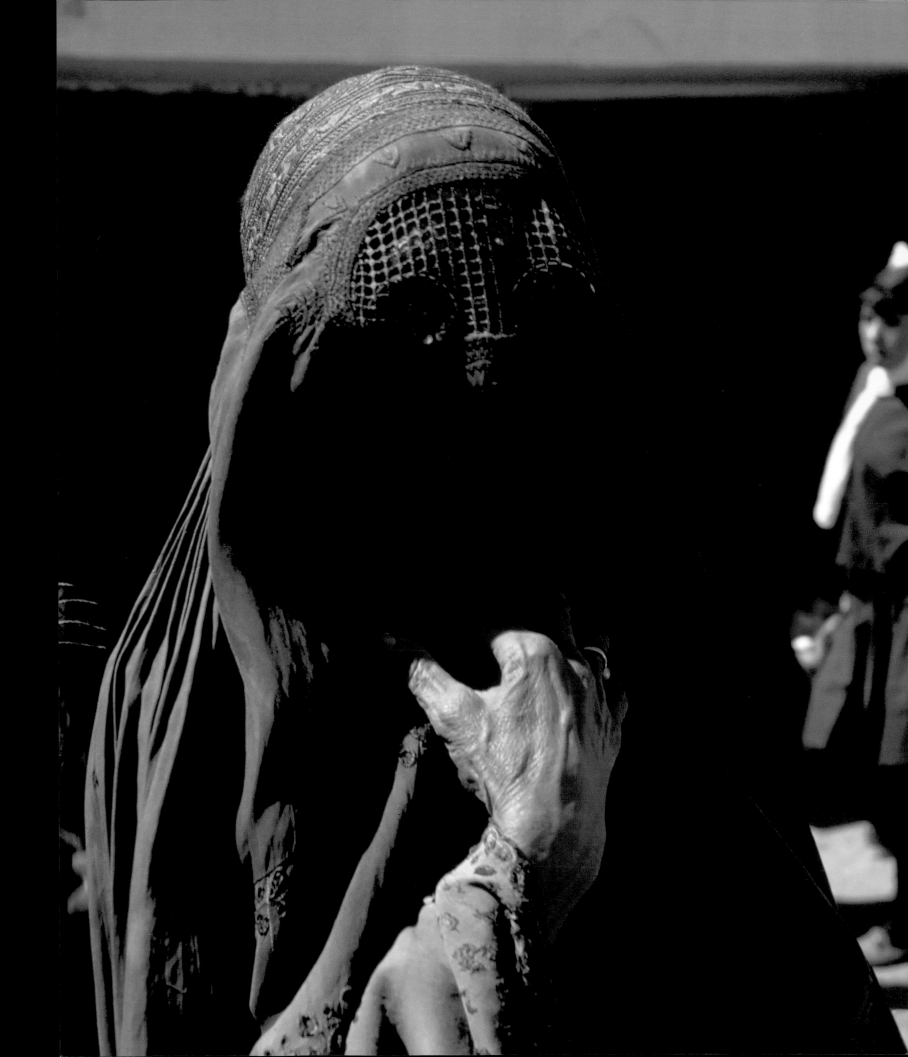

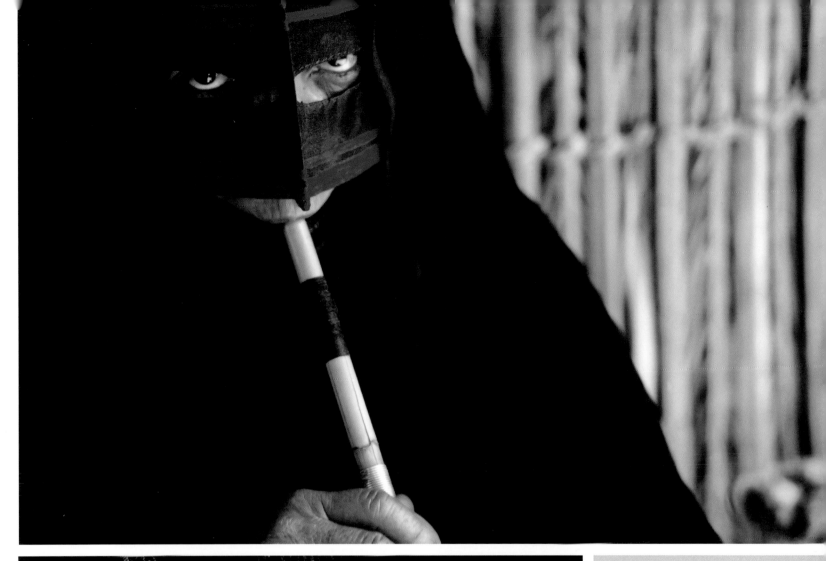

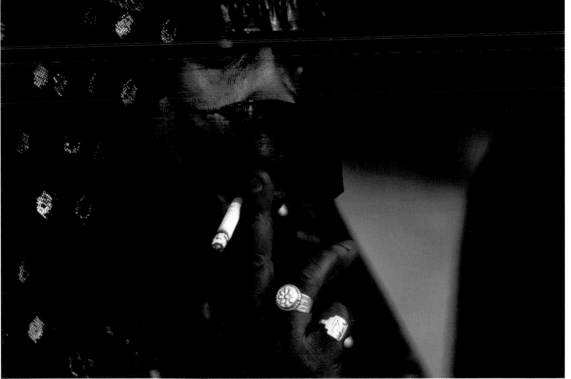

Above Veiled woman,
Muscat, Oman, 1969

Left Woman at wedding
celebrations, Dubai,
United Arab Emirates, 1971

Opposite Veiled woman,
Afghanistan, 1969

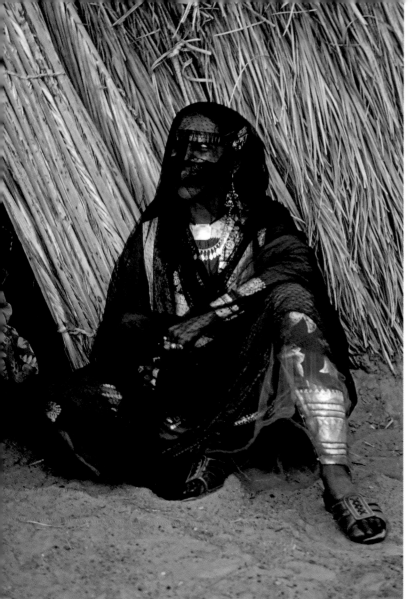

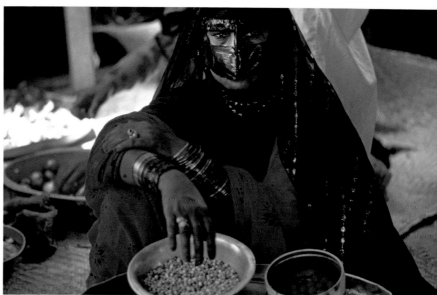

she is doing that they allow her deeper into their daily lives, a moment that allows some of the most intimate portraits of veiled women anyone has achieved. It starts with the veiled woman with her hand clasping the fabric of her burkah to her neck. Here the light catches the hint of the woman's forbidden face beneath the veil. But then comes the triumph of the posed photographs of working veiled women, and women relaxing in their home environments; the glorious trinketry and jewelry, and the extraordinarily detailed craftwork of the actual facial coverings. What Western teacher could compete with Eve Arnold's sensational veiled teacher – her gold jewelry cascading down to greet the woven neckline of her dress?

But for me, the crowning photograph in this sequence is the smoker. Again the revealed jewelry and facial masking, but here Eve achieves a complete understanding of the face and a gorgeous insight into the 'habit'. Yes, a veiled woman who clearly smokes on a regular basis, the telltale smoking finger pose and the tranquillity of expression visible in all who have dabbled with the tobacco weed. I believe it is Eve Arnold's 'Veiled Women' that defines her subtlety, artistry, and deep understanding of the human condition.

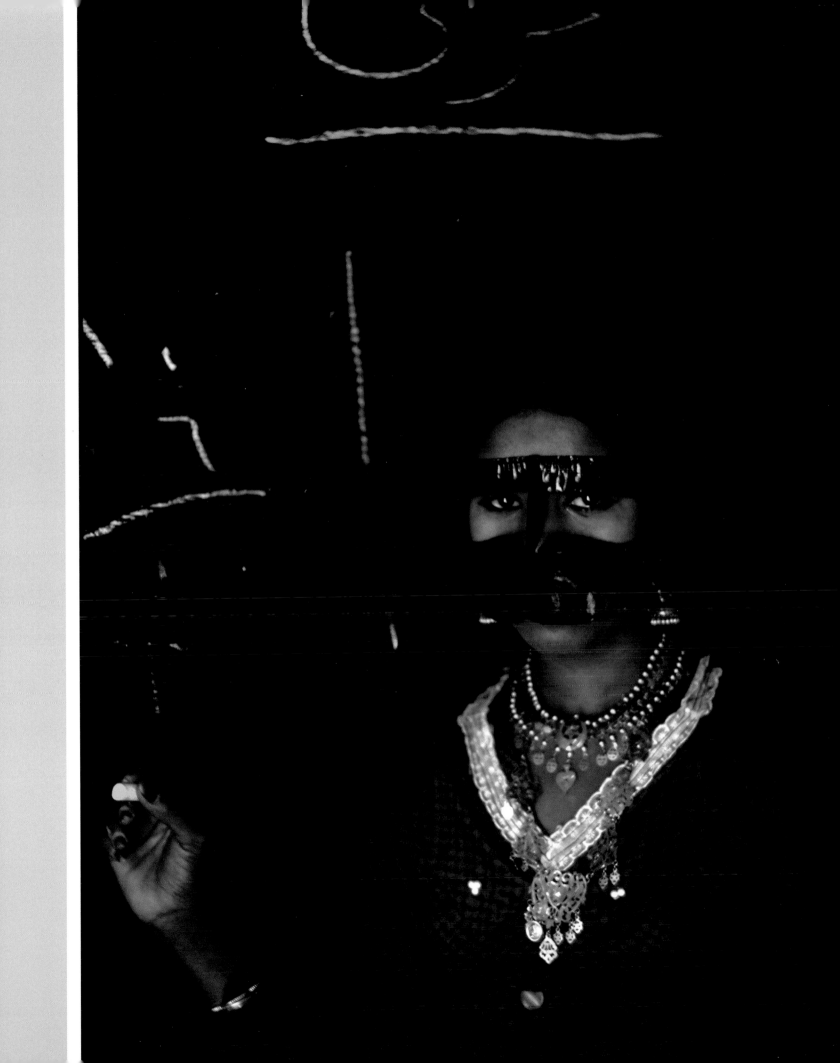

1971
1997

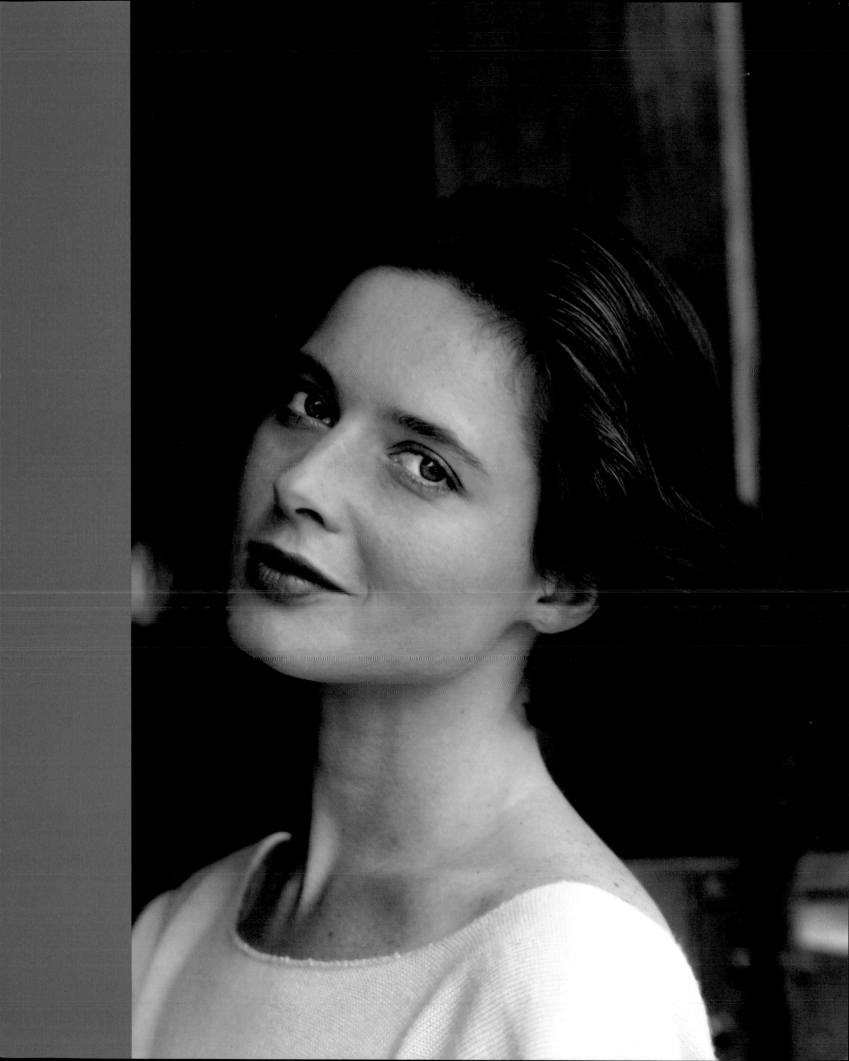

In the early 1960s Eve moved in to a top-floor flat in Mayfair, London. I remember very well the day, years later, when I climbed those five flights of stairs, on my way to be interviewed for the job of Cultural Director at Magnum's London office. It was there also that I met Linni Campbell, a friend and mainstay of Eve's through the course of many years. Eve has inspired the devotion of more than a handful of loyal friends, but Linni has always been counted among the innermost circle.

Another lasting friendship began when Eve's admirer was barely fourteen years old. The teenager was Beeban Kidron, in whom, characteristically, Eve saw not a callow teenager but a young adult full of appetite and curiosity about the world. She later worked for Eve as her assistant. Today Beeban Kidron is a film director of international repute (her work includes *Oranges Are Not the Only Fruit* and *Bridget Jones: The Edge of Reason*). She vividly evokes the atmosphere at Eve's Mayfair home.

I was invited to meet Eve Arnold in 1975. She had seen one of my photographs in a magazine and wanted me to show her 'the rest of my work'. I had been taking pictures for several years, but had never considered that I might have a 'body of work' – so I gathered from all corners of the house a scruffy pile of photographs, onto which I accidentally spilt a jar of beetroot just before I left. Clutching the somewhat damp (and pink) photographs, I made my way to Mayfair – the buildings taller and grander than those in my part of town. Already intimidated, I rang the bell to be greeted by a voice so deep I mistook it for a man and it was only after several exchanges and confusions that I was instructed to climb the stairs 'to the top'.

Five flights later I was panting and as pink as my beetroot-covered work. 'If you want to be a photographer you'll have to be fitter than that,' said the silver-haired woman who met me at the top. She had great presence, little height and the longest hair I had ever seen. She disappeared into her book-lined room where tea and biscuits were already set for our meeting.

On that day she introduced me to tea with saucers and napkins, the work of Elliott Erwitt, the smell of her rose perfume and a whole range of anecdotes from parts of the world that I never imagined that someone I knew might visit. She also looked through my photographs, silently ignoring the pink blotches, the smell of fix that clung to the ones that had not been adequately rinsed, and the browned edges of my misshapen, hand-printed offerings. As she turned the last photograph, she explained that her much loved assistant Linni was leaving for a while and she was looking for a temporary replacement – would I be interested? I was knocked out, not least because that day – 1 May 1975 – was the day before my fourteenth birthday, and exams beckoned.

Two years and one day later, as I turned sixteen, she invited me to work for her once again. Against all the expectations of my parents, teachers and peers I left school to be her assistant. I don't think I was a very good assistant: Eve told me years later that when I left in the evening she would open my letters and retype them because my spelling was so bad and I routinely muddled up messages and appointments. Once I dropped a tray in surprise at seeing the actor Terence Stamp in her living room. But I relished my job and whilst my contemporaries struggled through exams, I learnt from Eve about colour and form, about visual narrative and keeping faith with your subject. I sat with her photographic books and entered a world so far beyond my experience and knowledge that I still carry the awe of the images that ignited my imagination thirty years ago.

Very recently a young friend of my daughter came to a rehearsal. After 45 minutes watching the same four lines being rehearsed again and again until they were perfect, she commented that it was amazing how much effort went in to making something look effortless. It was precisely that lesson that I learnt as a sixteen-year-old working for Eve.

Before she went on trips Eve would fill notebook after notebook with research and thoughts about the place she was going – she would cold-call experts and talk to friends to gather their wisdom. Her packing covered every eventuality from monsoon to heat-wave, from potential illness to royal invite, and at the same time accounted for the fact that she may well have to carry her bag and her camera bag, alone. Her return would be a whirlwind of developing, sorting and printing – never jet-lagged, she would often work into the night screening images on the walls of her apartment while she edited – plucking some slides out of the moving carousel with absolute conviction, relegating them to obscurity, leaving only the 'chosen' to represent her and her subjects. In the two years that I worked for her and the thirty years that have elapsed since then, I have never seen her leave anything undone that might make her better understand her subject or improve her work.

Beeban Kidron's observations give an insight in the effort and all-consuming curiosity that fuelled Eve's work. John Tusa understands how this sense of commitment and compassion runs deep in her character.

Eve Arnold has described herself as 'curious', about life, conditions, circumstances, and, of course, people. What she does not emphasize or play up is the cost to herself in pressing on with this relentless curiosity. All those miles, countries, places, events she visited took their own toll on her. Even she could not predict when the

surroundings she was witnessing would become too strong for her. Covering South Africa under the cruelties of apartheid was going to be a tough shoot, that was obvious. But one so cruel that it ravaged her? She returned from South Africa 'absolutely shattered'. She told me, 'My GP sent me to a heart man, and I went and he prescribed something. Still it went on for months. And he said, "The only way I can describe it is that you are suffering from a broken heart".'

Eve does not quarrel with the diagnosis. 'The poverty, you can't express it. What happened that broke my heart was that men would go, leave for the mines, they would come back once a year, and because they had no way of know-ing of birth control, the wife would be impregnated again. They sent very little money home and you saw these women struggling.'

If South Africa precipitated a desperate reaction of sheer pity which was beyond her control, the Soviet Union created an atmosphere of misery, depriva-tion, despair and hopelessness that Eve translated into deliberately 'cold' images.

'It was very grey, and very depressing and slow, and it seemed to me that was the tempo of it, and it came from them, not from me. What I tried every time I picked up the camera was not to impose what I thought was there but hopefully to let it come up from underneath... It was that kind of bleakness that I saw and I felt.' No one would call Eve a vulnerable person but her occasional vulnerabil-ity and her invariable sensitivity to the realities of the events she witnessed make her achievement all the more admirable.

For those of us who despair of the 'celebrity' photographers whose private, uncaring milieu is the controlled, self-congratulatory, self-serving world of the supposed 'celebrities' of show business, money and sport, the world where fame is more than the spur but the satisfaction itself, the world where the photogra-phers enter into a complicit pact of flattery and mutual advantage with their sub-jects, Eve Arnold is a wonderful corrective. But she is not to be defined in terms of the failings of others. Her personal and moral stance is respected as valuable and totally authentic in its own right. She speaks of and she reveals a huge, loved, common humanity that unites us all, celebrity and nonentity alike. But Eve believes in the humanity that binds us. It is infinitely precious, infinitely admirable. For we are all, in her eyes, and through her lens, 'Eve's People'.

In her mid-sixties, when most people's thoughts might reasonably turn to retire-ment, Eve chose to embark on a new phase in her career: she started to put together books of her work. Not only did she work on the photographic edit, she wrote her own words. She was greatly helped by her long-time literary agent Ed Victor and editor Robert Gottlieb. At first she made compilations of past

work, but *In China* (pp. 154–65) was conceived as a book from the start, although the money was put up by the *Sunday Times*.

She was involved in every detail of publication, even visiting the printer when the book went to press in order to make sure the reproductions were just as she wanted them to be. When it was rumoured that her first book, *Unretouched Woman* (1976), might be banned on the grounds of obscenity in South Africa, thanks to the appearance of Vanessa Redgrave's bare bottom (p. 75), Eve wrote indignantly to the press in South Africa that if anything might be called obscene in the book it surely was the picture of a child dying of malnutrition, and not the shapely bottom of a famous actress. With the books came exhibitions, and with major exhibitions came print sales, making it less necessary for Eve to rely on advertising jobs for her bread and butter. She served as a very effective vice president of Magnum during the second half of the 1990s, a respected voice at the legendary Magnum annual general meetings, and was ever willing to exercise her vote on the well being of the company and the recruitment of new members.

Mary McCartney met Eve at the opening of *In Retrospect* in 1996 at the Museum of Photography, Film and Television (now the National Media Museum) in Bradford. Mary attended in place of her mother Linda Eastman McCartney, whose own exhibition was showing at the same time, and who was not well enough to attend. Mary got on with Eve instantly, and they remained in contact long after that. Now a photographer herself, Mary cites Eve as one of her strongest influences.

When I first met Eve, she was hanging her show at the Museum of Film Television and Photography in Bradford. As a photographer myself I found the show inspiring – seeing that exhibition showed me the scope and breadth of her work over the years. Eve's informal approach to photography really helped to pioneer a new wave in portraiture: her photojournalistic style is much more about capturing her sitter's personality and intimate moments, rather than the veneer of a studio-manicured look. I thought at first glance that she was a quiet little lady – she's anything but! She knows the images she wants and will not rest until she captures them. I also found her to be very generous with her advice and I love the naughty twinkle she still has in her eyes.

Some of my personal favourites are of 'Fabulous', the glamorous model who took part in the Harlem fashion shows in the early 1950s (p. 21). She captured the glamour of the time. All these images seem intimate because it was Eve and her camera observing the situations she found herself assigned to: wonderful moments captured in an instant by asserting her confidence and trust in her subjects.

Eve has an assured and elegant style that I identify with as a female photographer. She would cover each assignment with a sense of responsibility and a feminine quality within each grainy, gritty image. The picture of a bar girl in a Havana brothel (pp. 24–25) shows this well. You get a sense of her vulnerability – you feel her life has been difficult, but that Eve is not judging her with her camera; there is a very sympathetic human quality to the photograph. Eve was hesitant about taking images which may later embarrass her subject – she had no interest in cashing in on making people look bad. Her subjects seemed to have confidence to allow her into their private moments, as they could sense she would not take advantage of them.

I was surprised when Eve told me she only carried a camera with her when she was on assignments. I found this odd at the time, thinking of missed images, but then I came to understand that Eve would put her all into her assignment, and at home perhaps she needed to focus on real life, and not from behind the camera. I couldn't help feeling maybe she had to sacrifice family moments to go out to get the strong graphic images she craved so much.

Magnum organized Eve's last assignment in 1997. She had always wanted to return to Cuba to find out what had happened to Juana, a little girl whom she had photographed in 1954 and whose parents had asked Eve to adopt her, so she would have a better chance in life. Eve had declined, but she never stopped wondering what had become of her. Juana was found alive and well in Cuba. Juana did remember Eve, and together they had the pleasure of going through the pictures that Eve had taken of her and her family 43 years earlier, and that Juana was seeing for the first time. Eve derived deep satisfaction from her reunion with someone who was not just a subject before her lens, but someone whom she had thought about for the years in between, and who now – like Eve herself – was a grandmother, albeit one of a different generation.

After a lifetime spent toting heavy bags full of camera gear, long distance travel had become physically intolerable. This journey marked the end of Eve's serious travels, but it was by no means the end of her serious professional participation in the world of photography. Eve devoted herself to the task of helping to prepare the abundance of material that makes up her archive, to be sent to Yale University: in addition to the vast collection of negatives, Eve kept her notebooks and documentation of every assignment. Her work is still represented by Magnum, which distributes it in digital form. Even at almost 100 years of age, Eve's continuing desire to engage with people in the wider world – as well as with photography in general, and with Magnum in particular – remains as strong as ever.

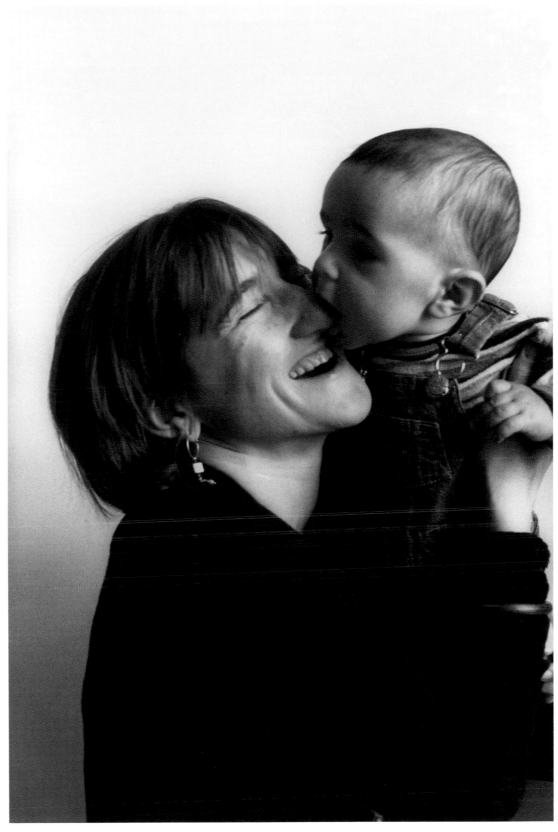

Beeban Kidron and Noah, 1995

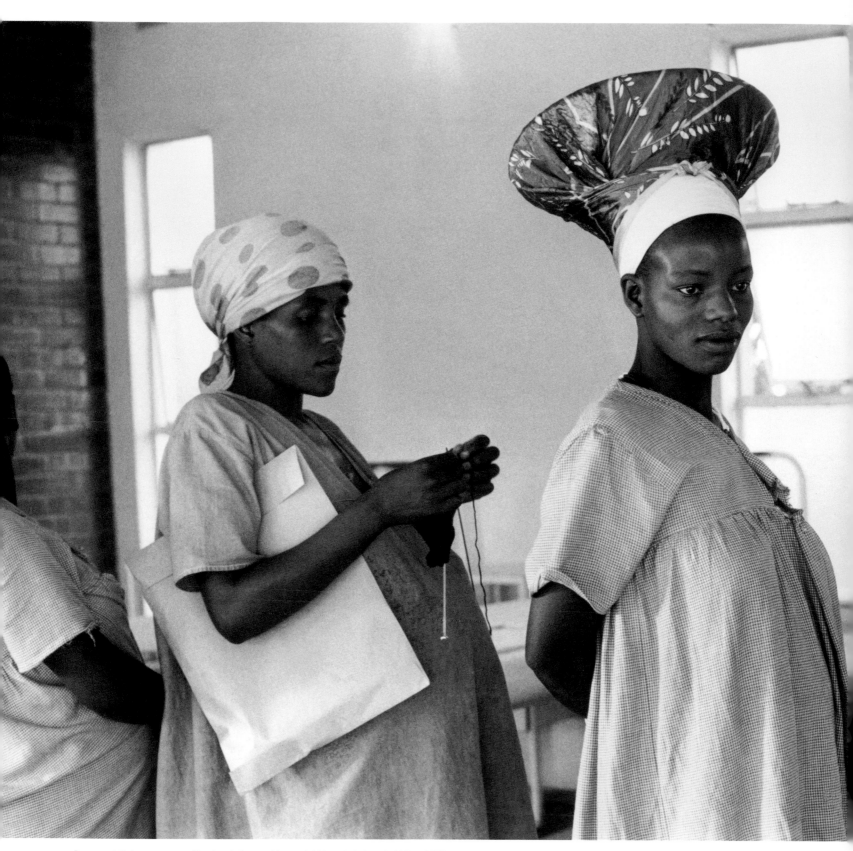

Pregnant Zulu women at Charles Johnson Memorial Hospital, South Africa, 1973

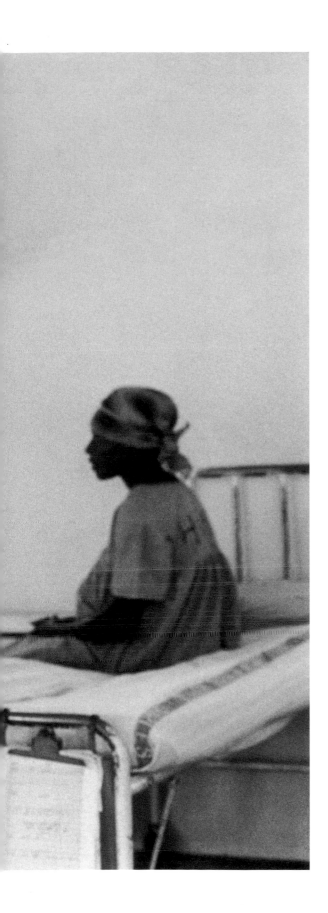

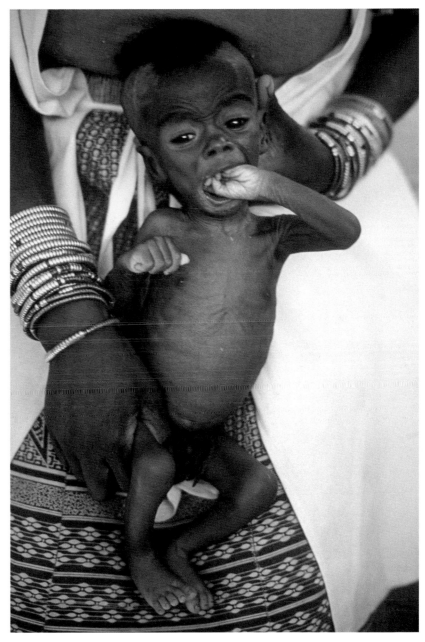

Child suffering from malnutrition at Charles Johnson Memorial Hospital,
South Africa, 1973

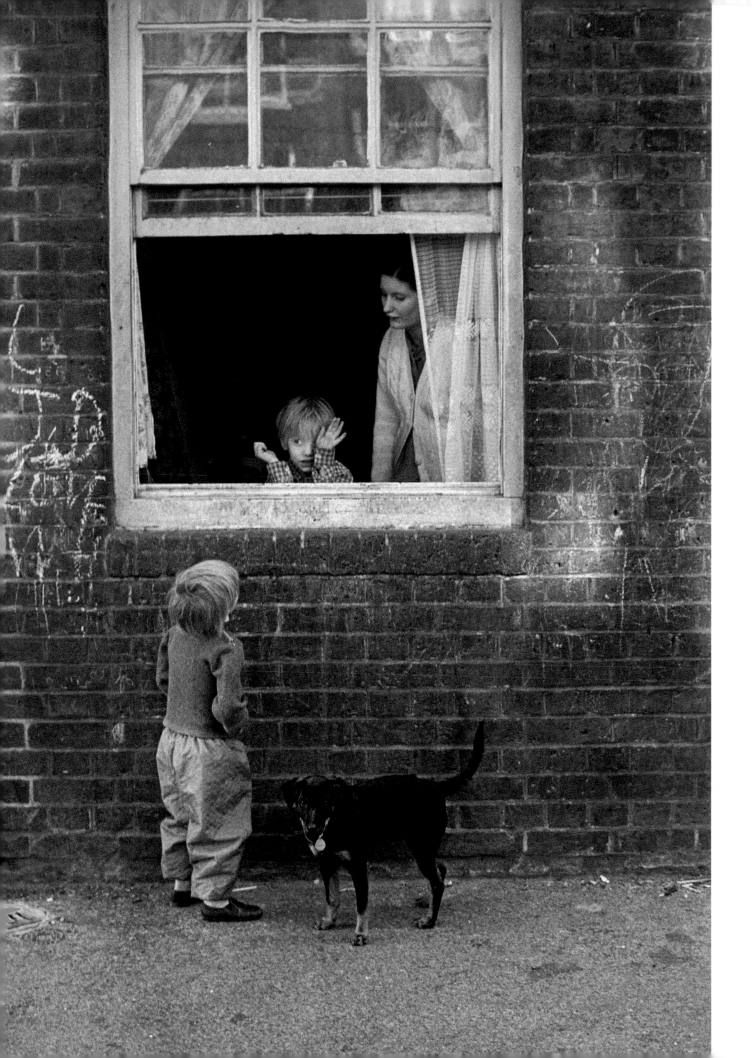

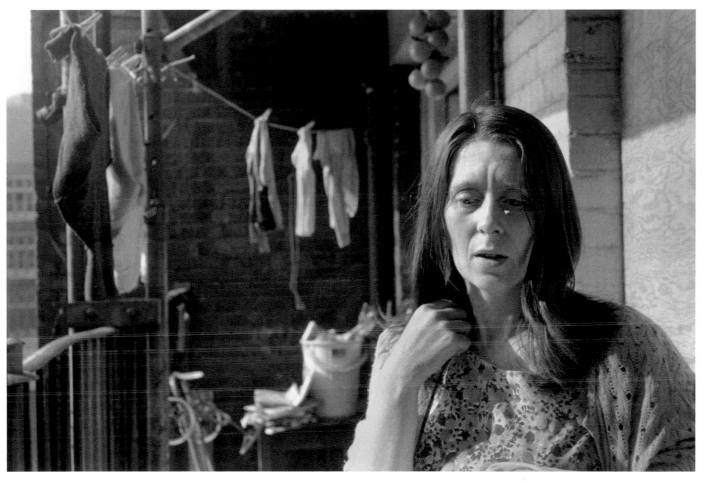

A mother at a halfway house; she has been waiting six years to be re-housed, London, 1972

Opposite Can Johnny come out to play? London, 1972

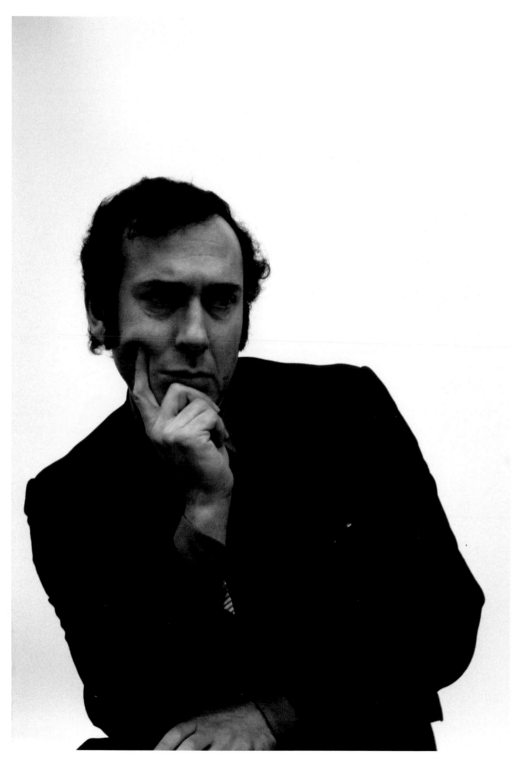

Harold Pinter, playwright, London, 1976

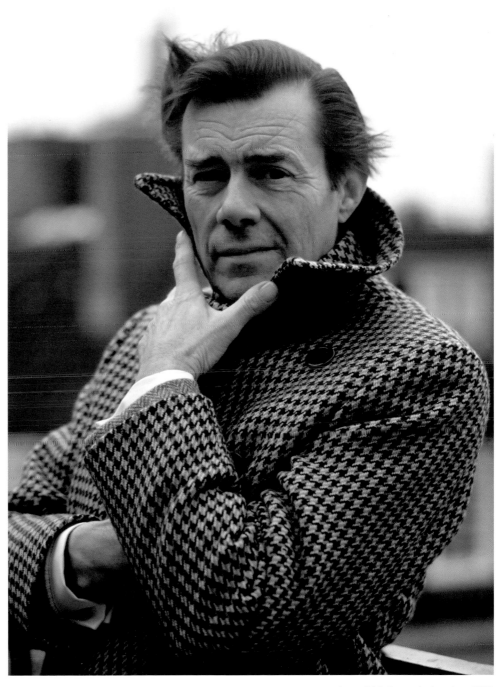

Actor Dirk Bogarde, London, 1978

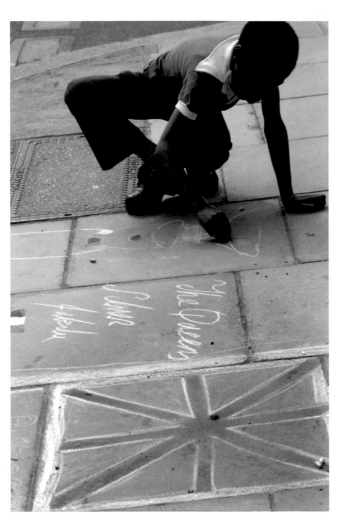

The Queen's Silver Jubilee, Notting Hill, London, 1977

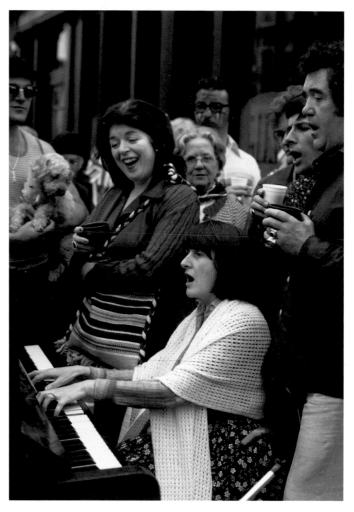

A street party in London to celebrate the Queen's Jubilee, London, 1977

Opposite Elderly couple at home, Cumbria, England, 1978

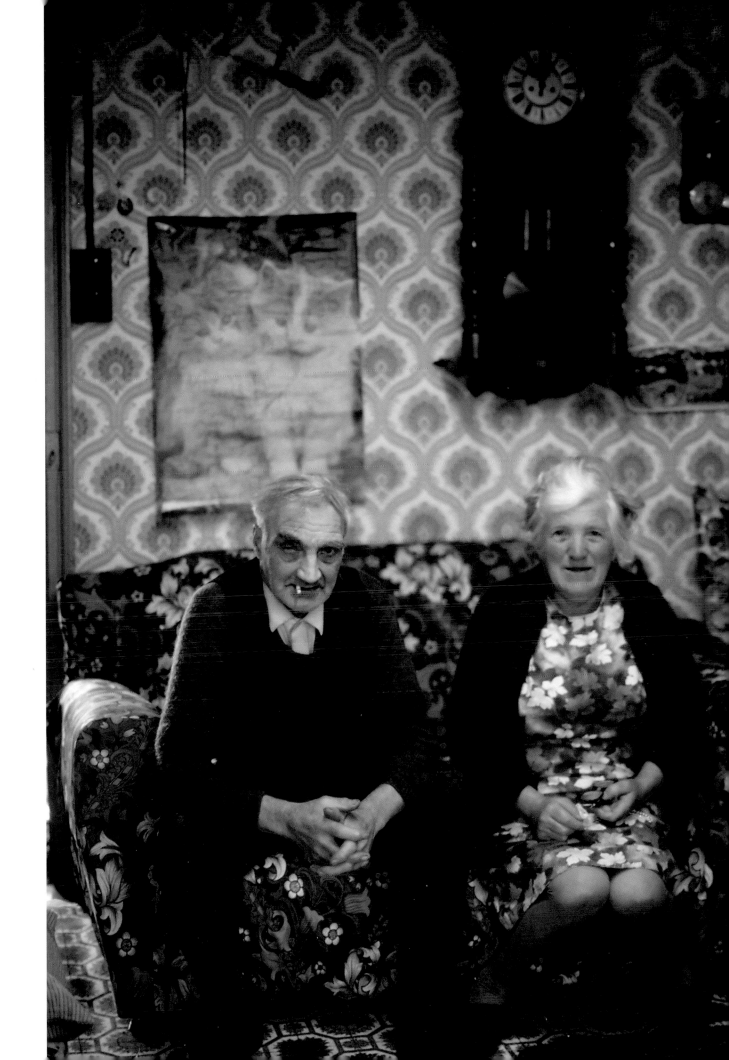

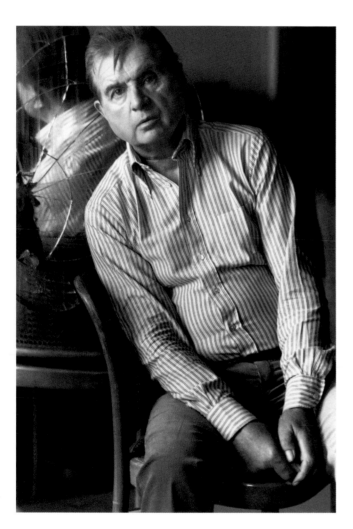

Francis Bacon, painter, London, 1978

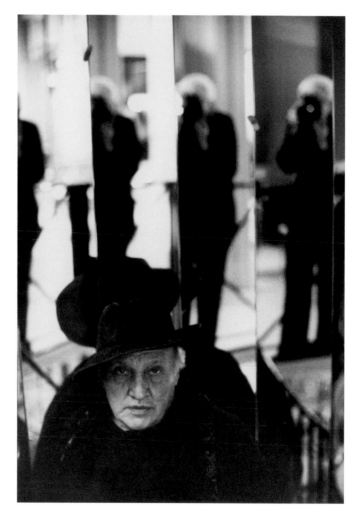

Joseph Losey, film director, Paris, 1977

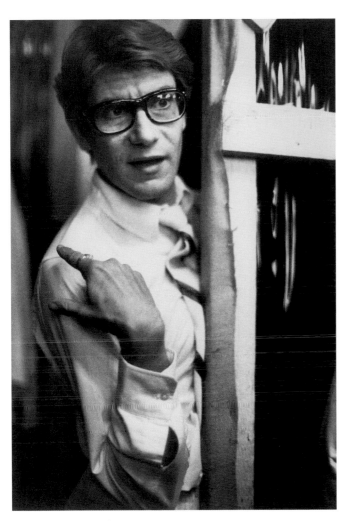

Couturier Yves Saint Laurent, Paris, 1977

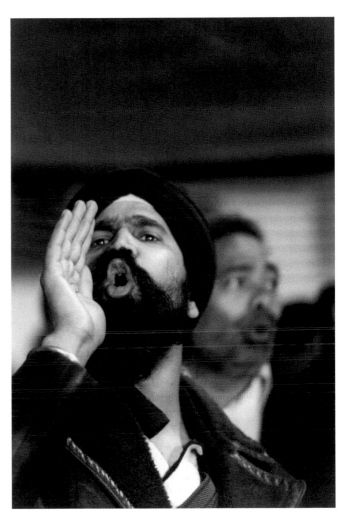

A heckler in Southall, London, 1978

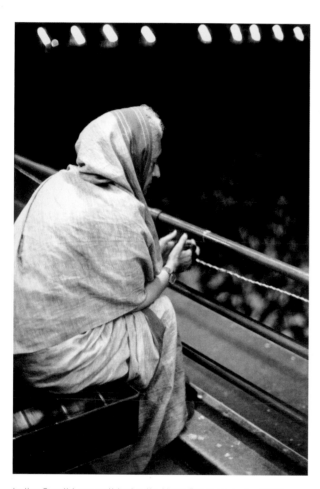

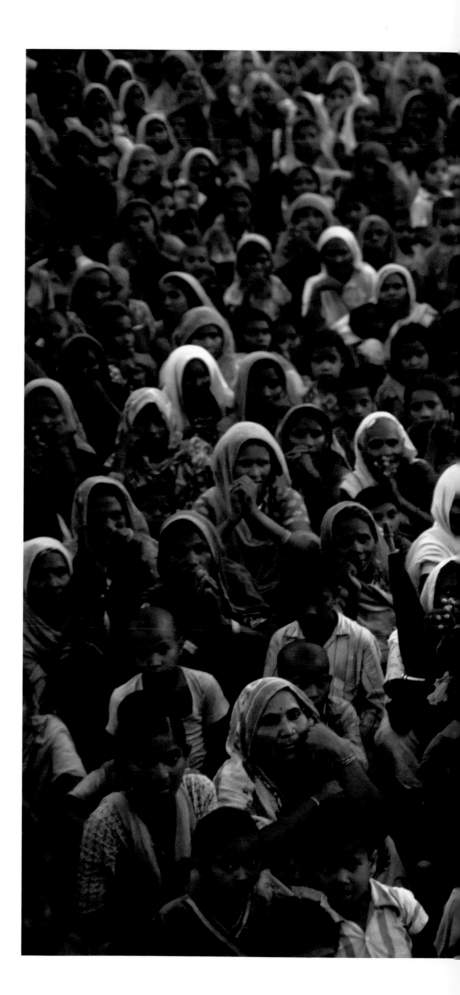

Indira Gandhi at a political rally, Uttar Pradesh, India, 1978

Right Crowd at an Indira Gandhi rally, Uttar Pradesh, India, 1978

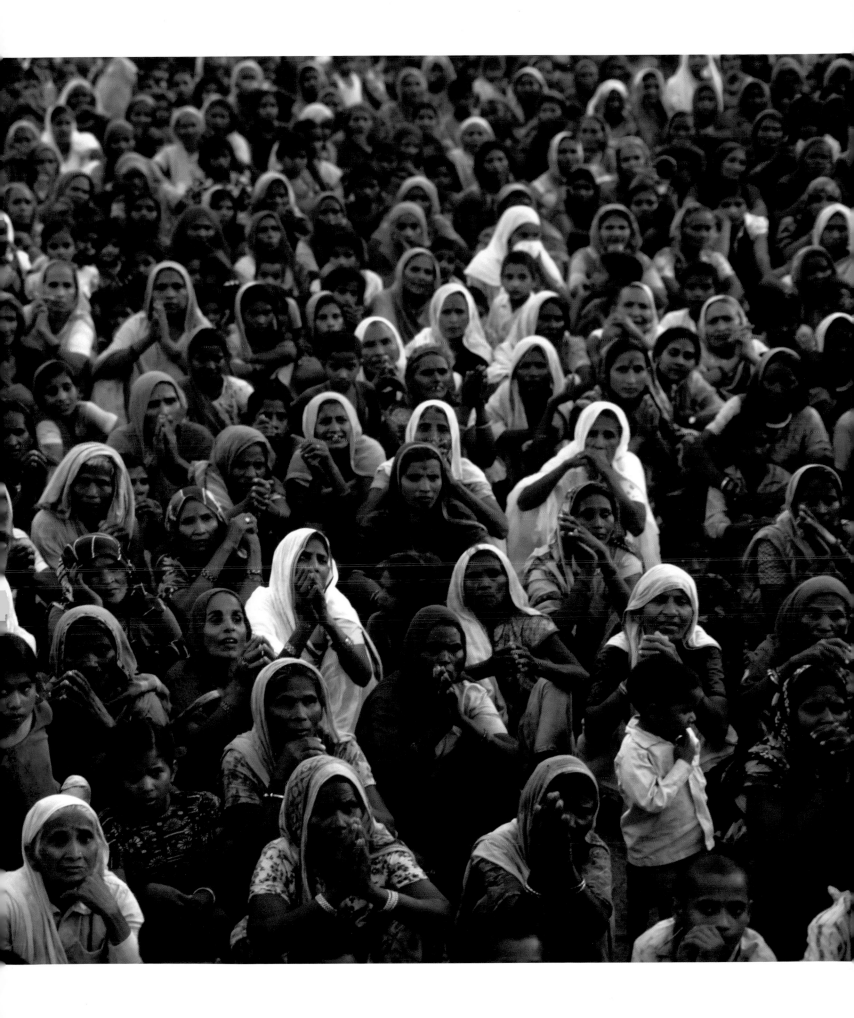

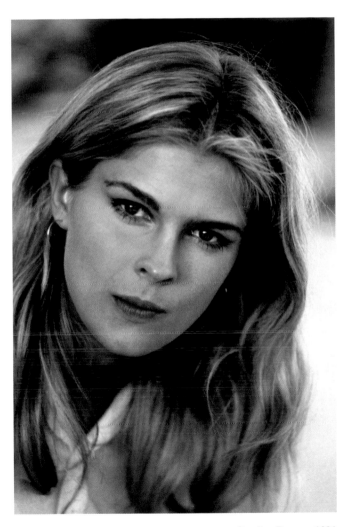

Candice Bergen, 1981

Vanessa Redgrave, London, 1985

Opposite John Huston, 1980

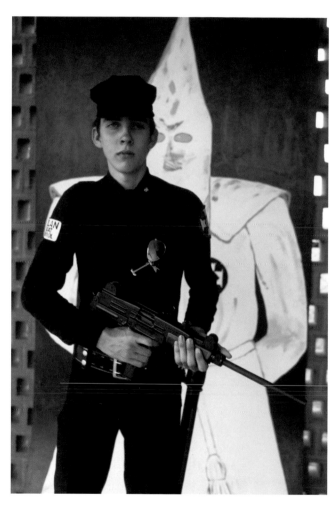

Klansman, Texas, 1984

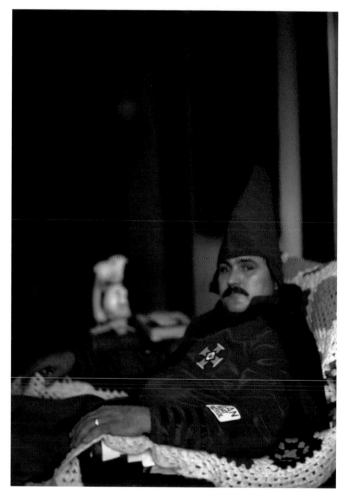

Imperial Wizard, Ku Klux Klan, Texas,1981

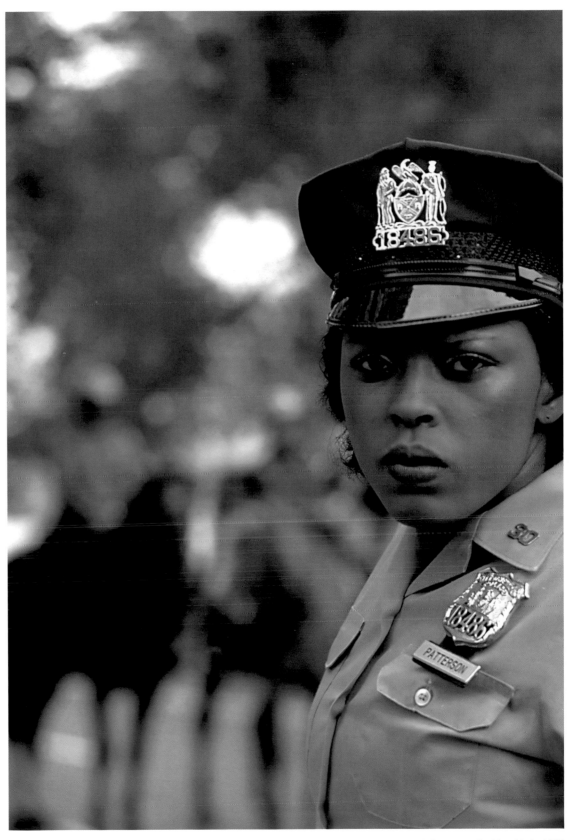

Anti-Reagan rally, New York, 1981

Following pages Prisoners, Sugarland, Texas, 1982

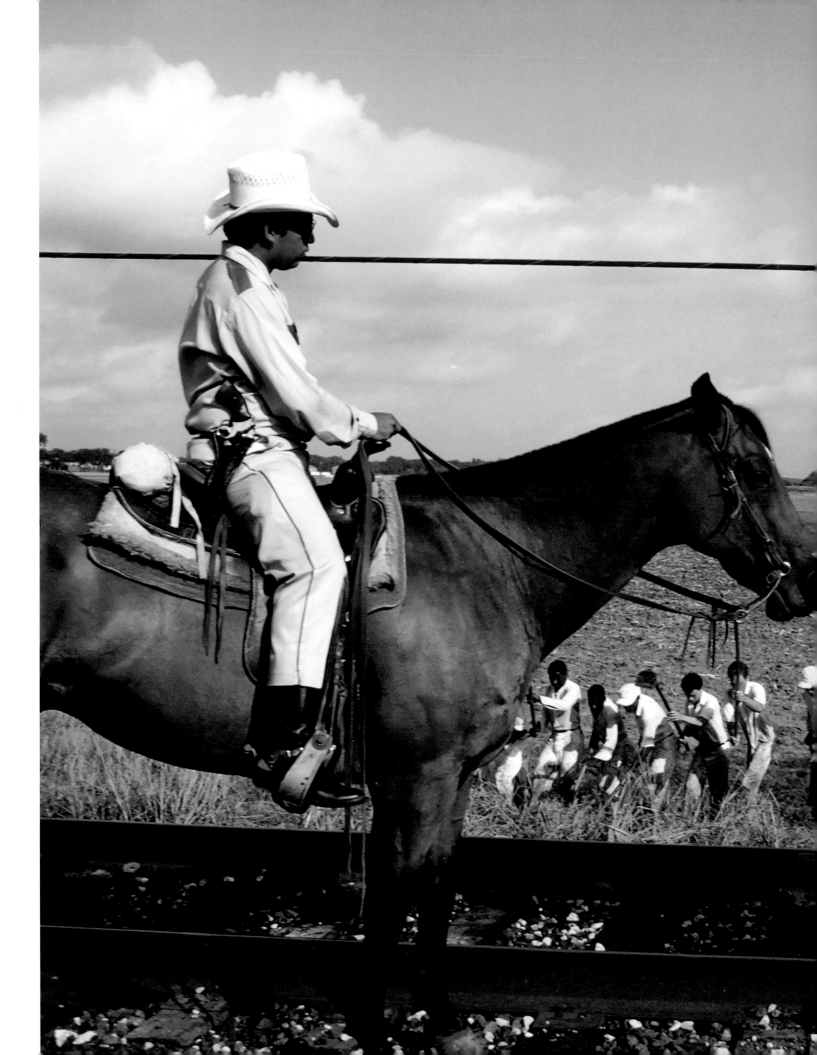

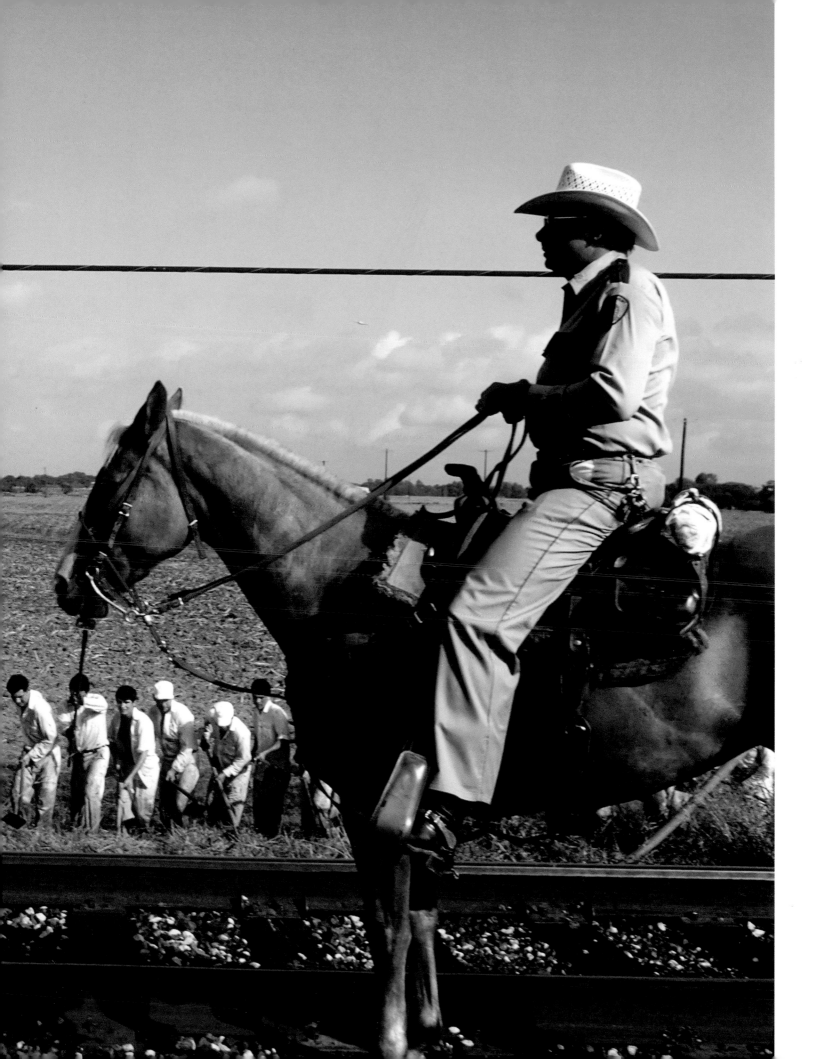

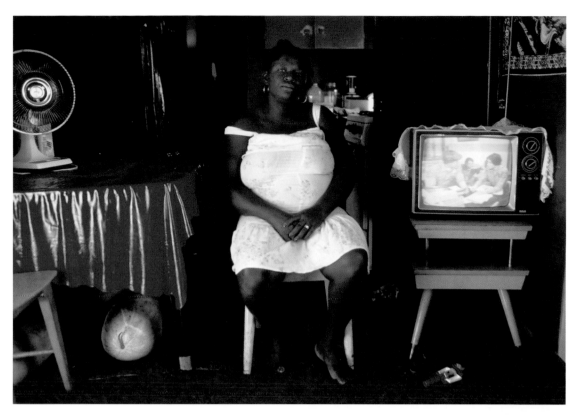

Haitian migrant, Florida, 1981

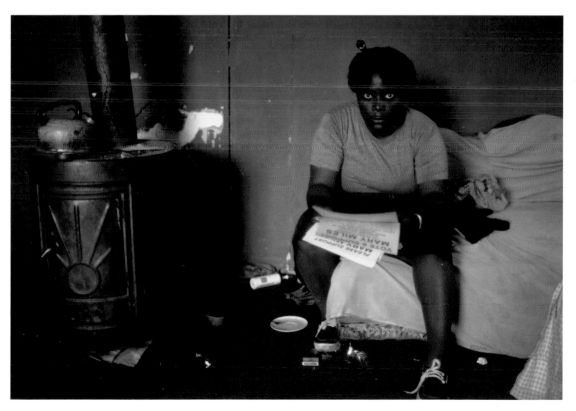

Housewife, South Carolina, 1981

Opposite Blacksmith at Coon Rapids, Iowa, 1981

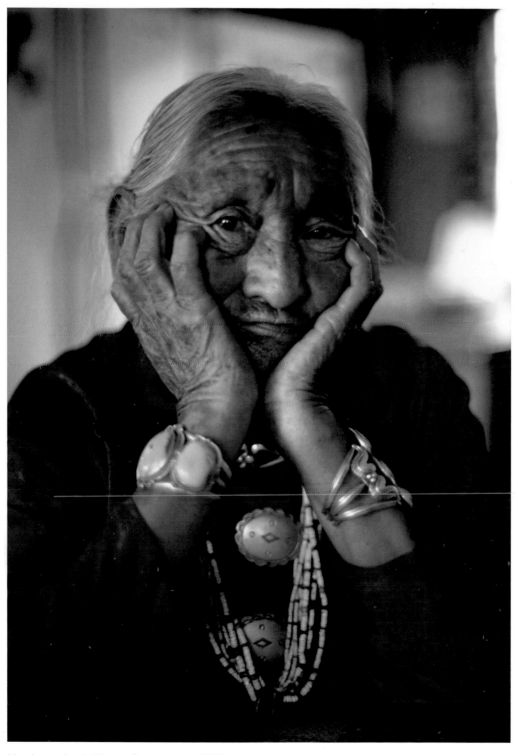

Navajo matriarch, Window Rock, Arizona, 1981

Opposite Motion Picture and Television Home and Hospital, Los Angeles, 1984

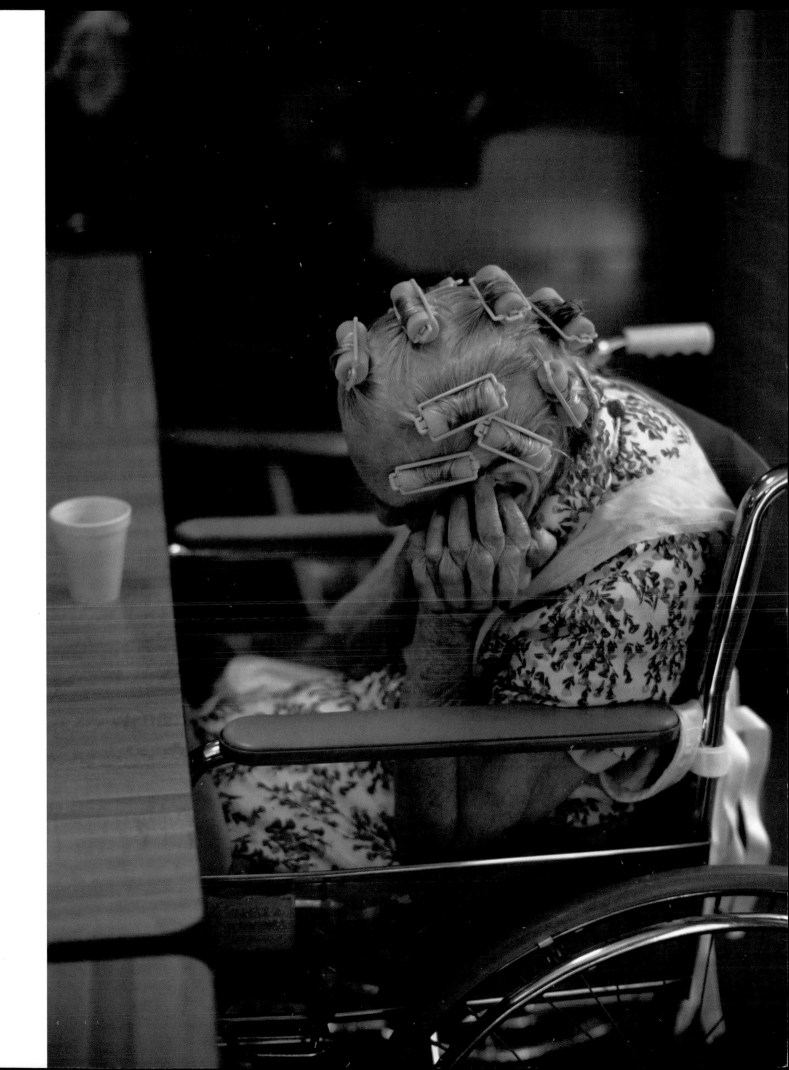

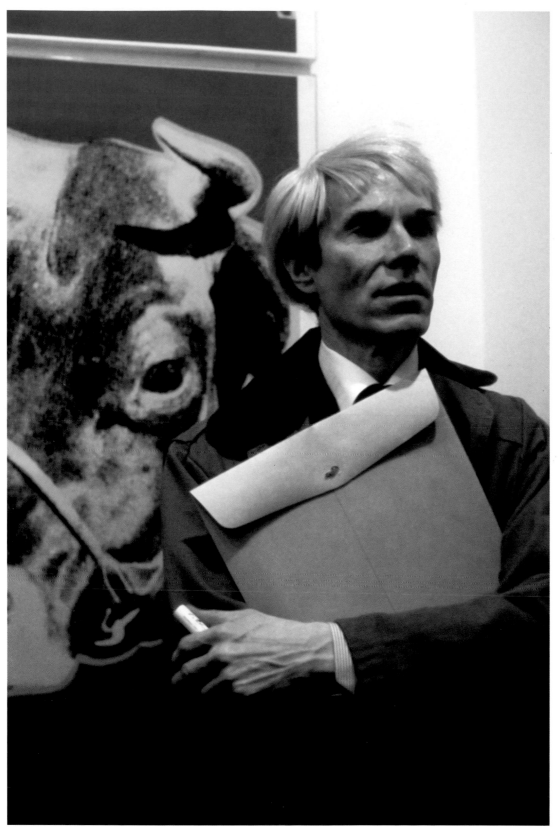

Andy Warhol at an exhibition opening of his work, New York, 1984

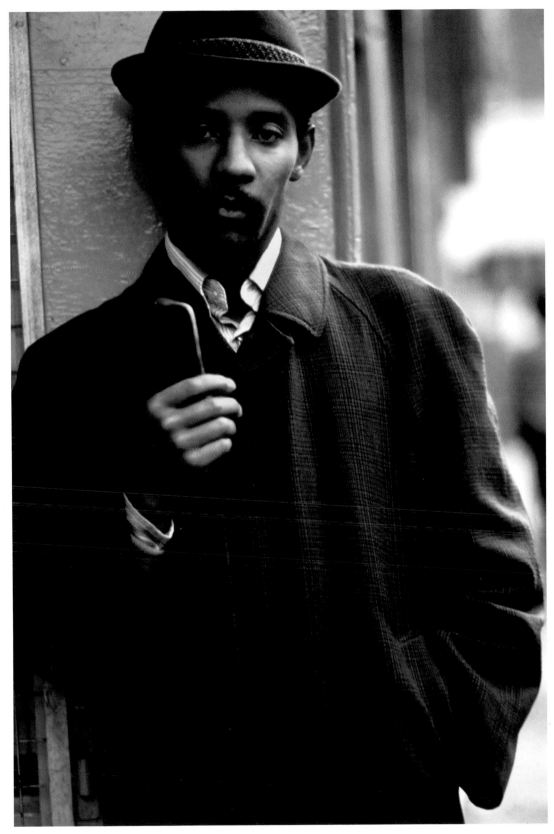

Linton Kwesi Johnson, poet, England, 1984

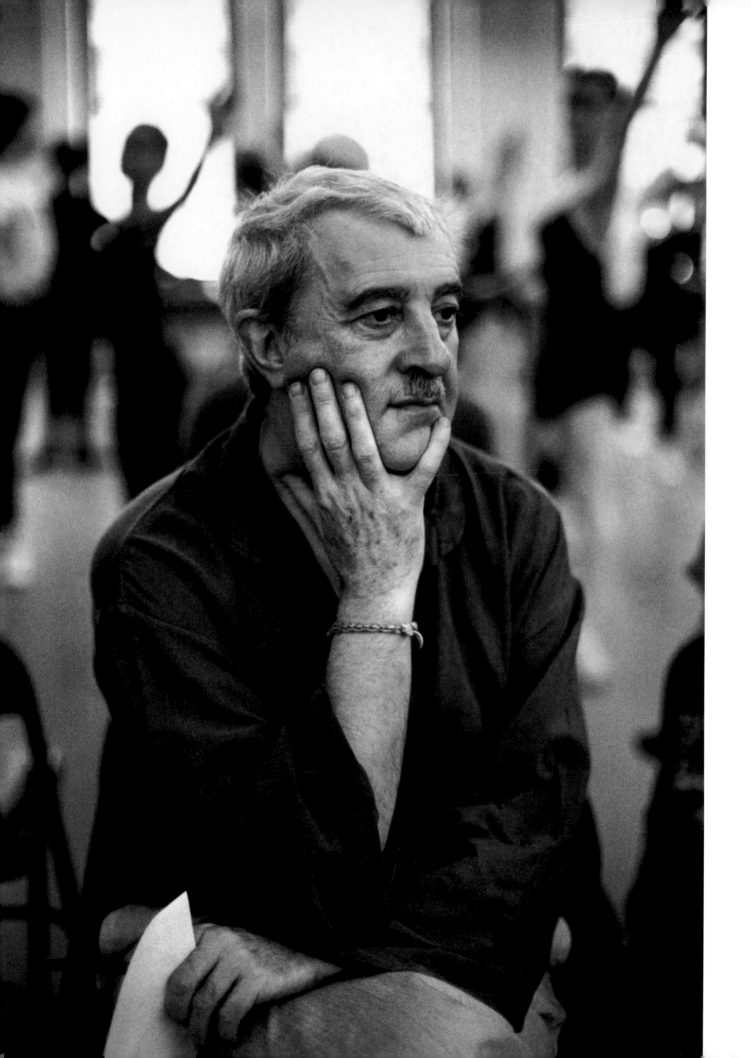

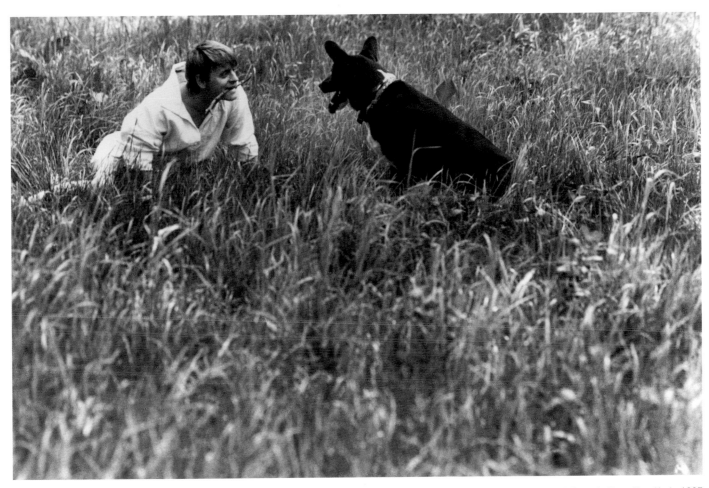

Mikhail Baryshnikov, New York, 1987

Opposite Sir Kenneth MacMillan at a warm-up session at the American Ballet
Theatre in New York before a performance of his version of *Swan Lake*, New York, 1987

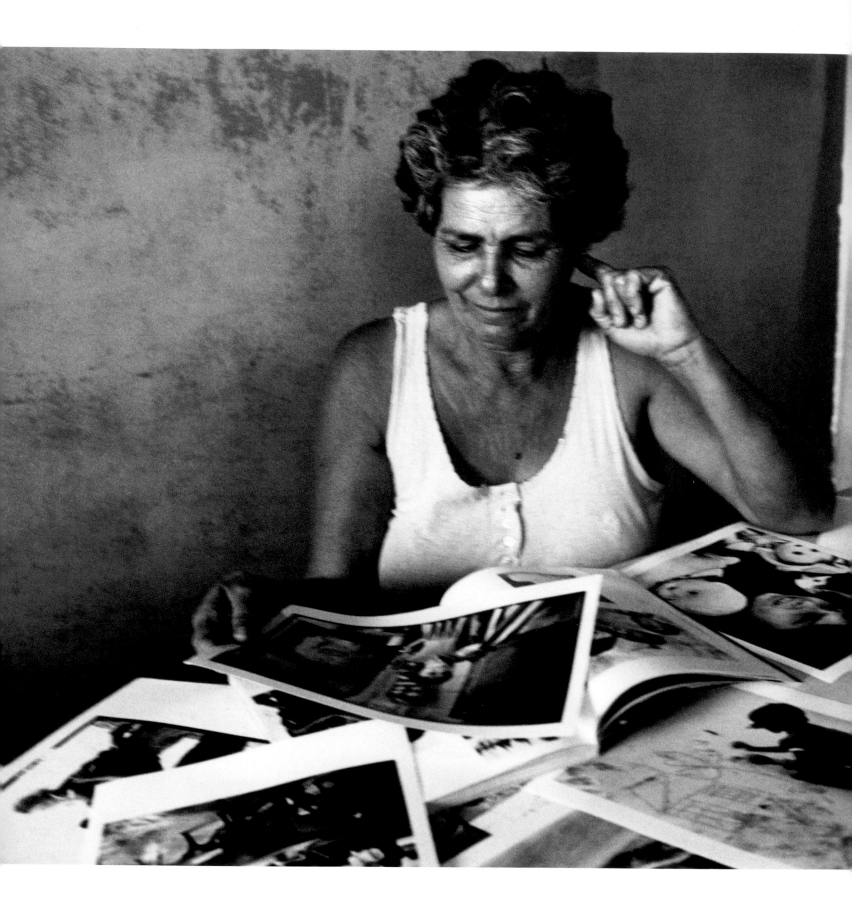

David Arnold, London, 1994

Left Island girl revisited. Juana Chambrot examines for the first time photos that Eve had taken of Juana and her family forty-three years earlier, Cayo Carenero, Cuba, 1997

Photo Stories

In Depth

In China, 1979

Retired woman, China, 1979

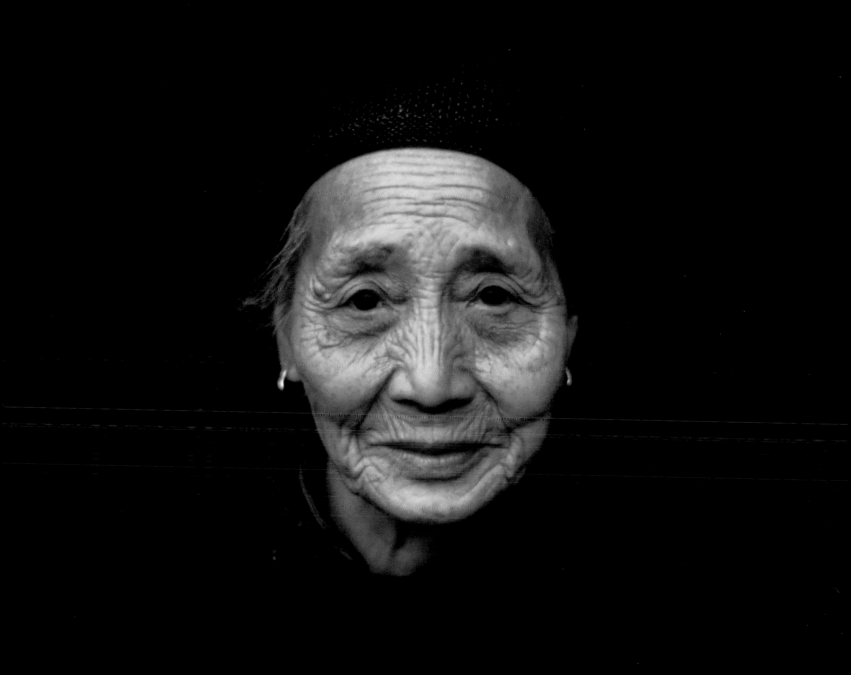

In China, 1979

To travel to China was, for Eve Arnold, a long-awaited assignment. Since the early 1960s, the *Sunday Times* had applied for a visa every year on Eve's behalf, but her request had been routinely rejected. However, her fascination with the country never waned, and she read voraciously anything she could lay her hands on. Then, in the late 1970s, Eve struck up a friendship with Sirin, a Thai girl who had been brought up by Chinese premier Zhou Enlai. After America and China established diplomatic relations in 1979, Sirin swiftly managed to get Eve that much wanted visa, valid for three months, then an unheard of duration. Michael Rand at the *Sunday Times* did not hesitate to arrange funding for her trip, and Robert Gottlieb, Eve's editor at Alfred A. Knopf in New York, immediately agreed to do a book.

Eve's visa allowed her to travel the length and breadth of the country, which was truly unprecedented for the time. Now aged 67, she took on an exhausting schedule set for her by the Chinese authorities, accompanied by an interpreter. Eve found the Chinese in a euphoric mood: they had been promised rapid industrialization, and by the year 2000, they were told, the country would lead the world. After a generation of imposed secrecy, the Chinese government was opening up to the outside world for the first time, and to an extent to its own people: economic incentives were to replace ideology.

As soon as Eve left the cities, large curious crowds would gather who had never seen a street photographer, or even a Western woman. But she overcame all sorts of difficulties and discomfort, and her first visa was followed by a second for a further three months. Looking back, Eve marvels at the audacity of the project: to achieve a commission on a country so large and so alien to her, with only six months to shoot. She chose to use colour film on these trips, rather than the monochrome still favoured by many of her Magnum colleagues. Her aim was to photograph the lives of people from every level of society: from high

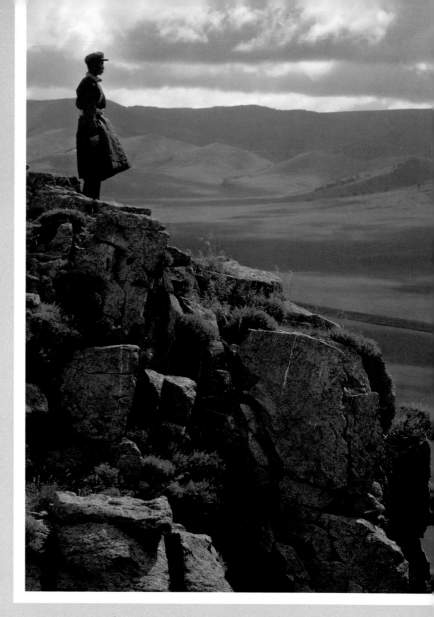

Above Cowboy, Inner Mongolian steppes, China, 1979

Opposite Buddhist monks studying sutras at Cold Mountain Temple, Suzhou, China, 1979

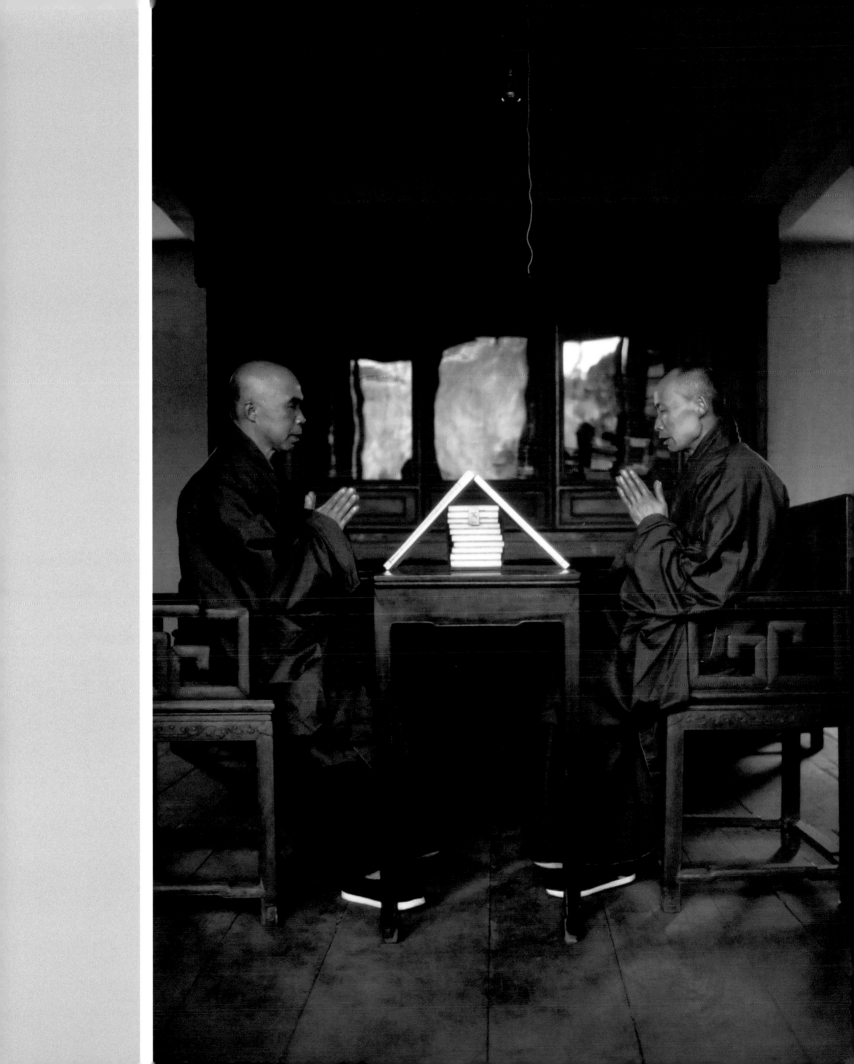

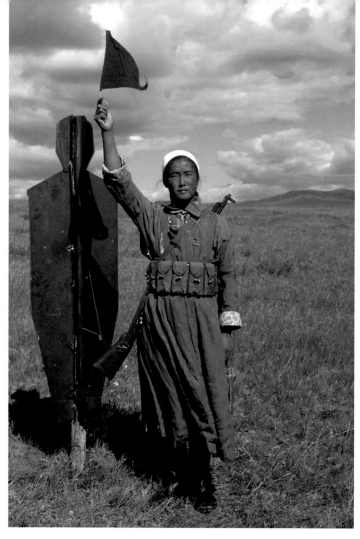

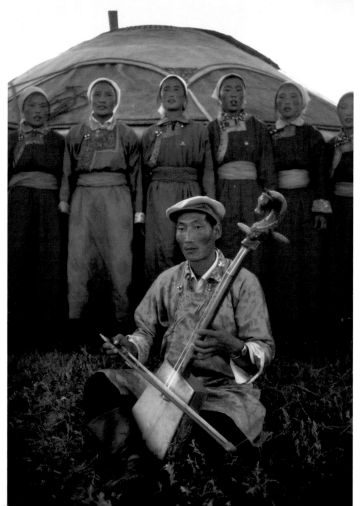

Above left Member of the militia, Inner Mongolia, China, 1979

Left Members of the Golden River White Horse Company
militia singing a folk song, China, 1979

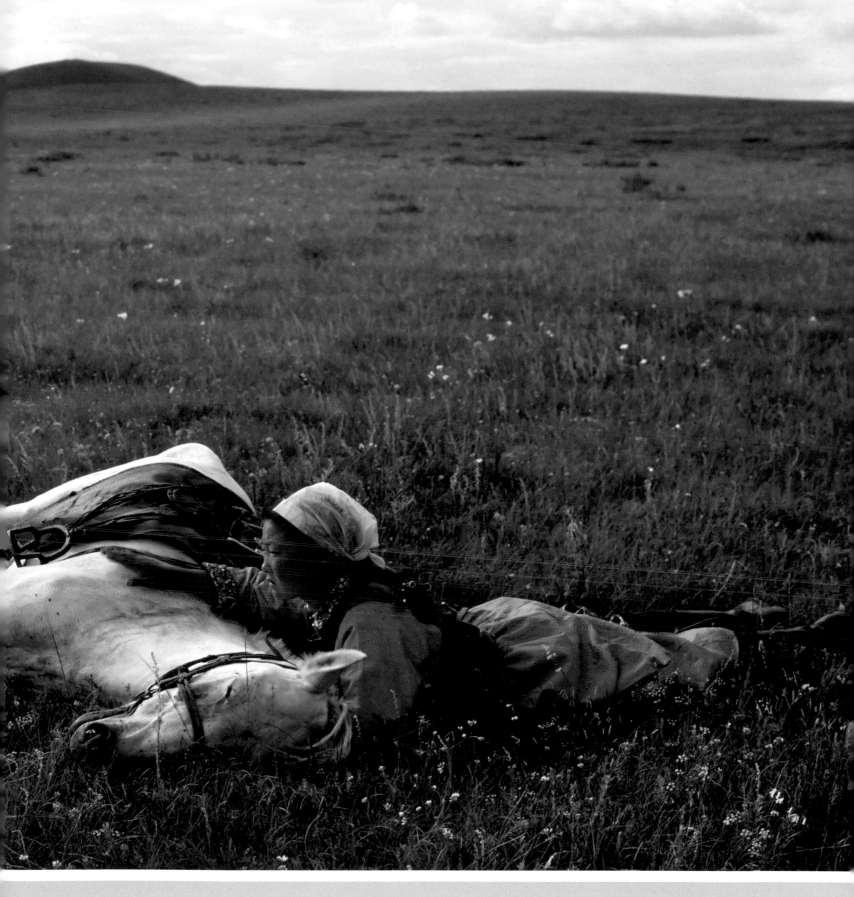

Above Horse training for the militia, Inner Mongolia, China, 1979

officials to manual workers, in urban and in rural areas, in every corner of the vast country.

Early on in the trip Eve developed bronchitis; she suffered high fevers that required heavy medication. One morning, weakened by her illness, as she ventured out for a short walk, she glimpsed an old woman in a doorway. Eve just had time to take one photograph before the face retreated into the shadows. The picture was a triumph, and was used as the award-winning cover image for the book.

The book sold out, and the touring exhibition was a noted success. Eve's arduous journeys along the Yangtze river, through the Gobi desert, from village to village and city to town across China, were richly rewarded. She had captured a vast nation on the brink of momentous change.

Art class, Chongqing, China, 1979

Opposite top left Democratic posters, Chongqing, China, 1979

Opposite top right Making noodles, China, 1979

Opposite bottom Making steamed bread, China, 1979

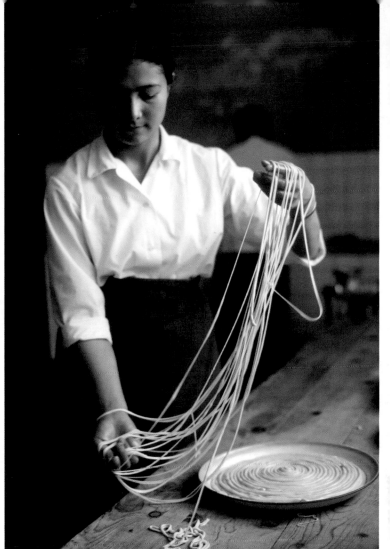

Opposite Tractor factory worker,
China, 1979

Top left Traditional doctor, China, 1979

Top right Accountant, China, 1979

Bottom left Mother and child,
China, 1979

Bottom right Permanent wave,
China, 1979

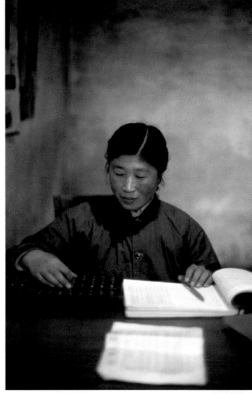

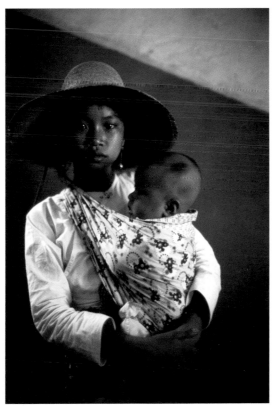

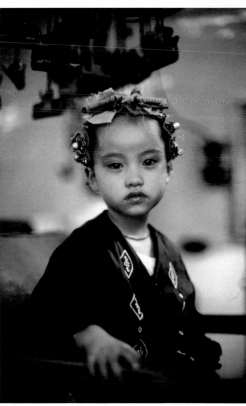

Following pages Cotton mill nursery,
Beijing, China, 1979

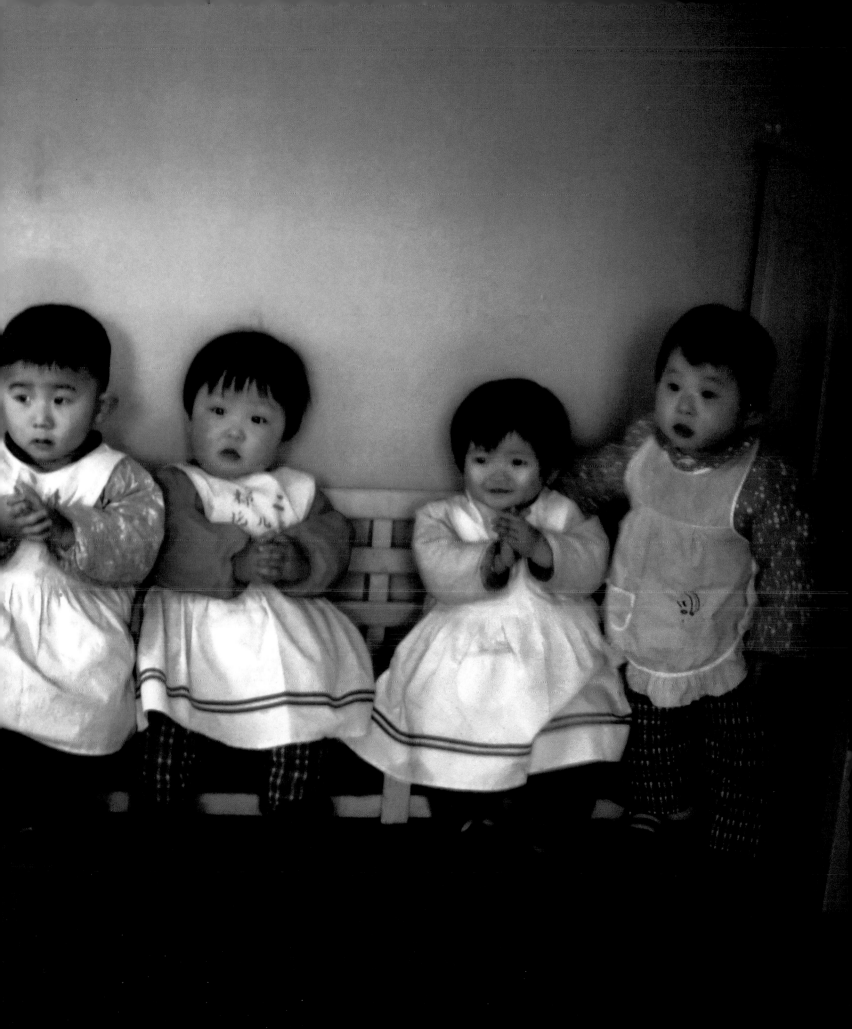

Photographic Assignments

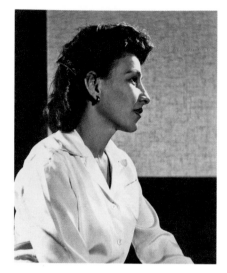

Eve Arnold, Stanbi Photos, Hoboken, New Jersey, c. 1946

Throughout her career Eve Arnold maintained a year-by-year list of her photography assignments. It is reproduced here as faithfully as possible, though capitalization of titles and descriptions, punctuation, and the order of elements in the 'Subject' column are sometimes minimally adjusted for clarity. Editorial insertions are enclosed in square brackets. Occasionally Arnold included work by others in the list: these instances are clearly identifiable.

Except where (in the case of advertising assignments) this is implicit, the client or commissioning agent is shown in parentheses at the end of the story title / description; italic forms in parentheses are the names of magazines and newspapers.

The number of rolls of film and the medium (colour or black and white) are given only when the original listing provides them.

Notes sequenced by lower-case letters are original: quotation marks indicate verbatim reproduction of Arnold's wording, which is given particularly in cases where the meaning is unclear. Unsequenced notes are editorial.

Eve Arnold's archives are now in the Beinecke Library of Yale University (acquired 2003).

Unnumbered Stories (1950s)

A Auctions
B [Baker] Josephine Baker Day
 Barber (colliers)
 Barmaid (includes Women's Christian Temperance Union)
 Baseball (Ladies' Day at the baseball game)
 [Bennett] Tony Bennett, recording session
 'Billy' Joins the Big Three (goat, army mascot)
 [Burrows] Abe Burrows
 Bowling, Port Jefferson
 [Bresson] Henri Cartier-Bresson
C Charney (Fortune)
 Child drawing; Child in Museum of Ind[ianapolis];
 Child drawing in the street
 Child models
 [Clemen] Dolores Clemen
 Connie's kids

 Country circus
D Donkey baseball
E East of Eden, Actors Studio [New York], charity benefit
 Emancipation Day
 Engels (personal assignment)
 Elizabethan Fashion
F Fashion in Harlem (see 50-4)
 Female medical student, Generation X (Magnum Photos assignment)
 Flower show
G Greenwich Village (see 50-3)
H [Hagan] Patricia Hagan
 Halloween
 Hubert's Museum, New York
K Kite flyers
L Lotte Lenya, recording session
M [Mathieu] Bea Mathieu (friend of EA)
 Metropolitan Opera (see 50-2)
 [Mitchell] Guy Mitchell and Mitch Miller, recording session
 Multiple sclerosis
N New York miscellaneous: At Night, In Spring, etc.
 Nuns and Children, recording sessions
P (personal assignment) Arnold
 Preacher, itinerant
R [Rosenberg] Anna Rosenberg
S [Saunders] Felicia Saunders, singer
 [Summer house] Looking for a summer house
 Summer, Fall, Winter
T [Thornburg] Max Thornburg
 Toronto
U Ukrainian Easter eggs
V [Verdon] Gwen Verdon, dancer
W Washington Post, 'Home' [section]
 West Point (and Hudson River)
 West Indies Day, Harlem

Story no.	Subject	No. of rolls, negative size, medium

1950

1950s	Emancipation Day Parade	8 × 120 and 35 mm
1950	Fashions in Harlem	
50-1	42nd Street	
50-2	Metropolitan Opera	14 × 120
50-3	Greenwich Village	

1951

51-1	Migrant Labor	32
51-2	Christmas Story	23
51-3	20th Century: José Ferrer and Gloria Swanson	11 × 120
51-4	Theatre session: International Group, UNESCO, Rockefeller Foundation	
51-5	Bride (Francis's babysitter), Miller Place	

1952

52-1	Republic Aircraft	13 × 120
52-2	Marlene Dietrich	15 × 120
52-3	Julie Harris	9 × 120
52-4	Christopher Isherwood and W. H. Auden	
52-5	Republican Convention	33 × 120

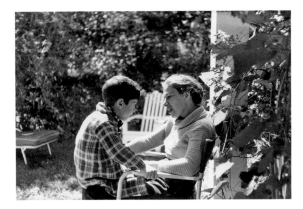

Eve Arnold and son Francis, Long Island, c. 1950

52-6	Charlotte's baby	1 × 35 mm, 3 × 120
52-7	Greenwich Village	
52-8	Vera Zorina	
52-9	TV Elections	23 × 120
52-10	Denver opportunity school	4
52-11	Mamie Eisenhower	cut up 120

1953

53-1	Housewife on wheels	
53-2	Hollywood plot	
53-3	*The Crucible*	97 × 120
53-4	Arthur Miller	4[a] × 120
53-6	Dean Pike	10 × 120
53-7	Royal tour, Jamaica	1 × 35 mm, 6 × 120
1953	Sunday School Teacher	
1953	Generation X, Medical student (Magnum Photos group project)	

No. 53-5 unassigned.
a Includes 1 roll taken at a lecture.

1954[a]

54-0	Son and friend selling lemonade	1 × 35 mm
54-1	Benson and Farm policy	1 × 35 mm, 12 × 120
54-2	Lilli Palmer	
54-3	Magda Gabor	
54-4	Haitian doctor	1 × 35 mm
54-5	Island girl, Cuba	3 × 35 mm, 2 × 120
54-6	Sexiest city in the world	2 × 35 mm, 39 × 120
54-7	Atlantic City	1 × 35 mm, 68 × 120
54-8	[Rosemary] Clooney and [José] Ferrer with [Marlene] Dietrich	
54-9	Hilda Sims	
54-10	Nuns, God's Children	26 + 2 strips × 35 mm, 5 × 120
54-11	[Senator Joe] McCarthy	
54-13	Insane Asylum, Haiti	

a 'is 54-12: How America Lives [?]'

1955

55-1	Teenagers, Port Jefferson High School	15 × 35 mm, 7 × 120
55-2	Marilyn Monroe	15 × 35 mm
55-3	Alistair Cooke	13 × 120
55-4	Susan Strasberg and Paul Newman, Actors Studio [New York]	3 × 35 mm, 4 × 120
55-5	Grand Union	

55-6	Female trombonist: Lillian Briggs at Brooklyn	11 × 35 mm
55-6a	Extra film on Lillian Briggs	6
55-7	James Cagney	
55-8	David Oistrakh	7 × 35 mm
55-9	Eileen Farrell	6
55-10	Picture of Eve Arnold by Cornell Capa	1 copy negative

1956

56-1	Rocky Marciano	11 × 35 mm
56-2	Marilyn Monroe with [Laurence] Olivier	5 × 35 mm
56-3	Gesell children	20 × 35 mm, 2 × 120
56-4	Rocky Marciano (*see also* 56-1)	
56-5	Voodoo, Haiti	3 × 35 mm, 21 × 120[a]
56-6	Louie Erwitt[b]	
56-7	Oral Roberts	38 × 35 mm, 3 × 120
56-8	Male model	19 × 35 mm
56-9	Lunts [Alfred Lunt and Lynne Fontanne]	10 × 35 mm
56-10	Sylvana Mangano	28 × 35 mm
56-11	Experiment I: Children's Hour	18 × 35 mm, 6 × 120
56-12	Jack Benny	6 × 35 mm, 1 × 120
56-13	Fashion (Grey Advertising)	
56-14	Book cover	
56-15	Mrs. Haskill	
56-16	Mr. Thornburg (see Unnumbered Stories] 1950s)	
56-17	Susan Kohner	14 × 35 mm, 1 × 120
56-18	Joan Crawford	15 × 35 mm, 3 × 120
56-19	Life of a sailor	13 × 35 mm
56-20	Teenagers[c]	
56-21	Arthur Godfrey	4 × 35 mm, 1 × 120
56-22	American Male	12 × 35 mm, 4 × 120

a Number of rolls of each type of film uncertain.
b Identification uncertain.
c Perhaps part of 55-1.

1957

57-1	Fashion (Grey Advertising)	
57-2	Fashion (Grey Advertising)	
57-3	Pregnant Women's Confab (independent production)	3 × 35 mm
57-4	Fashion Celebrities (Grey Advertising)	
57-5	Mike Wallace (*Esquire*)	5 × 35 mm
57-6	Polish Trade Delegation (*Fortune*)	1 × 35 mm
57-7	Simplicity Patterns (Grey Advertising)	
57-8	William Carlos Williams (*Coronet Magazine*)	25 rolls + 1 strip × 35 mm
57-9 to 57-17	Simplicity Patterns (Grey Advertising)	
57-18	American Cyanamid (American Cyanamid)	5 × 35 mm
57-19	El Al Mural (El Al Airlines)	6 × 35 mm
57-20	Mount Sinai (independent production; *see* 58-4)	
57-21	Boats and Bait: Little boy in a boat – Francis Arnold (independent production)	16 × 35 mm
57-22	Davis Family (independent production)	
57-23	Columbia University (*Pageant*)	23 × 35 mm
57-24	Simplicity Patterns (Grey Advertising)[a]	
57-25	Vera Zorina (Columbia Records)	
57-26	HCB [Henri Cartier-Bresson] Exhibition in San Francisco (independent production)	9
57-27	Burt Glinn (*Esquire*; independent production)	
57-28	Backyard Fence: 'Our Neighbourhood' Fire Dep[artmen]t (Standard Oil)	8 × 35 mm, 8 × 120

a Campaign includes fourteen different ad takes.

1958[a]

58-1	My People: Italian-Americans in Hoboken	58[b] × 35 mm
58-2	Gina Lollobrigida in New York	16 × 35 mm
58-3	School Bus (Standard Oil)	4 × 35 mm, 5 × 120
58-4	American Chronicle	
58-5	Museum Fire	2 × 35 mm
58-6	Cotton at Home: father and child	
58-7	Pfizer Birth	
58-8	Dupont Advertising Project	
58-9	Savings and Loan	
58-10	Dawn Norman's Legs	
58-11	Integration Story	34 × 35 mm
58-12	Securities and Exchange Commission	
58-13	Hanging Wash (Standard Oil)	4 × 35 mm, 6 × 120
58-14	Mary Martin	3 × 35 mm, 1 × 120
58-15	Houston Story	85 × 35 mm
58-16	Coca Cola	
58-17	Istel Club, New York (Schlumberger Investments)	
58-18	Born Yesterday (Life Insurance advertisement)	16 × 120
58-19	Three Portraits: Magriel, Tazzi and Price	
58-20	Simplicity Patterns[c]	
50003	'Billy' Joins the Big 3: Goat mascot of [sic] British regiment in Jamaica [see also Unnumbered Stories (1950s)]	
58-21	Francis [Arnold] in snow	3 × 35 mm

a 'Check with Columbia Records – Do they have Bruno Walter recording 1950s session?'
b Four strips from roll 56 missing.
c Labelled as 'Shapiro Grandchildren' on the negative pocket

1959

59-1	Platter Story	12 × 35 mm
59-2	Birth	28[a] × 35 mm, 1 × 120
59-3	Mennen advertisement	4 × 35 mm, 3 × 120
59-4	Art in Houston	14 × 35 mm
59-5	Auction: American Chronicle (continuation of 58-4)	11 × 35 mm
59-6	Marlene Dietrich at Museum of Modern Art	4 × 35 mm
59-7	General Electric	
59-8	Matchbook Toys	
59-9	The Aged	47 × 35 mm
59-10	World Petroleum Congress (Fortune)[b]	
59-11	Allan Roos	4 × 35 mm
59-12	Joan Crawford	142 × 35 mm
59-13	Back to Play, advertising (Eli Lilly)	3 × 35 mm, 14 × 120
59-14	Haya Harareit	6 × 35 mm
59-15	Mrs. Khrushchev Luncheon in New York	18 × 35 mm
59-16	CBS Covering Khrushchev's Visit to New York	9 × 35 mm
59-17	Good For Children Too, advertising (Eli Lilly)	5 × 35 mm
59-18	Eileen Farrell	
59-19	Redbook advertisement	
59-20	Vera Zorina	
59-21	Opening, Museum of Modern Art [New York]	9 × 35 mm
59-22	Mary Martin	28 × 35 mm
59-23	Kissing children, advertising (N. W. Ayer Co.)	6[c] × 35 mm
59-24	Maria Callas's Mother	3 × 35 mm
59-25	Pharmaceutical advertisements (Eli Lilly)	
59-26	Margaret Sullivan	1 × 35 mm
59-27	Middle-Aged Man Recuperating, advertising (Eli Lilly)	color
59-28	Trignani: Dr Kulke	
59-29	Jr. [Junior] Executives	20 × 35 mm

a '[Rolls] 4 and 6 incomplete, 4 × 5 neg missing.'
b 'Is it at Fortune?'
c '1 negative strip missing to N. W. Ayer.'

1960

60-1	Doane House in Eleuthra, Bahamas	14 × 35 mm
60-2	Monet Opening	8 × 35 mm
60-3	Life in Small Town, Bahamas	19 × 35 mm
60-4	1960 Candidates' Wives	23 × 35 mm
60-5	Mary Romig on Space Project, Convair	6 × 35 mm
60-6	Van der Mae, [at the] Space Technology Laboratory, Los Angeles (?)[a]	7 × 35 mm
60-7	Nan Glennan, [at the] Space Technology Laboratory, Los Angeles (?)[a]	6 × 35 mm
60-8	Irmgard Flugg-Lotz, Space Project, Stanford [University, Palo Alto, California]	5 × 35 mm
60-9	Helen Mann, Cape Canaveral	5 × 35 mm
60-9a	B. Finkelstein, Dayton, Ohio	6 × 35 mm
60-10	Opening, exhibition of paintings to be auctioned at Parke-Bernet Gallery [New York]	6 × 35 mm
60-11	Children's Ward in New York Hospital	38 × 35 mm
60-12	Non-Violence in Virginia[b]	48 × 35 mm
60-13	Iranian Princess Shahnaz	7 × 35 mm
60-14	Danish Ambassador to U.S. and Wife	5 × 35 mm
60-15	[John and Dominique] de Menil's Daughter's Wedding	11 × 35 mm
60-16	Myurgia perfume, advertising	19 × 35 mm
60-17	Speech Writers for [John F.] Kennedy and [Lyndon B.] Johnson	10 × 35 mm
60-18	Cheers, television commercial	
60-19	Shirley MacLaine	18 × 35 mm
60-20	Misfits	212 × 35 mm
60-21	Jim Goode[c]	7 × 35 mm

a Location uncertain.
b Also called 'Passive Resistance in Virginia'.
c Not included in the Magnum Photos, Paris, list.

1961

61-1	Adlai Stevenson at the U.N.	3 × 35 mm
61-2	Linda Emmet (Glamour)	
61-3	Harvey Schmidt (Playboy)	5 × 35 mm
61-4	[Erich] Lessing in Pilgrim Land	7 × 35 mm
61-5	[Erich] Lessing in Pumpkin Land	9 × 35 mm
61-6	Muslims	39[a] × 35 mm
61-6A	Black Muslims, U.S.A.	36 × 35 mm
61-7	Toy Testing	9 × 35 mm
61-8	Core Benefit	16 × 35 mm
61-9	Marilyn Monroe and [her hairdresser] Kenneth (Good Housekeeping)	3 × 35 mm
61-10	Danny Kaye at Tanglewood [Music Festival] (Show)	38[b] × 35 mm
61-11	African Nationalist Rally (Life)	6 × 35 mm
61-12	Harlem Miscellaneous: [Louis E.] Lomax	5 × 35 mm
61-13	Cancer Story	5 × 35 mm
61-16	Stravinski [Igor Stravinsky]	5 × 35 mm
61-17	Cheltenham Ladies' College (Sunday Times)	11 + 3 strips[c] × 35 mm
61-18	Wycombe Abbey Girls' School (Sunday Times)	10 × 35 mm, 4 color, 6 b/w
61-19	Heathfield Girls' School (Sunday Times)	26[d] × 35 mm
61-20	Cranborne Chase Girls' School (Sunday Times)	22 × 35 mm, 5 color, 17 b/w
61-21	Vicar Needing Funds (Queen)	25 × 35 mm
61-22	Widow Needing Companion (Queen)	20 × 35 mm
61-23	Dog Needing Owner (Queen)	13 × 35 mm
61-24	Girls Sharing Apartment (Queen)	19 × 35 mm

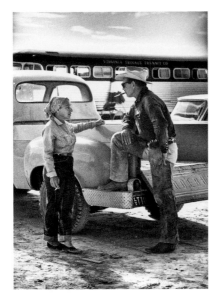

Eve Arnold and Clark Cable on the set of *The Misfits*, 1961

61-25	The Marquis of Bath at Longleat (*Queen*)	24ᵉ × 35 mm
61-26	Crockford's Club (*Free*)	2 × 35 mm
61-27	Joseph C. Harsche of NBC (McCann Erickson)	6 × 35 mm

Nos 61-14 and 61-15 unassigned.
Nos 61-17 to 61-27 headed 'LONDON STORIES'.
a Including one blank roll.
b 'No. 2, 3 and 40-39-23 blank.'
c The three strips are labelled 'E' on the negative pocket.
d 'Roll 108 [?], no strip 8.'
e 'No # 143.'

1962

62	Miscellaneous, Francis [Arnold]	2 × 35 mm
62-1	Pepsi Cola Exhibit (Shot by [Michelangelo] Durazzo)	2 × 35 mm
62-2	Love (*Show*)	
62-3	Marie-Hélène Arnaud (*Queen*)	9 × 35 mm
62-4	Marlene Dietrich	4 × 35 mm
62-5	Deaf Chinese Girl (*Saturday Evening Post*)	56ᵃ × 35 mm
62-6	Music Man, Mason City, Iowa (*Life*)	44
62-7	W. H. Paley (*TV Guide*)	
62-8	[Leonard] Goldenson and Moore (*TV Guide*)	
62-9	Dr Standon, CBS (*TV Guide*)	
62-10	[Robert] Kintner and [Robert] Sarnoff (*TV Guide*)	
62-11	Fun and Games (*Saturday Evening Post*)	27ᵇ × 35 mm
62-12	Monaco (CBS, Allan-Weber)	62ᶜ × 35 mm
62-13	Salvation Army	56 × 35 mm

62 EA often allocated the first story number of the year to a personal assignment, though the evidence of the list is that she did not always use it [see, for instance, 1971]. In this case (as also in 1970) she allocated the first number to another story and so gave no sequence number to her personal assignment for 1962.
a Including two blank rolls.
b Including one blank roll. Roll 14, 'no neg strip 32'.
c Two colour negatives amalgamated into one. ' No neg strip 7.'

1963

63-1	[Margot] Fonteyn and [Rudolf] Nureyev	7 × 35 mm, b/w
63-2	[Reginald] Maudling	4 × 35 mm
63-3	Church of England	82 × 35 mm, color
63-4ᵃ	Bedales	14

63-5	John Huston's son Danny, Bedales School (personal assignment)	22ᵇ × 35 mm
63-6	Music (*Sunday Times*)	104 × 35 mm
63-7	Roland wedding (personal assignment)	9 × 35 mm
63-8	Peter O'Toole, *Hamlet*	15 × 35 mm, b/w, color
63-9	*Becket* [produced by Hal] Wallis (Paramount Pictures)	102 rolls, b/w, 3 strips × 35 mm, color
63-10	Circus	1 × 35 mm, color
63-11	Mental Health (*Sunday Times*)	3 × 35 mm
63-12	Pumpkin Eater	46 × 35 mm, b/w
63-14	Passion Play, Malta, and John Huston (personal assignment)	8 × 35 mm

a Alternative story 63-4: 'Twist – The Roundhouse? [Location] New York, [No. of rolls] 3, [Negative size] 35 mm.'
b An additional 8 rolls of 35 mm film shot for John Huston.

1964

64-1	personal assignment	3 × 35 mm
64-2	John Bloom (*Sunday Times*)	20 × 35 mm
64-3	Sir Alec [Douglas] Home (*Sunday Times*)	14 × 35 mm
64-4	Women Keeping Fit (*Elle*)	14 × 35 mm
64-5	Color Whiskey advertisements (Reach–McClinton)	
64-6	The Living Theater	2 × 35 mm
64-7	[French] Lycée [London]	18 × 35 mm
64-8	Royal Societies (*Sunday Times*)	8 × 35 mm
64-9	Producers, USA (*Sunday Times*) [*see also* 64-17]	8 × 35 mm
64-10	New Statesmen (*Sunday Times*)	14 × 35 mm
64-11	Baseball Game (personal assignment)	1 × 35 mm
64-12	Royal Society of St George (*Sunday Times*)	4 × 35 mm
64-13	Royal Society, England (*Sunday Times*)	11 × 35 mm
64-14	Opening of Museum of Modern Art	8 × 35 mm
64-15	American Writing Scene (*Sunday Times*)	2 × 35 mm
64-16	Mrs. DeVita and Granddaughter (independent production)	1 × 35 mm
64-17	Producers, USA (*Sunday Times*) [*see also* 64-9]	33 × 35 mm
64-18	Teenagers in Washington (*Elle*)	
64-19	Mrs. Price (*Seventeen*)	4 × 35 mm
64-20	Fringe Religions, USA (*Sunday Times*)	34 × 35 mm
64-21	[Senator Barry] Goldwater (*Sunday Times*)	24 × 35 mm
64-22	Republican Convention	9 × 35 mm
64-23	Ritchel House in Carmel [California] (independent production)	9 × 35 mm
64-24	Alan Bates (*Vogue*)	4 × 35 mm
64-25	Robert Kennedy (Magnum X)	3 × 35 mm
64-26	Kingman Brewster of Yale (*Newsweek*)	
64-27	Negro Aristocracy (*Sunday Times*)	55 × 35 mm
64-28	Marion Spottiswoode (independent production)	
64-29	Dr. Leonard Kammer (Medical Issues)	4 × 35 mm
64-30	Auerbach, Pollak & Richardson [investment company] (Auerbach, Pollak & Richardson)	9 × 35 mm
64-31	Barbra Streisand and Curtis Taylor (*Seventeen*)	4 × 35 mm
64-32	Youth: Henry Jones (*Holiday*)	
64-33	Youth: Deimer True (*Holiday*)	
64-34	Andy Warhol (independent production)	13 × 35 mm

1965

65-1	BBC Woman's Hour (*Sunday Times*)	10 × 35 mm
65-2	Noah's Ark: John Huston in Rome (*Sunday Times*)	22 × 35 mm b/w
65-3	Women Without Men (*Sunday Times*)	41 × 35 mm
65-4	Russian Emigrés (*Sunday Times*)	3 × 35 mm

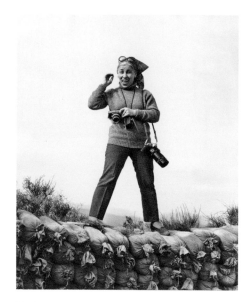

Eve Arnold on the set of *Patton*, 1969

65-5	Woodrow Wyatt (*Sunday Times*)	14 × 35 mm
65-6	Minou Drouet (*Sunday Times*)	3 × 35 mm
65-7	Duke of Norfolk (*Sunday Times*)	3 × 35 mm
65-8	Indian Immigrant (*Sunday Times*)	8 × 35 mm
65-9	*Life at the Top* (Columbia [Pictures])	52 × b/w
65-10	*Flight of the Phoenix*, Arizona (20th Century Fox)	25 × b/w
65-11	Slimming Story, Paris (*Sunday Times*)	7 × 35 mm
65-12	Modesty Blaise, Sicily	53 × b/w
65-13	Edward Heath	41 × 35 mm
65-17	[Mildred and Sam] Jaffe's grandchildren, UK (personal assignment)	6 × 35 mm
65-18	Russian Old Men, USSR	19 × 35 mm
65-19	Harold Lawrence, London (personal assignment)	2 × 35 mm
65-20	Wendy and Benn (personal assignment)	1 × 35 mm

Nos 65-14, 65-15 and 65-16 unassigned.

1966

66-1	Spanish Aristocracy (*Sunday Times*)	49 × 35 mm
66-2	*The Deadly Affair* (Columbia Pictures)	41 × 35 mm, b/w, color
66-3	The Bridegroom (*Sunday Times*)	1 × 35 mm
66-4	Vanessa Redgrave (*Sunday Times*)	18 × 35 mm
66-5	Simone Signoret (*Look*)	13 × 35 mm
66-6	Charles Chaplin (*Newsweek*)	2 × 35 mm
66-7	*Countess from Hong Kong*, Marlon Brando and Sophia Loren (film: independent production)	35 mm, color + 1 strip color conversion (Brando)
66-8	Marcia Panama (independent production)	4 × 35 mm
66-9	[A] Man for All Seasons, Orson Welles (Columbia [Pictures])	18 × 35 mm, b/w
66-10	Vanessa Redgrave and [Michelangelo] Antonioni (independent production)	1 × 35 mm
66-11	Anatomy of a Debutante (*Sunday Times*)	18 × 35 mm
66-12	Norman Parkinson (Fashion) (*Sunday Times*)	7 × 35 mm
66-13	Snob Club	2 × 35 mm
66-14	[A] Man for All Seasons, Vanessa Redgrave [(Columbia Pictures)]	6 × 35 mm, b/w
66-15	Prince Philip [Duke of Edinburgh] Interview (*Sunday Times*)	4 × 35 mm
66-16	Society Photographer (*Sunday Times*)	3 × 35 mm
66-17	Sports Photographer (*Sunday Times*)	6 × 35 mm

66-18	Small Town Photographers (*Sunday Times*)	3 × 35 mm
66-19	UK Beach Photographers (*Sunday Times*)	3 × 35 mm
66-21	*Dr Doolittle*, Samantha Eggar (film)	11 × b/w, color
66-22	Circus School, Moscow (*Sunday Times*)	7 × 35 mm
66-23	Secretary, Moscow (*Sunday Times*)	10 × 35 mm
66-24	Soviet Sunday, Moscow (*Sunday Times*)	10 × 35 mm
66-25	Pet Market, Moscow (*Sunday Times*)	2 × 35 mm
66-26	Tolstoy, Oldest Living Grandson in Moscow	5 × 35 mm
66-27	Ivan Ivanovitch Gets His Car	2 × 35 mm
66-28	Fashion, with Zeitsov	4 × 35 mm
66-29	Juvenile Delinquency Labor Colony	7 × 35 mm
66-30	Soviet Psychiatry: Mental Hospital, Moscow	5 × 35 mm
66-31	New Ripple [Moscow], advertising	4 × 35 mm
66-32	Dancing School (social [dancing])	4 × 35 mm
66-33	Monastery Church, Zagorsk	11 × 35 mm
66-34	Jazz, New Ripple, Moscow	2 × 35 mm
66-35	Movie Star	8 × 35 mm
66-36	Sports Academy	4 × 35 mm
66-37	Avant Garde Theater, New Ripple, Moscow	9 × 35 mm
66-38	The Courts: Divorce, Larceny, Moscow	9 × 35 mm
66-39	Ernst Neizvestny, sculptor	1 × 35 mm
66-40	Beer Automat	2 × 35 mm
66-41	Clinical death	3 × 35 mm
66-42	Shopping in G.U.M.	2 × 35 mm
66-43	George Kastaki, art collector	2 × 35 mm
66-44	Russian Village, in the Kuban	38 × 35 mm
66-45	Ikon Restoration	3 × 35 mm
66-46	P[arent] T[eachers'] A[ssociation] Meeting (Kropotkin)	1 × 35 mm
66-47	Krasnodar	1 × 35 mm
66-48	State Farm in the Kuban	5 × 35 mm
66-49	Ballet School	color
66-50	Tolstoy's Grandson in the Country	color
66-51	Sochi, beach	color
66-53	*Our Mother's House* [film]	47 × b/w, color

Nos 66-20 and 66-52 unassigned.
Nos 66-22 to 66-51 headed 'RUSSIA'.

1967

67-1	Therapeutic Community, Dingleton Hospital, Melrose	17 × 35 mm
67-2	Other People's Children	1[a] × 35 mm
67-3	Alcoholics	1 × 35 mm
67-4	Vatican	86 × 35 mm
67-5	*Salt and Pepper*, film	
67-6	*The Magus*, film	19[b] × b/w, color
67-7	Anthony Quinn Sings	2 × 35 mm
67-8	Lady Carr	3 × 35 mm
67-9	U.S. Marines Training	

a Negatives missing.
b 'in August '89 only 1 roll B&W and <u>some</u> color – not A+.'

1968

68-1	Moroccan Jews in Paris	3 × 35 mm
68-2	London Demo	b/w
68-3	Anjelica Huston in Ireland	color
68-4	Lord Harlech	6 × 35 mm
68-5	Motherhood	12 × 35 mm
68-6	The Queen	
68-7	Anjelica and her Father in Ireland	10 × 35 mm
68-8	Anjelica and her Mother in London	

68-9	Anjelica Huston in the film *A Walk With Love and Death*, made in Austria	23 × 35 mm, b/w
68-10	[Anouk Aimée in the film] *Justine* [made in] Tunisia	b/w, color
68-11	Drop City: Hippie Commune (*Sunday Times*)	b/w, color
68-12	Black is Beautiful (*Sunday Times*)	35ᵃ × 35 mm, b/w, color
68-13	Puerto Rico and the Pill (*Sunday Times*)	6 × 35 mm, b/w, color
68-14	Sheep in churchyard (personal assignment)	
a	'Rolls 9–12 are James Brown.'	

1969

69-1	Marcia Panama (personal assignment)	3 × 35 mm
69-2	[Filming of] *Patton* in Spain	16 × 35 mm, b/w, color
69-3	*Anne of 1000 Days* [film]	21 × 35 mm, b/w, color
69-4	Godfrey Smith (personal assignment)	
69-5	Joan Crawford	1 × 35 mm, b/w, color
69-6	The Cure, Montecatini	3 × 35 mm
69-7	Afghanistan	20 × 35 mm, [b/w]
69-7C	Afghanistan, color conversion [of 69-7]	color
69-8	Toni Hair, advertising	
69-9	Pretty Polly, advertising	
69-10	Pretty Polly, advertising	
69-11	Wedding of Safia Tarzi (personal assignment)	

1970

70-0	Madeleine and Matthew (independent production)	2 × 35 mm
70-1	Egypt: Behind the Veil (*Sunday Times*)	b/w, color
70-2	Trucial States: Behind the Veil (*Sunday Times*)	b/w, color
70-3	Advertisement (Gold Advertising)	color
70-4	Toni Hair Oil, advertising	b/w
70-5	Buckminster Fuller	color
70-6	Sobranie International, advertising	color
70-7	Trees (calendar), advertising	1ᵃ × b/w
70-8	Fathers and Daughters: John Betjeman and [Candida] Lycett Green	color
70-9	Ann[e] Heywood [on the set of the] film *I Want What I Want*	color
70-10	Baby Food: Infant Breast Feeding (Heinz)	color
70-11	Northern Ireland, advertising	color
70-12	André Previn and Mia Farrow [with their] Twins	21 × 35 mm, color
70-13	Sobranie Cigarettes, advertising	color
70-20	Spiro Agnew	b/w
70-22	Kyung Wha Chung	2 × 35 mm, b/w, color
70-23	National Guard	3ᵇ × 35 mm, color
70-24	Young Lords	1 × 35 mm, color
	Nos 70-14 to 70-19 and 70-21 unassigned.	
a	Some negatives missing.	
b	One roll missing.	

1971

71-1	personal assignment	
71-2	Charnos Tights, advertising	5 × 35 mm, color
71-3	Lord Longford	color
71-4	Cambridge Demonstration	b/w, color
71-5	Telephone advertisements (Post Office)	13 × 35 mm, b/w
71-6	Wedding in Dubai	color
71-7	Queen Elizabeth, Investiture	color
71-8	*Behind the Veil*, Dubai [EA's own film]	color
71-9a	Yeast-Vite, advertising	7 × 35 mm, b/w
71-9b	Yeast-Vite, advertising	9 × 35 mm, color
71-10	Frantic Housewife (*Sunday Times*)	23 × 35 mm, b/w
71-11	Northern Ireland: Ballycastle, advertising	color
71-12	Northern Ireland: Newry Golf Course and Paddy's Bar, advertising	color
71-13a	Yeast-Vite, advertising	9 × 35 mm, b/w
71-13b	Yeast-Vite, advertising	9 × 35 mm

1972

72-1	personal assignment	
72-2	Manhood: Newcastle Shipyard (*Sunday Times*)	color
72-3	Royal Veterinary College (*Sunday Times*)	color
72-4	*Julia*, German magazine, advertising (Ruhle & Partners, Hamburg)	color
72-5	Lucozade, advertising (Leo Burnett LPE)	color
72-6	J. Paul Getty	b/w
72-7	Pretty Polly Tights, advertising	color
72-8	Yeast-Vite, advertising	b/w
72-9	François-Marie Banier, Writer	color
72-10	Kissing, advertising (Mary Quant)	color
72-11	Victorian Girl, advertising (Sharwoods)	sepia
72-12	Polo Club, advertising (Sharwoods)	sepia
72-13	Dining Room, advertising (Sharwoods)	sepia
72-14	John Schlesinger	color
72-15	Lady Spencer Churchill	color
72-16	Victorian Rose Garden, advertising (Sharwoods)	sepia
72-17	Indian Grocery Store, advertising (Sharwoods)	sepia
72-18	Madras Curry Powder, advertising (Sharwoods)	sepia
72-19	Birth of baby: Lola [personal assignment]	color
72-20	Olympics	6 × 35 mm, color
72-21	Stress	16 × 35 mm, b/w, color
72-22	Gnotobiotics	color
72-23	Union Commerce Bank	
72-24	Sir Compton Mackenzie	

1973

73-1	personal assignment	
73-2	South Africa	14 × 35 mm, b/w, color
73-3	Scottish Widow, advertising	color
73-4	Child Poet	color
73-5	Beer poster, advertising (Amstel)	color
73-6	Picasso Heirs	color

1974

74-1	personal assignment	
74-2	[André] Malraux (*Sunday Times*)	
74-3	The Social Services: Postman, Busman (Magnum Photos, New York)	8
74-4	Harmony Hair Color, advertising	
74-5	Tom Driberg	
74-6	Advocaat Liqueur, three advertisements	
74-7	Galya, Russian Model (*Sunday Times*)	
74-8	Cigarette Campaign, Switzerland, advertising (Philip Morris)	
74-9	Irish Tourist Board: Killarney, Glencar, the Aran Islands, advertising	

1975

75-1	Barney Wan (personal assignment)	
75-2	*The Man Who Would Be King*, John Huston film, shot in Morocco (independent production)	color [29 rolls Koda[chrome], 5 rolls Ekta[chrome]]
75-3	First Love: McGibbon (*Sunday Times*)	5 × color [Koda[chrome]]

75-4	André Previn, advertising (Menzies newsagent / McCallum Advertising Agency, Edinburgh)	b/w (4 rolls TRI-X), color (4 rolls Koda[chrome])
75-5	Egg Cozy: Bols Advocaat, advertising (Fletcher, Shelton)	11 × color
75-6	Arthritic Patient, advertising (Norman, Craig & Cummel)	13 × b/w, color
75-7	Flint Cigarettes, advertising, shot in Zurich (Philip Morris)	90 × color
75-8	The Golden Road to Samarkand (Sunday Times)	62 × color
75-9	State Express Cigarettes, advertising	18 × color

1976

76-1	April 12th – pictures of [the] Jaffes, to celebrate Sam [Jaffe's] 80th birthday (personal assignment)	4 × b/w
76-2	Mexico (independent production)	4 × color
76-3	Mrs. Mary Wilson, PM's [British prime minister's] wife (Sunday Times)	4 × b/w, color
76-4	Eric Heffer and wife (Sunday Times)	5 × color
76-5	Medical advertisement (Ambrose & Co.)	13 × color
76-6	State Express Cigarettes, advertising	19 × color
76-7[a]	Beachy Head / Go-Go dancers: tests done on Olympus camera to show its unique properties, advertising assignment (Collet, Dickinson & Pearce)	13 × b/w, 2 × color
76-8	The Unretouched Woman, BBC film (25 minutes) on EA, for which she photographed: Old Ladies' Recreation Centre Cricket Match Michael Caine's wife, Shakira	19 × color; 5 × color
76-9	Air India, advertising (Life)	7 × color
76-10	4th July Bicentennial, Philadelphia (Life)	2 × b/w, color
76-11	Democratic Convention, New York (independent production)	5 × b/w
76-12	Harold Pinter (Newsweek)	1 × b/w, 5 × color
76-13	Mother and Daughter, Mother and Son, advertising assignment (Belgian client)	11 × b/w
76-14	Avon Lady, advertising	15 × color

76-8 EA was filmed at work, a sequence for which she took the photographs listed.
a 'Pro-Abortion [for test for above] Rolls 1–5.'

1977

77-1	Personal assignment: Jan. 6th – Lizzy Gottlieb's 6th birthday, New York Nov. 27th – Michael James Arnold [EA's grandson], born Nov. 26th Dec. 22nd – Michael James Arnold	b/w 1 × b/w 4 × b/w
77-2	Inaugural, President Carter, Washington D.C. (independent production)	
77-3	PG Tips, advertising	9 × color
77-4	Complan: two sets of old people, advertising	11 × b/w
77-5	Complan: family shot, advertising	10 × b/w
77-6	Carmen Nail Kit, advertising	12 × color
77-7	Men's clothes, advertising (German client)	12 × b/w
77-8	Brent Cross Shopping Centre, Hendon [London](Sunday Times)	11 × b/w, 22 × color
77-9	Lacrosse, Netball, Fencing, Dance and Archery, shot at Wycombe Abbey [Girls' School] and Merton Lacrosse Tournament (Women's Sport)	2 × b/w, 36 × color
77-10	Hands: David Rappaport, dwarf actor (The Observer)	6 × b/w
77-11	[Queen's Silver] Jubilee Block [Street] Party (Sunday Times)	12 × b/w, color
77-12	Jubilee Band of Horseguards, Horseguards' Parade; Country Party, Long Crendon [Buckinghamshire](Sunday Times)	26 × color
77-13	Anti-Jubilee Story, shot in Slough [Berkshire] (Sunday Times)	3 × b/w
77-14	Jubilee: Day of Jubilee[a] (Sunday Times)	2 × b/w, 9 × color

	Jubilee: River Pageant (Sunday Times)	2 × b/w, 13 × color
77-15	Yves S[ain]t Laurent (French Vogue)	b/w
77-16	Paris Collections, with Joseph Losey directing (French Vogue: fashion 43 pages, beauty 3 pages)	113 × b/w, color
77-17	Margaret Thatcher: Orkneys (Sunday Times)	10 × b/w, 2 × color
	Margaret Thatcher: Blackpool (Sunday Times)	5 × b/w, 11 × color
	Daycare Centre, Northcote Road, Putney [London], and Brent Cross [Hendon, London] (Sunday Times)	7 × color
77-18	Sam Cummings, Interarms Salesman, Monte Carlo (Esquire)	1 × b/w, 12 × color
	Sam Cummings, at The Arsenal, Manchester (Esquire)	3 × b/w, 11 × color
77-19	Dorma Sheets, advertising: Lovers Child Old People Old People reshoot	11 × color 23 × color 9 × color 10 × color
	personal assignment	1 × b/w
77-20	People in bed (British Vogue): John Schlesinger Thea Porter Lady Solti	10 × color 5 × color 9 × color

a 'shot at Mall, top building opposite St Paul's [Cathedral]'.

1978

78-1A	Feb. 20 – Michael James [Arnold]; Oct. 5 – Michael James, shot in Manchester (personal assignment)	3 × b/w
78-1B	Nov. 20 – Tony Huston Wedding (personal assignment)	7 × b/w
78-1A [sic]	Dec. 18 – Michael James, shot Manchester, Dec. 16 (personal assignment)	3 × b/w
	Michael Arnold, shot 1/28/79 (personal assignment)	3 × b/w
78-2	Asthma, advertising (R. Entwistle)	1 × b/w, 3 × color
78-3	Irene Pappas (Vogue)	3 × b/w, 3 × color
78-4	Optrex, advertising (Davidson, Pearce, Berry & Spottiswood) 1st shot, firemen 2nd shot, nursing mother 3rd shot, lorry driver	2 × color 2 × b/w, 9 × color 9 × color
78-5	The Great Train Robbery, film, Mar. 22: Sean Connery's fittings	6 × b/w
	Remainder[a]	2 × b/w, 22 × color
78-6	Dirk Bogarde (independent production)	3 × b/w, 4 × color
78-7	[Sergiu] Celibidache, Conductor, LSO [London Symphony Orchestra] (Sunday Times)	2 × b/w, 8 × color
78-8	English Tourist Board, advertising (Kingsley, Manton & Palmer)	8 × color
78-9	Mme Gandhi in India (Sunday Times)	7 × b/w, 53 × color [33 rolls K[odachrome] 64, 20 rolls E[ktachrome] 6]
78-10	Indian Troubadors (Sunday Times)	1 × b/w, 18 × color [13 rolls K[odachrome] 64, 5 rolls E[ktachrome] 6]
78-11	White Jews of Cochin (Sunday Times)	2 × color
78-12	English Tourist Board, advertising (KMP [Kingsley, Manton & Palmer])	44 × color
78-13	Pentax advertisement (Kirkwood Agency)	20 × color
78-14	Francis Bacon (Sunday Times)	3 × b/w, 5 × color
78-15	Rolex Watch advertisement: Yehudi Menuhin (J. Walter Thompson)	6 × color
78-16	Rolex Watch advertisement: Don McCullin (J. Walter Thompson)	8 × color
78-17	Lesley Ann Down (Life)	14 × color
78-18	Mrs. Gandhi in London (independent production)	b/w
78-19	Michael Crichton (Look)	10 × color
78-20	Alien, film (20th Century Fox)	b/w, color

a Identification unclear.

Eve Arnold. Photo: Jodi Buren

1979

79-1	Michael, Francis and Liz Arnold (personal assignment)	6 × b/w
79-2	Jon Voight (*Look*)[a]	
79-3	China (*Sunday Times* and for [EA's] book *In China*)	150[b] × b/w, color
79-4	Industrial job (C. R. Bard International)	12 × color
79-5	China, 2nd trip (for book *In China*)	338 × color [291 rolls K[odachrome] 64, 17 rolls E[ktachrome] 160, 30 rolls E[ktachrome] 400]
79-6a	Lord Olivier, *Clash of the Titans*, film (*Newsweek*)	18 × color
79-6b	Heineken Beer, advertising, shot in Holland (BBDO)	20 × color

a 'billed in N.Y.'
b '7 rolls here, May '89.'

1980

80-1	Michael Arnold (personal assignment)	4 × b/w
	John Huston in Budapest, for book jacket (Knopf: no fee charged)	6 × color
80-2	Heineken Beer, advertising (BBDO)	94 × color
80-3	Rolex advertisement: Kiri Te Kanawa (J. Walter Thompson)	12 × color
80-4	Heinz Baby Food, advertising (Dorlands)	26 × color
80-9	Eve Arnold, photographed by Costa Manos	7 × b/w

Nos 80-5 to 80-8 unassigned.

1981

81-1	Personal assignment	
81-2[a]	Book *In America*	
81-2	CC1 and CC2 [color conversion 1 and color conversion 2]: Male strippers	2 × color neg[atives]
81-3	Perry Ellis	

a 'This number was used for the entire book – There are no more numbers until 83-1.'

1982

'There were no story numbers in 1982 – the book *In America* was being worked on in 1982.'

1983

83-1	Michael Arnold (personal assignment)	2 × b/w
83-2	*Under the Volcano*, film, director John Huston	b/w, color

1984

84-1	Michael Arnold (personal assignment)	5 × b/w
84-2	Scindia Family, India (*Sunday Times*)	101 × color
84-3	Heinz Baby Food, advertising (Dorlands)	46 × color
84-4	Angela Carter (*Sunday Times*)	12 × color
84-5	*White Nights*, film (Columbia Pictures)	color
84-6	African Kingdom, South Carolina (Stern)	62 × color
84-7	Linton Kwesi Johnson, poet (Paris clients)	6 × color
84-8	*Steaming*, film (independent production)	color

1985

85-1	Personal assignment: John Huston and granddaughter	1 × b/w, 3 × colour
	Michael, Francis, Ann [Arnold]	3 × color
85-2	Vanessa Redgrave and daughter Joely (*Sunday Times*)	7 × color
85-3	Annual Report, advertising (Wood MacKenzie, London and Edinburgh)	5 × b/w, 52 × color
85-4	Miracle in Medjugorje, Yugoslavia (*Sunday Times*)	53 × color
85-5	16-Year-Old Girls (*Sunday Times*)	51 × color
85-6	Isabella Rossellini, Long Island (*Life*, cover)	18 × color
85-7	Isabella Rossellini, Florida (L.H.S., cover)	12 × color
85-8	Chocolate Slimming Drink, advertising (Derek Harman)	10 × color

1986[a]

86-1	Francis's Wedding [Francis Arnold]; Rolleiflex test on Linni [Campbell]; Michael's 9th birthday [Michael Arnold] (personal assignment)	b/w
86-2	*Mr. Corbett's Ghost*, film, with John Huston, [directed by Danny Huston]	

a Spent the year writing *Marilyn Monroe: An Appreciation* and preparing exhibit for Knoedler and Castelli [galleries, New York].

1987[a]

87-1	Personal assignment	
87-2	Scottish Voices, record cover (Don Fitzpatrick)	6 × b/w, 5 × color
87-3	Carol Kidd, record cover (Don Fitzpatrick)	18 × b/w, 2 × color
87-5 to 87-16	Misha [Mikhail] Baryshnikov and the American Ballet Theater (Bantam Books)	220 × b/w[b]

No. 87-4 unidentified.
a Much of 1987 was spent on *Marilyn Monroe: An Appreciation*.
b 'There were also a few rolls of color: [Baryshnikov in] Washington, at home in Sneadon's Landing, and [the company] on tour in Springfield, Missouri.'

1988[a]

88-1	personal assignment	
88-2	USSR: Up the Volga (Condé Nast Traveller)	4 × b/w, 62 × color

a 'There was also some additional shooting on [Mikhail] Baryshnikov's book, *Private View*, during 1988.'

1989[a]

89-1A	Michael Arnold (personal assignment)	1 × b/w
89-1B	Marcia Panama (personal assignment)	1 × b/w
89-1C	Ann and Michael [Arnold] (personal assignment)	1 × color
89-1D	Ann and Michael [Arnold] (personal assignment)	1 × b/w
89-1E	Sarah Jane Arnold and Ann, Michael, Francis [Arnold] (personal assignment)	1 × b/w
89-1F	Sarah Jane Arnold and Francis and Ann [Arnold]	1 × b/w
89-1G	Sarah Jane and Francis [Arnold]	1 × b/w

Eve Arnold, 1996. Photo: Graham Piggott

89-2 Baby Products, advertising (Johnson & Johnson) 14 × color (2 x 200 ASA, 12 x 64 ASA)

a 1989 devoted to the Bantam and Hamish Hamilton book *All In a Day's Work*, published in the U.S. in 1989 and in Britain in 1990, and ordering prints and researching for two new books, *A Loving Look* and the retrospective. Also planning and working on the Magnum Image series and the BBC Magnum series. Exhibition at Castelli [gallery, New York].

1990ᵃ

90-1-4	Xmas 1989 (personal assignment)	b/w (3 rolls TRI-X), color (1 roll Koda[chrome] 64)
90-1-5	Sarah Jane Arnold (personal assignment)	1 × b/w
90-1-6-8	Sarah Jane Arnold and Francis and Ann [Arnold] in Manchester, Nov. 1990 (personal assignment)	3 × b/w
90-1-9	Sarah Jane Arnold and Ann [Arnold] in Manchester, Nov. 1990	1 × color
90-2	British Rail advertisements (Saatchi & Saatchi): (a) Women at tea shop, Sagne [London]; (b) Towcester Races; (c) Osterley Park; (d) St Anne's, Blackpool; (e) A couple, Grasmere Water; (f) Three girls, Grasmere Waterᵇ	7 × b/w, 51 × color (Kodachrome)

a Wrote *Eve Arnold in Britain* [Britain] / *The Great British* [U.S.] [see also 1991].
b '1 color neg (4 frames).'

1991ᵃ

91-1-2	Sarah Jane Arnold and Michael [Arnold] (personal assignment)	2 × b/w
91-1-3	Kenya (personal assignment)	1 × b/w
91-1-4-5	David Arnold and Family (personal assignment)	2 × b/w
91-1-6	Ann, Francis, Sarah Jane and David Arnold, Oct. 1991 (personal assignment)	1 × b/w (T-MAX), 3 × color (Kodachrome)

a Published *Eve Arnold in Britain* [Christopher Sinclair-Stevenson] and *The Great British* [Alfred A. Knopf] and printed, hung and promoted exhibition of the book at the National Portrait Gallery [London], and began writing the retrospective, working title *Playback*, which continued until 1995.

1992ᵃ

92-1	Michael Arnold, his negatives	b/w
92-2	John Major, Prime Minister (*Sunday Times*):	
	Nov. 12 at No. 10 [Downing Street]	16 × b/w
	Nov. 23 at No. 10	3 × b/w
	Nov. 27–28, Rome and Athens	8 × b/w
	Dec. 3	8 × b/w
	Dec. 4	7 × b/w
	Dec. 21	3 × b/w

a 'T-MAX [film] was used throughout (mainly 400 [ISO], pushed to 1600 or at the party 3200 was used).'

1993

93-1	Michael Arnold (personal assignment)	b/w
93-2	Jack Cheatle and Zelda (personal assignment)	2 × b/w

1994

94-1	Michael Arnold's pictures	1 × b/w
94-2	Sarah Jane and David Arnold's party (personal assignment)	3 × b/w

1995ᵃ

95-1	Beeban Kidron and son Noah (personal assignment)	6 × b/w
95-2	Isabella Rossellini modelling Betsy Johnson clothes in New York (for Beeban's film on EA)	5 × b/w
95-3	Francis, Ann, Sarah Jane and David Arnold (personal assignment)	1 × b/w

a *Eve Arnold: In Retrospect* published by Alfred A. Knopf in America.

1991–96

During this period, EA made an exhibition of 100 prints for a joint show with Inge Morath in Japan, called 'Women to Women' (1996). She also created a carbon portfolio of Marilyn Monroe prints (limited edition of 15), which travelled.

Eve Arnold: In Retrospect was published in England by Christopher Sinclair-Stevenson in 1996. An exhibition of the same title showed at the Barbican, London (220 prints), where it attracted more than 62,000 visitors (the second highest attendance in the gallery's history to that date), and at 15 other venues, including the International Center of Photography in New York (120 prints).

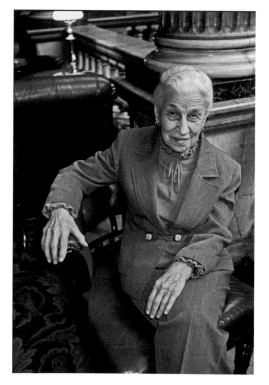

Eve Arnold, London, 1998. Photo: Henri Cartier-Bresson

Select Bibliography

Books by Eve Arnold

1976 *The Unretouched Woman.* Alfred A. Knopf, New York
1978 *Flashback! The 50s.* Alfred A. Knopf, New York
1980 *In China.* Alfred A. Knopf, New York
1983 *In America.* Alfred A. Knopf, New York
1985 *Portrait of a Film: The Making of White Nights,*
 photographs and texts by Eve Arnold, Introduction
 by Taylor Hackford. Harry N. Abrams, New York
1987 *Marilyn Monroe: An Appreciation.* Alfred A. Knopf, New York
1988 *Private View: Inside Baryshnikov's American Ballet Theatre,*
 text by John Fraser, photographs by Eve Arnold.
 Bantam Books, New York
1989 *All in a Day's Work.* Bantam Books, New York
1991 *The Great British.* Alfred A. Knopf, New York /
 Eve Arnold in Britain. Sinclair-Stevenson with
 the National Portrait Gallery, London
1995 *Eve Arnold: In Retrospect.* Alfred A. Knopf, New York
1995 *Keepsakes: The Photography of Eve Arnold in Retrospect.*
 Harry Ransom Humanities Research Center, Austin, Texas
1996 *Ciné-Roman.* Cahiers du Cinéma, Paris
2002 *Film Journal.* Bloomsbury, London
2004 *Handbook.* Bloomsbury, London
2005 *Marilyn Monroe.* Harry N. Abrams, New York

Magnum Photos, Group Books

1999 *Magna Brava: Magnum's Women Photographers.*
 Prestel Verlag, Munich
2001 *The Misfits: Story of a Shoot,* texts by Arthur Miller
 and Serge Toubiama. Phaidon Press, London
2004 *Magnum Stories,* edited by Chris Boot.
 Phaidon Press, London
2005 *Magnum Ireland,* edited by Brigitte Lardinois
 and Val Williams. Thames & Hudson, London
2007 *Magnum Magnum,* edited by Brigitte Lardinois.
 Thames & Hudson, London

Acknowledgments

Putting this book together has been a team effort. It is with enormous pleasure that I would like to express my heartfelt thanks to the contributors, Anjelica Huston, Isabella Rossellini, John Tusa, Elliott Erwitt, Sheena McDonald, Michael Rand, David Puttnam, Beeban Kidron, Jon Snow and Mary McCartney, who all agreed to take part without hesitation and sent their words in on time and with panache. Each and every one was a joy to work with.

At Magnum I would like to thank Fran Sears and Sophie Wright, and Nick Galvin, who from the start was generous with his advice and who steered us through the selection. My thanks also go to the indefatigable Paul Hayward, who with great skill and patience prepared all the images and matchprints.

At the London College of Communication my thanks go to Professors Janice Hart and Val Williams, whose unstinting belief in the validity of my projects is always a great encouragement.

I would like to thank my husband Des McAleer for his help with the text and his support throughout, and Fergal McAleer for putting up with my endless phone calls and occasional chaos when I was trying to meet the deadlines.

At Thames & Hudson my special thanks go to Andrew Sanigar, the book's commissioning editor, whose unfailing enthusiasm and dedication has steered the project from start to finish; to Maggi Smith, whose instinctive understanding of Eve's work made the laying out of this book seem effortless; to Philip Watson who with his characteristic calm and skill forged all our different contributions into one smooth-flowing text; and to Sadie Butler who handled the production control and printing of the book with exceptional efficiency.

Finally I would like to express my thanks to Linni Campbell, whose help throughout was truly invaluable; but most of all, of course, this book was sustained by the participation of Eve herself, whose enthusiasm is at the heart of it.

Index

Pages numbers in *italic* indicate photographs.